The Art of
Acrylic Painting

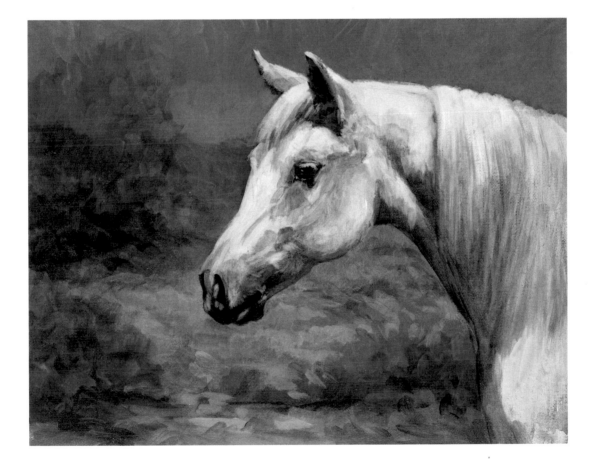

Walter Foster

WALTER FOSTER PUBLISHING, INC.
23062 La Cadena Drive
Laguna Hills, California 92653
www.walterfoster.com

CONTENTS

INTRODUCTION TO ACRYLIC PAINTING

Acrylic is a very distinctive painting medium. In addition to having a unique look and feel of its own, it can mimic other media, such as watercolor, oil, and even pastel. It's as convenient and quick-drying as watercolor, as permanent as oil, and as vibrant as pastel. Moreover, it's extremely versatile; it can be thinned with water to near transparency or applied in thick strokes straight from the tube. These qualities make acrylic an ideal medium for capturing a variety of subjects—from animals and landscapes to still lifes, flowers, and more. The lessons presented here explore the acrylic painting methods of a variety of seasoned artists, who share their experiences and insights as they teach you how to master this amazing medium. You'll find essential information regarding painting tools, tips, and techniques. And along the way, you'll also discover the inspiration you need to start creating your own breathtaking acrylic paintings!

TOOLS AND MATERIALS

To get started with acrylic, you need only a few basic tools: paints, brushes, supports, and water. When you buy your acrylic supplies, remember to purchase the best you can afford at the time, as better-quality materials are more manageable and produce longer-lasting works.

SELECTING PAINTS

Acrylic paints come in jars, cans, and tubes. Most artists prefer tubes, as they make it easy to squeeze out the appropriate amount of paint onto your palette. There are two types of acrylic paints: "student grade" and "artist grade." Artist-grade paints contain more pigment and less filler, so they are more vibrant and produce richer mixes.

BUYING BRUSHES

Acrylic paintbrushes are categorized by hair type (soft or stiff and natural or synthetic), style (e.g., filbert, flat, or round), and size. For the projects in this book, you'll want to have small, medium, and large sizes of both soft and stiff (bristle) brushes. Synthetic-hair paintbrushes work well with acrylic, as the hairs are soft but springy enough to return to their original form. In addition to buying brushes, you'll also want to purchase a palette knife or painting knife for mixing colors on your palette and experimenting with textural effects on your canvas.

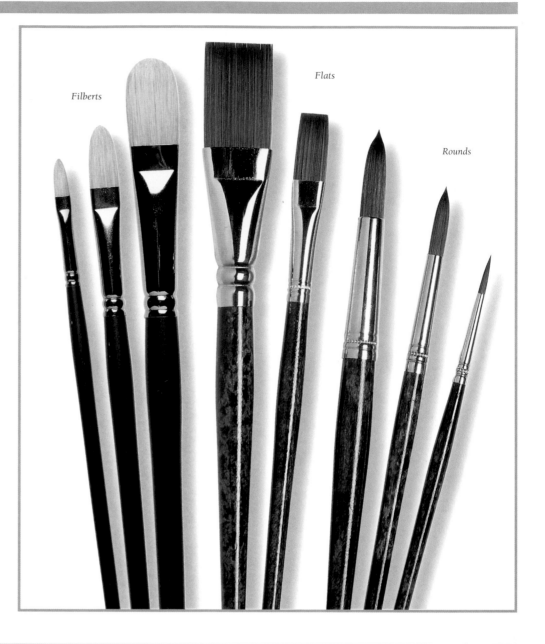

Filberts

Flats

Rounds

CHOOSING YOUR COLORS

These 14 colors, including white, make a good palette for beginners. From them, you can mix just about any color you like—and they're available in most brands. Although you can also buy black paint, many artists prefer to create their own black paint by mixing colors from their palette. (See page 8 for more about mixing neutral colors.)

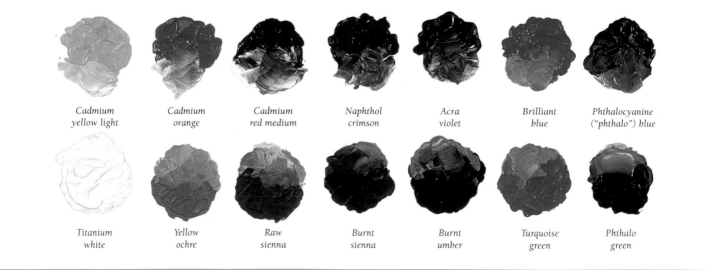

Cadmium yellow light	*Cadmium orange*	*Cadmium red medium*	*Naphthol crimson*	*Acra violet*	*Brilliant blue*	*Phthalocyanine ("phthalo") blue*
Titanium white	*Yellow ochre*	*Raw sienna*	*Burnt sienna*	*Burnt umber*	*Turquoise green*	*Phthalo green*

Setting Up Your Work Space The way you set up your work station will depend on whether you are right- or left-handed. Try to keep your supplies in the same place, so that when you sit down to paint, you don't have to waste time searching for anything. If natural light is unavailable, make sure you have sufficient artificial lighting. And, above all else, make sure you're comfortable!

SELECTING A SUPPORT

Acrylic can be applied to almost any surface that has first been primed with *gesso*—a water-based mixture of a chalklike substance and glue that applies like paint and makes the surface less absorbent. (See page 19.) This material also bonds well with the paint. Many artists choose to paint on primed canvases or canvas boards, which provide a fine-fabric surface with a slight grain. Primed pressed-wood panels offer a smoother alternative to canvas, as they have a fine-grained, less coarse surface. For projects that call for a thin watercolor effect, you can use canvas paper or acid-free 140-lb or 300-lb cold-press watercolor paper.

PURCHASING A PALETTE

Palettes for acrylic paints are available in many different materials—from wood and ceramic to metal and glass. Plastic palettes are inexpensive, and they can be cleaned with soap and water. Disposable paper palette pads are also very convenient; instead of washing away the remains of your paint, you can simply tear off the top sheet to reveal a fresh surface beneath.

GATHERING THE BASICS

Before you get started painting, you'll need a few more things: two jars of water (one for wetting your brushes and diluting your paint mixes and one for rinsing out your brushes), a spray bottle of water (for keeping the paints and mixes on your palette moist), and paper towels or rags (to help with cleanup). You might also want to to try out some of the various acrylic mediums that are available. (See page 18.)

Primed hardwood panel (rough side)

Primed hardwood panel (smooth side)

Illustration board

Canvas

Surface Textures The surface on which you paint determines the textures of your strokes and washes. In the examples above, you can see how thick (left) and thin (right) applications of paint appear on the various supports.

COLOR THEORY

Before you begin painting with acrylic, it's important to get to know the basic principles of color theory. Color plays a huge role in the overall mood or "feel" of a painting, as colors and combinations of colors have the power to elicit various emotions from the viewer. On these pages, you'll learn some of the basic color terms referred to throughout the lessons in this book. And you'll also discover how colors affect one another, which will help you make successful color choices in your own paintings.

LEARNING THE BASICS

The color wheel is a circular spectrum of colors that demonstrates color relationships. Yellow, red, and blue are the three main colors of the wheel; called "primary colors," they are the basis for all other colors on the wheel. When two primary colors are combined, they produce a *secondary color* (green, orange, or purple). And when a secondary and primary color are mixed, they produce a *tertiary color* (such as blue-green or red-orange). The term *hue* refers to the color itself (such as blue or red), and *intensity* (or *chroma*) means the strength of a color, from its pure state (straight from the tube) to one that is grayed or diluted.

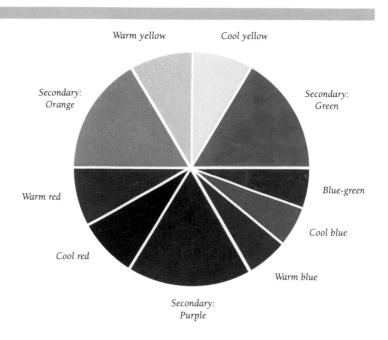

The Color Wheel This handy color reference makes it easy to spot complementary and analogous colors (see page 9), making it a useful visual aid when creating color schemes.

MIXING COLORS

In theory, you can mix every color you might need from the three primaries (red, yellow, and blue). But all primaries are not created alike, so you'll need to have at least two versions of each primary available to work with—one warm (containing more red) and one cool (containing more blue). (See page 90.) As shown on the chart at right, the two primary sets give you a wide range of secondary mixes. You'll also find that they produce a generous array of subtle, neutral shades when mixed.

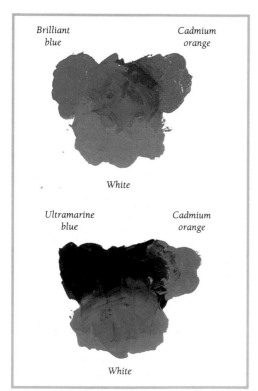

Brilliant blue — Cadmium orange

White

Ultramarine blue — Cadmium orange

White

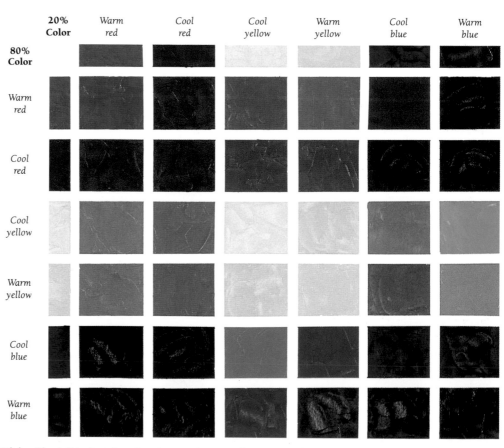

Mixing Chart This chart shows how the two primary sets (warm and cool) provide a wide range of secondary mixes. You'll also find that these colors produce a generous array of subtle, neutral shades when mixed.

MIXING NEUTRALS

Neutral colors (browns and grays) are formed either by mixing two complementary colors or by mixing the three primaries together. By altering the quantity of each color in your mix or by using different shades of primaries, you can create a wide range of neutrals for your palette. These slightly muted colors are more subtle than those straight from the tube, making them closer to colors found in nature. At left are a couple of possibilities for neutral mixes using the complements blue and orange.

UNDERSTANDING VALUE

Value is the lightness or darkness of a color or of black. Variations in value are used to create the illusion of depth in a painting. Darker values generally tend to recede, while lighter values tend to come forward. With acrylic, artists lighten their colors with water or with a light color, such as white or Naples yellow, and they darken their colors by adding black or a dark color, such as burnt umber.

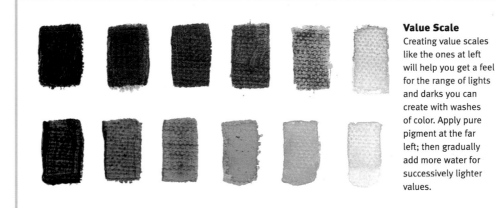

Value Scale Creating value scales like the ones at left will help you get a feel for the range of lights and darks you can create with washes of color. Apply pure pigment at the far left; then gradually add more water for successively lighter values.

EXPLORING COLOR "TEMPERATURE"

The color wheel is divided into two categories: *warm colors* (reds, oranges, and yellows) and *cool colors* (blues, greens, and purples). Warm colors tend to pop forward in a painting, making them good for rendering objects in the foreground; cool colors tend to recede, making them best for distant objects. Warm colors convey excitement and energy, whereas cool colors are considered soothing and calm. Color temperature also communicates time of day or season: warm corresponds with afternoons and summer, and cool conveys winter and early mornings.

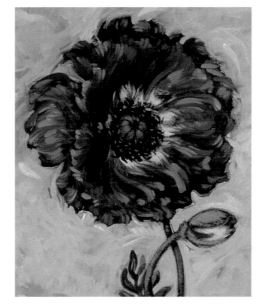

Warm Colors Warm colors can convey a sense of cheer and comfort or passion and aggression. They are also the most forward—they stand out because our eyes see them as advancing toward us. In this example, the fiery red petals really seem to pop off the canvas.

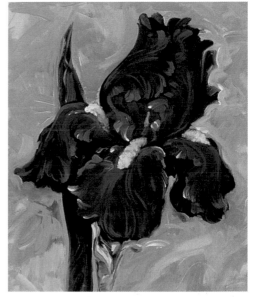

Cool Colors We tend to associate cool colors with shadows, depth, and quietude. Cool colors also normally retreat from the eye, which makes them good choices for backgrounds and distant objects. Here the blues and purples of the petals have a calm and soothing effect.

USING COMPLEMENTARY COLORS AND ANALOGOUS COLORS

Complementary colors are any two colors that are directly across from each other on the color wheel (such as purple and yellow or orange and blue). When placed next to each other in a painting, complements create lively exciting contrasts, as you can see in the example at right. *Analogous colors,* on the other hand, are those that are adjacent to one another on the color wheel (for example, yellow, yellow-orange, and orange). And because analogous colors are similar, they create a sense of color harmony when used together in a painting.

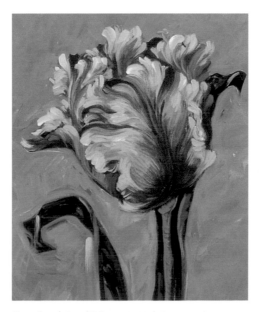

Complementary Colors Place a color next to its complement whenever you want high drama and a lot of vitality. This combination of a warm orange flower against its cool complement—blue—uses both "temperature" and contrast to draw attention to the subject.

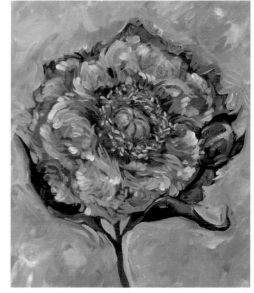

Analogous Colors The petals of this peony are painted with analogous colors—various hues and values of pink and peach. Because all the colors in this blossom are similar to one another—and the same colors are repeated in the background—the painting elicits a feeling of unity.

DRAWING TECHNIQUES

Drawing is an art in itself. It is also a very important part of painting—even acrylic painting. You'll often need a light guideline of the shape and form of the subject to start an organized acrylic painting. (An unorganized form of painting would be the free flow of color in nonrepresentational masses.) Your drawings don't need to be tight and precise as far as geometric perspective goes, but they should be within the boundaries of these rules for a realistic portrayal of the subject.

Drawing is actually simple; just sketch the shapes and the masses you see. Sketch loosely and freely—if you discover something wrong with the shapes, you can refer to the rules of perspective to make corrections.

Practice is the only way to improve your drawing and to polish your hand-eye relationships. It's a good idea to sketch everything you see and keep all your drawings in a sketchbook so you can see the improvement.

In acrylic painting, there are several approaches to sketching. Some artists use charcoal to sketch directly on the canvas, some "draw" their composition on the support with a brush and paint, and others transfer their sketch to canvas using transfer paper or a projector.

Following are a few exercises to introduce the basic elements of drawing in perspective. Begin with the one-point exercise.

ONE-POINT PERSPECTIVE

In *one-point perspective*, the face of a box is the closest part to the viewer, and it is parallel to the horizon line (eye level). The bottom, top, and sides of the face are parallel to the picture plane.

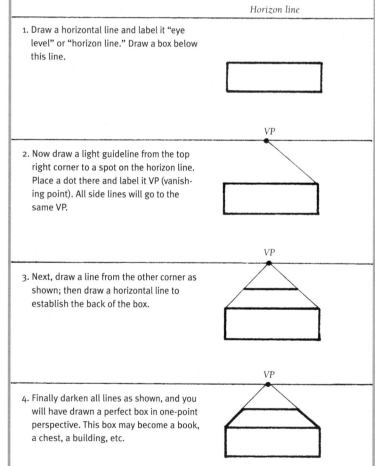

Horizon line

1. Draw a horizontal line and label it "eye level" or "horizon line." Draw a box below this line.

2. Now draw a light guideline from the top right corner to a spot on the horizon line. Place a dot there and label it VP (vanishing point). All side lines will go to the same VP.

3. Next, draw a line from the other corner as shown; then draw a horizontal line to establish the back of the box.

4. Finally darken all lines as shown, and you will have drawn a perfect box in one-point perspective. This box may become a book, a chest, a building, etc.

TWO-POINT PERSPECTIVE

In *two-point perspective*, the corner of the box is closest to the viewer, and two VPs are needed. Nothing is parallel to the horizon line in this view. The vertical lines are parallel to the sides of the picture plane.

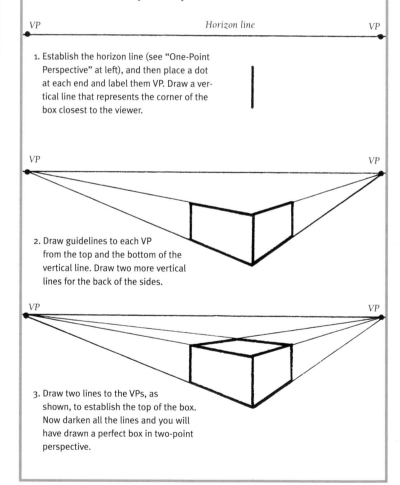

Horizon line

1. Establish the horizon line (see "One-Point Perspective" at left), and then place a dot at each end and label them VP. Draw a vertical line that represents the corner of the box closest to the viewer.

2. Draw guidelines to each VP from the top and the bottom of the vertical line. Draw two more vertical lines for the back of the sides.

3. Draw two lines to the VPs, as shown, to establish the top of the box. Now darken all the lines and you will have drawn a perfect box in two-point perspective.

FINDING THE PROPER PEAK AND ANGLE OF A ROOF

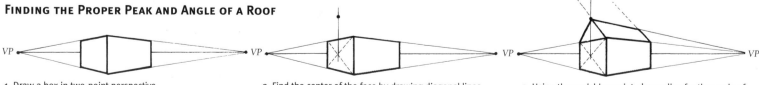

1. Draw a box in two-point perspective.

2. Find the center of the face by drawing diagonal lines from corner to corner; then draw a vertical line upward through the center. Make a dot for the roof height.

3. Using the vanishing point, draw a line for the angle of the roof ridge; then draw the back of the roof. The angled roof lines will meet at a third VP somewhere in the sky.

BASIC FORMS

There are four basic forms you should know: the cube, the cone, the cylinder, and the sphere. Each of these forms can be an excellent guide for beginning a complex drawing or painting. Below are some examples of these forms in simple use.

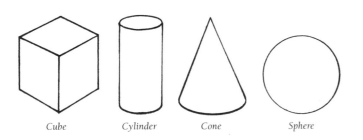

Cube *Cylinder* *Cone* *Sphere*

CREATING DEPTH WITH SHADING

To create the illusion of depth when the shapes are viewed straight on, shading must be added. Shading creates different values and gives the illusion of depth and form. The examples below show a cone, a cylinder, and a sphere in both the line stage and with shading for depth.

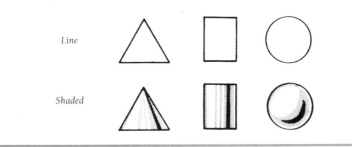

Line

Shaded

FORESHORTENING

As defined in Webster's dictionary, to *foreshorten* is "to represent the lines (of an object) as shorter than they actually are in order to give the illusion of proper relative size, in accordance with the principles of perspective." Here are a few examples of foreshortening to practice.

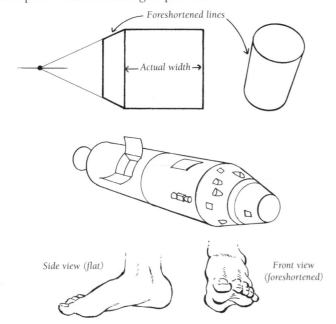

Foreshortened lines

Actual width

Side view (flat) *Front view (foreshortened)*

ELLIPSES

An *ellipse* is a circle viewed at an angle. Looking across the face of a circle, it is foreshortened, and we see an ellipse. The axis of the ellipse is constant, and it is represented as a straight centerline through the longest part of the ellipse. The height is constant to the height of the circle. Here is the sequence we might see in a spinning coin.

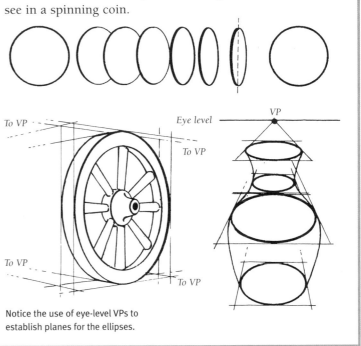

To VP Eye level *VP*

To VP

To VP

To VP

Notice the use of eye-level VPs to establish planes for the ellipses.

CAST SHADOWS

When there is only one light source (such as the sun), all shadows in the picture are cast by that single source. All shadows read from the same vanishing point. This point is placed directly under the light source, whether on the horizon line or more forward in the picture. The shadows follow the plane on which the object is sitting. Shadows also follow the contour of the plane on which they are cast.

Light rays travel in straight lines. When they strike an object, the object blocks the rays from continuing and creates a shadow relating to the shape of the blocking object. Here is a simple example of the way to plot the correct shape and length of a shadow for the shape and the height of the light.

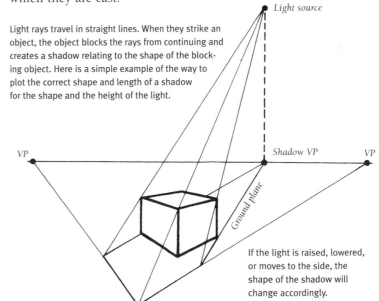

Light source

VP *Shadow VP* *VP*

Ground plane

If the light is raised, lowered, or moves to the side, the shape of the shadow will change accordingly.

PAINTING TECHNIQUES

There is an endless number of ways to apply and manipulate acrylic paint. The next four pages present some of the most common techniques and special effects—from drybrushing to spattering. Once you get the basics down, you'll be able to decide which techniques work best for each of your subjects. And remember that, as you paint, it's a good idea to get in the habit of spicing up your art with multiple techniques, which will help keep your painting process from becoming too repetitive or formulaic.

Flat Wash A *wash* is a thin mixture of paint that has been diluted with water. The most common type of wash—a flat wash—is used to quickly cover large areas with solid color. First load a large flat brush with a diluted mix of paint and water; then tilt the paper as you lightly sweep overlapping, horizontal strokes across the page. Gravity will help pull and blend the strokes together.

Graded Wash With a graded wash, the color transitions down the page from dark to light, creating a value gradation that's perfect for skies or water. Tilt the support and paint horizontal strokes across the top in the same manner as for a flat wash. But this time, add more water to your brush before each new stroke. The color will gradually fade out as you move down the painting.

Drybrushing To create coarse, irregular strokes of color as shown in this example, load a brush with color and wipe off any excess paint with a paper towel. Then lightly drag the brush over the painting surface, letting the paint drag off onto the surface in a broken pattern. This is good for creating rough, natural textures, like wood or grass.

Impasto Impasto simply means to apply paint thickly, as shown in this example. To create this rich, buttery texture, use short, quick strokes to apply very thick paint to your support. Don't overwork the paint—just dab it on so you don't flatten it out. A thick application like this adds dimension to the painting, making it perfect for rendering bushy foliage, foamy water, or shaggy animals.

Wet-into-Wet For this technique, apply color next to another color that is still wet. Then blend the two colors by lightly stroking over the area where they meet. Use your brush to soften the edge, producing a smooth transition. This technique is ideal where subtle blends and gradations are needed—such as in a sunset sky where the color gently changes from pink to orange to yellow.

Thick on Thin Instead of blending your colors, try layering them, as shown in this example. First apply a thin wash of paint to establish your "ground." Once the first layer is dry, apply thick paint over it, leaving some gaps in the thick paint to allow some of the undercolor to show through. This is a good way to add some depth and texture to a painting.

Dabbing For soft dabs of built-up color, load the tip of your brush with an ample amount of paint and dot on color in a jabbing motion. Layering several different hues of green and yellow will give fullness and dimension to foliage, as shown in this example.

Sponging To produce this mottled texture, use a natural sponge to apply the paint. First dampen the sponge with water; then dip the sponge in the paint and lightly dab the color onto the support. The resulting texture is perfect for adding texture to sand, rocks, or clouds.

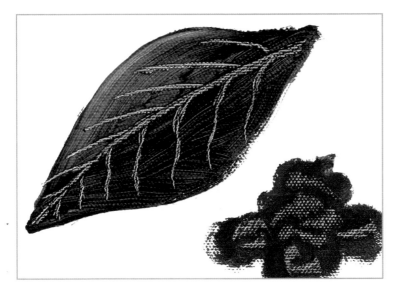

Scraping Also called "sgraffito," scraping is a method used to remove wet paint from the painting surface; the purpose is to reveal the lighter values beneath. For this technique, use a pointed tool , such as the end of your brush handle, to scrape off wet paint. You can actually "draw" lines in the paint, as shown in the veins of the leaf above.

Spattering This technique is used to speckle your canvas with fine dots of color, as shown here. Just load an old toothbrush with diluted paint and run your thumb against the bristles, allowing the paint to spatter onto the paper. This special effect can be used for depicting flower fields, rain, sand or pebbles—or even a starry sky.

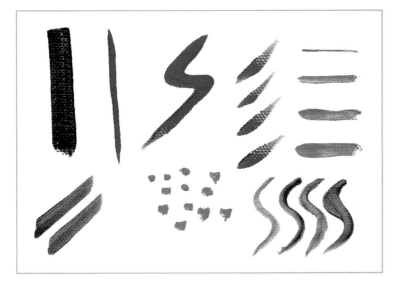

Drawing with the Brush Use the tip of your round brush to produce long, thin lines, or use a flat brush to produce thicker lines. "Drawing" with the brush makes it easy to add crisp edges and small details, such as flowers, leaves, and stems, to your paintings.

Double-Loading Dip half of a brush into one color and dip the other half into a second color. As you stroke, both colors will appear side by side. This method produces interesting, two-toned shapes that are perfect for rendering leaves, flower petals, or distant trees.

PAINTING TECHNIQUES (CONTINUED)

GLAZING

Glazes are thin mixes of paint and water or acrylic medium (see page 18) applied over a layer of existing dry color. An important technique in acrylic painting, glazing can be used to darken or alter colors in a painting. Glazes are transparent, so the previous color shows through to create rich blends. They can be used to accent or mute the base color, add the appearance of sunlight or mist, or even alter the perceived color temperature of the painting. When you start glazing, create a mix of about 15 parts water and 1 part paint. It's better to begin with glazes that are too weak than ones that are too overpowering, as you can always add more glazes after the paint dries.

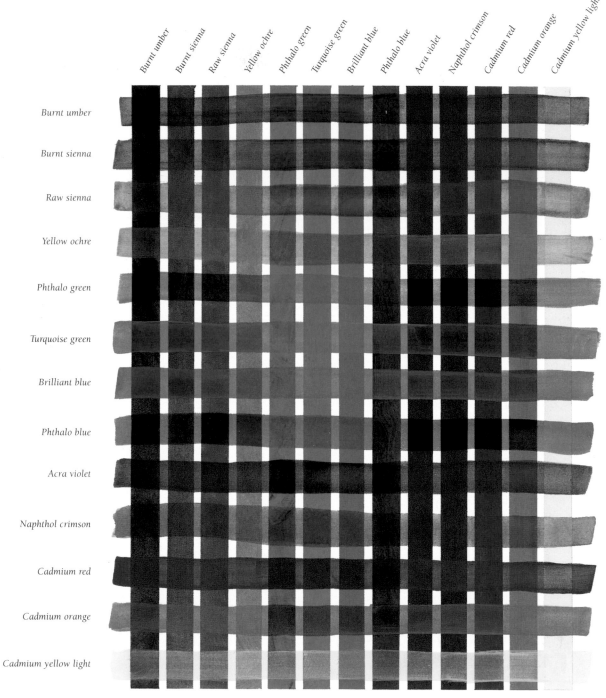

Glazing Grid In this chart, transparent glazes of 13 different colors are layered over opaque strokes of the same colors. Notice how the vertical opaque strokes are altered by the horizontal translucent strokes.

Painting Knife Knives are frequently used to mix paint, but using your knife to paint with as well as mix can add real drama to your painting. Use the flat blade to spread a thick layer of paint over the surface. Each knife stroke leaves behind thick ridges and lines where it ends, mimicking rough, complex textures like stone walls or rocky landscapes. Or you can use the edge of the blade, working quickly to create thin linear ridges that suggest and define shapes. Even the point of the knife is useful; it can scrape away paint to reveal whatever lies beneath.

APPLYING AN UNDERPAINTING

An underpainting is a thin wash of color that is applied to the support at the beginning of the painting process. An underpainting can be used to simply tone the support with a wash of color to help maintain a desired temperature in a final painting—for example, a burnt sienna wash would establish a warm base for your painting; a blue wash would create a cool base. An underpainting can also provide a base color that will "marry with" subsequent colors to create a unified color scheme. You can also use an underpainting to create a visual color and value "map," giving you a guideline for applying future layers. An underpainting can help provide harmony and depth in your paintings. Experiment with various underpaintings to discover which colors you prefer.

Magenta

Burnt sienna

Purple

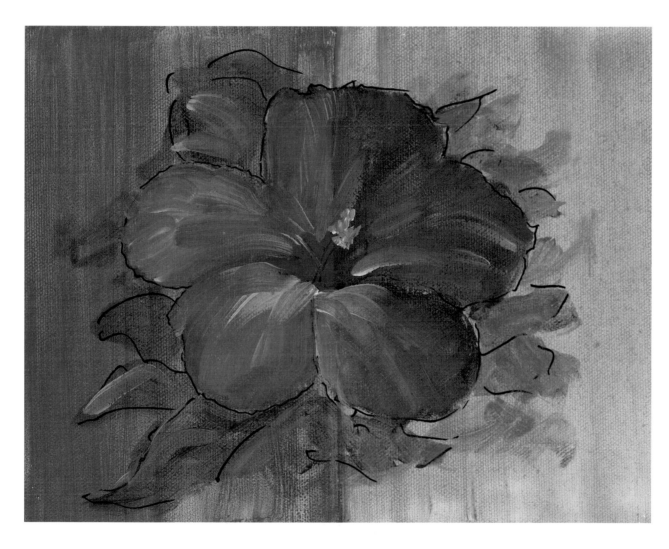

Underpainting for Temperature In the example at left, the flower has been painted over two different underpaintings: magenta (left) and light blue (right). Although the final flower is painted with identical colors on both sides of the canvas, the underpainting color greatly affects the appearance of the later layers of color. Notice that the left half of the flower appears significantly warmer in temperature, whereas the right half has a cool blue undertone.

USING FRISKET

Frisket is a masking material that is used to protect specific areas of a painting from subsequent layers of color. You can use frisket on a white surface or over previously applied color that has been allowed to dry. Liquid frisket is a type of rubber cement that is applied with a brush or sponge. When applied with a brush, it can be used for saving areas of fine detail, such as the veins of a leaf or the highlight of an eye; when applied with a sponge, it can be used to create random textures and patterns. When you're done painting, simply rub off the dried frisket with your finger. Paper frisket comes in sheets or rolls; cut out the shape you want to mask and place it sticky-side-down on the area of the painting you want to protect.

PAINTING WITH
KEN
GOLDMAN

Ken Goldman is a popular instructor at the Athenaeum School of the Arts in La Jolla, California, where he teaches portrait, artistic anatomy, and landscape painting classes. He is the author of five Walter Foster books, including Pastel: *Portraits* (HT240), *Pastel: Landscapes* (HT242); *Acrylic 1* (HT273); and *Basic Anatomy and Figure Drawing* (HT289) in the How to Draw and Paint series, and *Charcoal Drawing* (AL25) in the Artist's Library series. Ken received his training in New York at the Art Students League, National Academy of Design, and New York Studio School. A recipient of numerous awards, Ken has exhibited widely in various group shows and more than 30 one-man shows in the United States, Mexico, and Europe. His artwork is featured in the permanent collections of several major museums. Ken lives in San Diego, California, with his artist-wife, Stephanie Goldman.

TAKING THE FIRST STEPS

Starting a new painting gives me a wonderful feeling. It's a combination of excitement, anticipation, and the joy of participating in a creative process. You may choose to start by warming up with sketches, or you may prefer to begin painting directly from life or from a photo—or even from a painting in a book, like this one. The important thing is to just jump in and get those creative juices flowing!

Using Photo References
You may want to start out by using photographs as reference material. Then you won't have to worry about arranging the objects or finding the best lighting; you can just start painting!

USING ACRYLIC MEDIUMS

You can use acrylic in its pure form because it spreads fairly well, but if you're painting large areas, adding a painting medium will allow the acrylic to flow even more freely. Choose the type of medium that best suits your needs, and try a ratio of one part medium to one part paint. These are the different types of mediums: *Gloss* medium extends paint and leaves a shiny surface. A small amount simply makes it easier to spread the paint around, whereas a large amount makes the color very transparent, which is great for glazing. *Matte* medium works the same way gloss medium does, but matte has a chalky talc added that reduces glare, so the surface won't be shiny. *Gel* medium acts the way matte and gloss mediums do, but gel also makes paint thicker, adding a textural effect. *Retarder* slows drying time to make blending easier, but be careful not to add too much or your paints may dry unevenly.

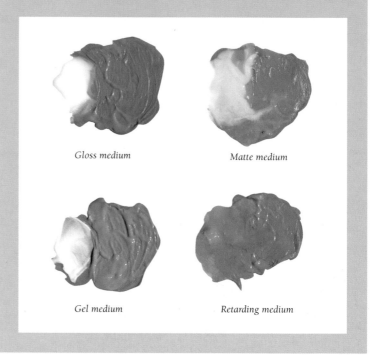

Gloss medium

Matte medium

Gel medium

Retarding medium

DECIDING WHAT TO PAINT

So how do you decide what to paint? I take a sketchbook almost everywhere I go so I can record ideas for future paintings, and I often take photographs and keep them in a file for source material. If you really look around, you can find interesting subjects that are close at hand, such as around your house or in your own backyard. Or you could collect ideas from books, magazines, newspapers—even calendars. And I bet if you went into the kitchen right now and started pulling things out of the cupboards, you'd have a terrific still life setup in no time. The important thing is to find something that interests you or has a special meaning to you—and if you're just learning to paint, keep things simple. Then the only problem will be narrowing your selection!

STARTING OUT

Once you've chosen what to paint, do some quick pencil sketches before going to color. This is where you will determine the placement of your subject on the canvas and work out the correct shapes, proportions, and perspective. Then you're ready to draw directly onto the painting surface. Keep the shapes simple and blocky—there's no need to do a fully rendered drawing with shading and a lot of detail; you'll just paint over it anyway.

Once you're happy with your drawing, find a place with good lighting, gather all your painting materials, and make sure the telephone answering machine is on. Lay out the paints you want to use on your palette, and then follow the steps on page 19 to start painting!

Studying your Subject It's a good idea to study a variety of subjects and practice drawing them before starting a painting. I use a sketchbook, such as the one shown above, and go out in the field to draw from life to familiarize myself with as many different subjects as I can. I also make detailed notes about shape, color, and texture, which I find very helpful to refer to when I'm painting the subject back in my studio.

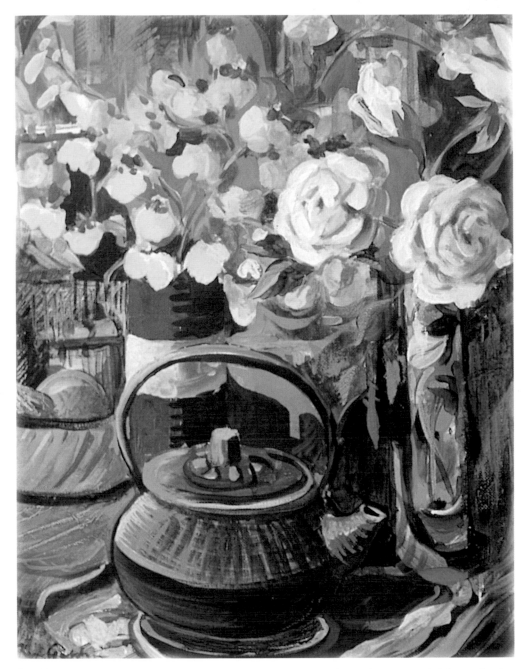

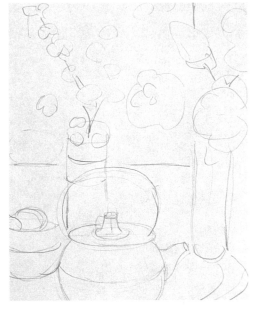

STEP ONE I often sketch directly on my canvas using pencil or charcoal. Here I lightly sketch only the general outlines of the objects: the flowers and vases are simple circles and cylinders; the teapot is circles and ellipses with a spout. This sketch establishes the proportions and shapes and provides a guideline for applying color.

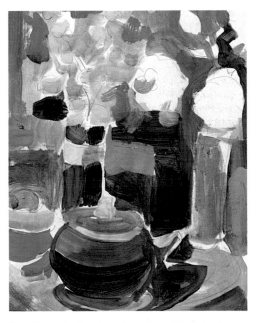

STEP THREE Feel free to interpret your reference rather than just copy it—in other words, use your *artistic license*. Here I made the background much more active than it is in the actual photograph on page 18. I liked the backlighting of the photo, but decided to take a closeup view of the teapot instead.

STEP TWO I begin painting by applying the most extreme colors first—both the darkest and the lightest areas. (These are easier to see if you squint your eyes.) I use a fairly large brush and work very loosely. The idea is just to get a base of all the right colors in the right places. Then I start making my shapes more accurate while still keeping my brushstrokes loose.

PRIMING YOUR SUPPORT

Preprimed supports are readily available at any art store, but you may prefer to prime the canvas or board yourself. To do this, you will need a hardwood board or stretched canvas, a jar of acrylic gesso, and a 2"-wide brush (a house painting brush works well).

Pour some gesso directly on the support, and spread it evenly with the paintbrush, stroking alternately back and forth and up and down until the surface is smooth (For a more textured surface, don't smooth out all the brushstrokes completely.)

If you start with a charcoal sketch, be sure to paint over it with a layer of thinned acrylic to keep the charcoal from polluting successive colors.

Underpainting in One Color

I often start with a one-color (monochromatic) base, so I can temporarily forget about what colors to choose and instead focus on the fundamentals: drawing, composition, and values. This base is called the "underpainting," and it lays the drawing and value foundation for the actual colors I plan to use. (See page 15.) You may not fully realize the power of values—the light, dark, and in-between shades of a color or of black—but they are what give shapes and colors dimension and life. And painting in one color is a fun and easy way to explore and learn about values.

FOCUSING ON THE VALUES

For a monochromatic underpainting, I choose a color, such as blue, and then develop a range of values: I add white where I want light areas and black where I want it darker and richer. The advantage of using only one color is that I can concentrate on establishing the correct values. The disadvantage is that a blue painting with white and blackish areas looks a bit raw. I prefer to start with a one-color underpainting and then add accents with contrasting colors at the end. Here I'll go through it step by step, so you can see how the values evolve.

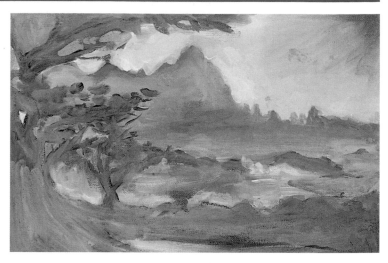

STEP ONE As for any painting, I start with a sketch of the basic shapes. Here, on primed canvas paper, I draw with a brush and apply the paint in a very loose, free style—a "painterly" way of drawing.

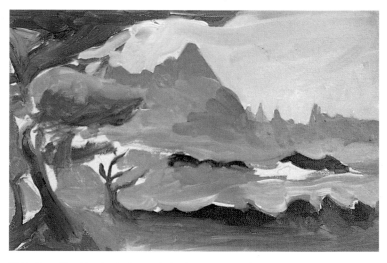

STEP TWO Now I begin placing my dark values as accurately as possible. Acrylic is very opaque and dries quickly, so this stage is a matter of refining the shapes and edges until I think they are right; when needed, I correct a dark edge with a light edge, and vice versa.

MAKING ACRYLIC COLORS LIGHTER OR DARKER

To darken a color as dark as ultramarine blue, only black or a very dark burnt umber or sepia can make it darker. To lighten it, however, you have two choices. The most obvious method is to add white, but since acrylics are water-based, they can also be lightened by adding water. However, do keep in mind that while adding water will lighten the values of your colors, adding too much water can weaken the strength of the polymer binder. Thin your paint color with a lot of water only at the beginning of a painting, and use painting mediums (see page 18) to thin color for the final layers.

Adding Black	**Adding White**	**Adding Water**
Pure ultramarine blue	*Pure ultramarine blue*	*Pure ultramarine blue*
Ultramarine with a little black	*Ultramarine with a little white*	*Ultramarine with a little water*
Ultramarine with more black	*Ultramarine with more white*	*Ultramarine with more water*

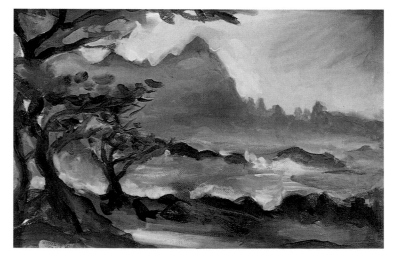

STEP THREE By this stage, I can see that the values are working, but the intense blues and white sky look too raw and pasty to me. A lot of artists do make complete paintings in one color, but I wouldn't choose to do a monochromatic painting in such an intense blue. For me, the painting at this point is a good underpainting but not a finished piece of art. It needs more color and paint texture.

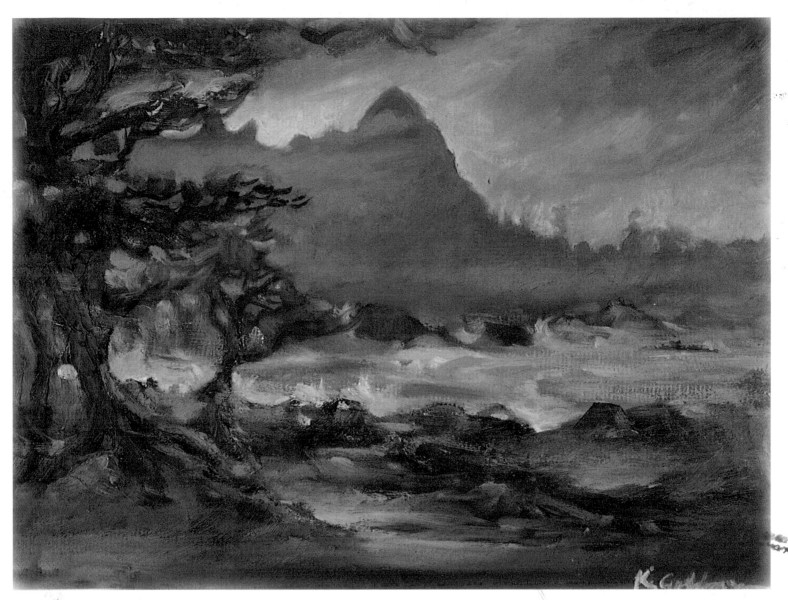

STEP FOUR The additional touches of raw umber, yellow ochre, and cadmium yellow light give this painting a more refined look.

If your subject has mostly earth tones, underpaint with a neutral color, such as raw umber or a mixed gray.

Working with a Limited Palette
Here's another example of a painting done in basically one color, but this time in shades of brown instead of blue. I like its bold, graphic quality and the fact that it derives its strength from value and composition, rather than from a multitude of colors.

Capturing Motion

Movement in a painting can mean many different things. It can refer to the way you direct the viewer's eye through a composition, or it can mean showing a figure or an animal "frozen" in mid-move. It can also relate to the way blurred brushwork is used to indicate a speeding object or the way wavy lines show that the subject is being blown by the wind. Instead of focusing on just one type of movement, I thought it would be fun to explore a few different acrylic techniques for showing subjects in action.

Expressing Movement with Line

What image comes to mind when you think of a windy day? I think of trees bending and branches stretching out, hair blowing in streams, fabric billowing in undulating waves, and water cresting into myriad whitecaps. These are all examples of how curving lines can create the illusion of movement in objects that have some fluidity. Below I've shown the steps I took to create the illusion of flags flapping in the breeze by focusing on flowing lines and developing highlights and shadows. Notice that all the patterns on the flags follow the contours of the cylindrical-shaped folds and reinforce the line of movement. This helps integrate the stars and stripes into the fabric and keeps them from looking as if they were pasted on.

Step One I start the flags with pencil and colored pencil so I can work out the basic lines, forms, and colors before applying the acrylic. I especially want to make sure I have all the curved lines correct before I start rendering the forms. I draw each flag pole at a different angle, as diagonals increase the sense of movement.

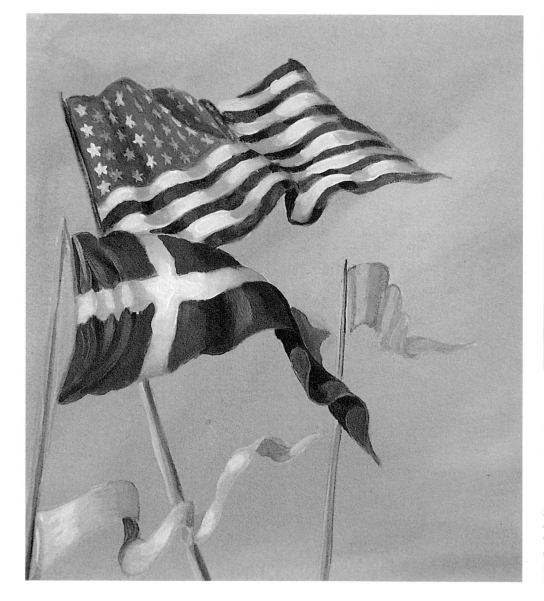

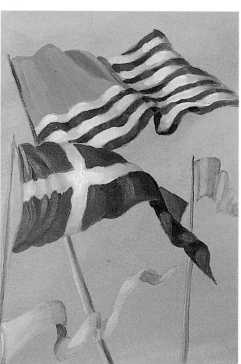

Step Two I use watercolor paper and a fairly dry brush, because drier paint smudges easily and shows the texture of the paper. I like the way the blurred color adds to the feeling of movement. At this stage, I'm not concerned with details; all I'm interested in is getting the basic forms correct.

Step Three To complete this picture, I darken the shadow areas and lighten the highlights. Then I place stars on the American flag and finish modeling the ribbonlike forms of the other flags. Notice that the flags extend out of the picture plane, as though the paper cannot contain their movements.

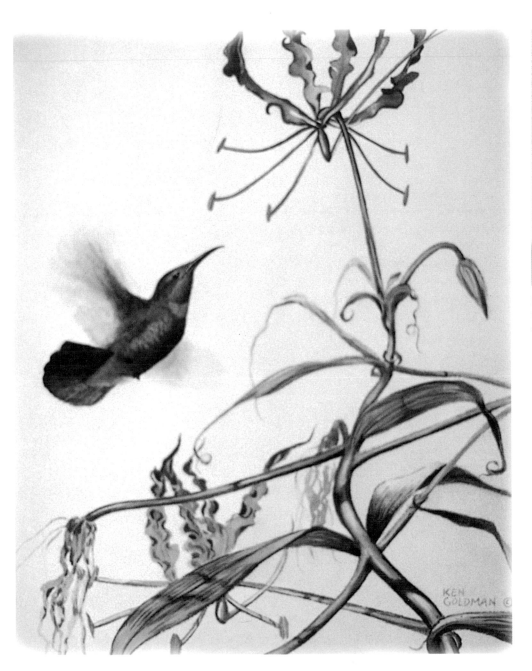

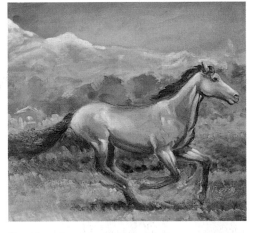

Focusing on Wings Detail In this detail, you can see how I blurred the wings, using drybrush and a rag. This is exactly the way they appeared to me.

I find it easier to convey a sense of movement in a painting if I work from life or sketches, rather than from photographs.

Blurring Movement While in Barbados, I painted this green-throated carib from life, using only binoculars and a field guide. I have always been disappointed by paintings that stop the action of hummingbird wings. Stop-action should be left to strobe cameras.

SHOWING ACTION WITH DRYBRUSH

Drybrush allows me to pick up the texture of the painting surface (especially if I'm using rough-textured watercolor paper), and it also makes it easy to create the blurred brushstrokes that impart a sense of movement, as I did on the painting of the galloping horse. I don't mean that you should blur all the forms so that it looks like a cartoon character with legs churning like a locomotive; just that you soften some of the edges and details so the moving subject looks just the way it would if you were viewing it in person—a little bit out of focus.

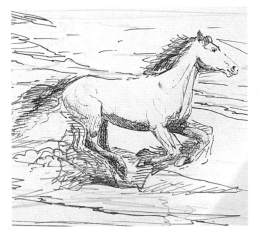

STEP ONE I sketch this horse on paper first, primarily to clarify my thoughts on how I plan to paint it. I practice sketching many legs in movement because I am curious to see how they might look as a blur if I decide to paint them that way.

STEP TWO Here I use drybrush on the legs to accent their movement and add some drybrush to the flowing lines of the mane and tail. Then I introduce another "action" element: asymmetry. Because the horse is off-center, it seems to be galloping out of the scene!

PAINTING SKIES

Skies can be nearly any color. In the daytime, the colors you see will depend on the time of day and whether you are looking out toward the horizon or up above your head. And don't be fooled into thinking that the phrase "black of night" means "devoid of color"; some of the most compelling paintings focus on the luminous blues and greens of a nighttime sky. When I paint during the day, I find that the most interesting skyscapes are those that are filled with clouds, and acrylic is perfect for depicting their translucency.

SHOWCASING DAYTIME CLOUDS

Clouds will reflect some of the colors of the sky, so before I start painting clouds, I need to establish the sky colors. Looking toward the horizon, morning skies often have a yellowish, warm-neutral glow that becomes more turquoise and dull pink as midday approaches. Evening sky colors are similar to those of the morning, but the reds and pinks are more intense. Once I've laid in the sky colors, I'm ready to add the clouds, but I don't block them in as puffy circles of cotton. I always keep in mind that clouds have form, with a distinct top, side, and base, and I make them look more realistic by overlapping them to create a sense of depth.

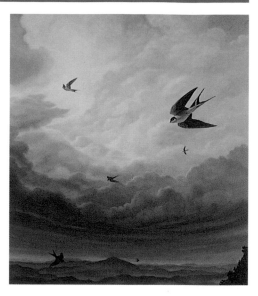

Creating Dramatic Skyscapes This thunderhead is an example of the way bright clouds in the distance can glow in yellows and reds. If you tried to achieve this effect without using at least some yellow or orange, the clouds would look too pasty-white and unrealistic.

Build a Cloud First paint a blue background; then drybrush cloud shapes over it using titanium white. Allow a little of the blue to show through.

Give It Form Next mix orange, ultramarine blue, and white to make the gray of the cloud base. Use a little retarder to slow the drying time if necessary.

Add Brilliance Add a touch of orange to the white so it looks more brilliant, and add a little pumice dust for drybrushing. Finish by adding accents.

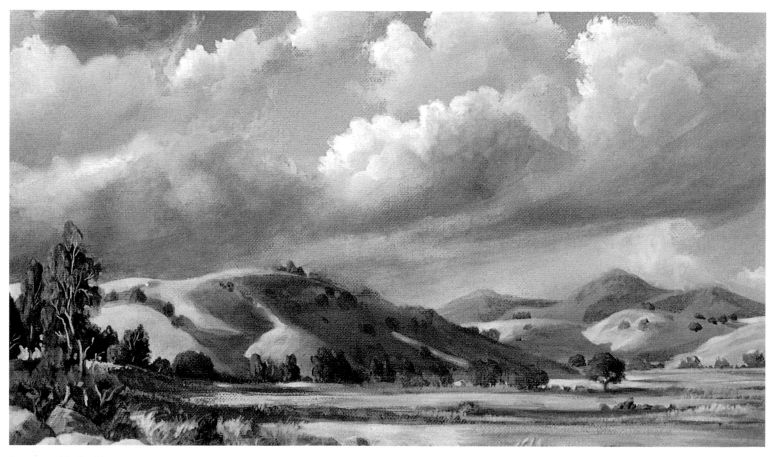

Starting with the Sky Using primed canvas paper, I paint in a daytime sky first, using deep cobalt blues at the top and blending into a pinkish turquoise at the horizon. For the mass of ground tone, I use a dark purple. I lightly draw in the clouds with a white pastel pencil, painting in the whole mass first. Then I add grays by mixing ultramarine blue, cadmi- um orange, and white right on the canvas. At the same time that I complete the landscape, I also refine the clouds by adding a little yellow and pink to the lightest areas so they won't look pasty. To create soft transitions between the cloud bases, sides, and tops, I use my finger dipped in wet paint as a blending tool.

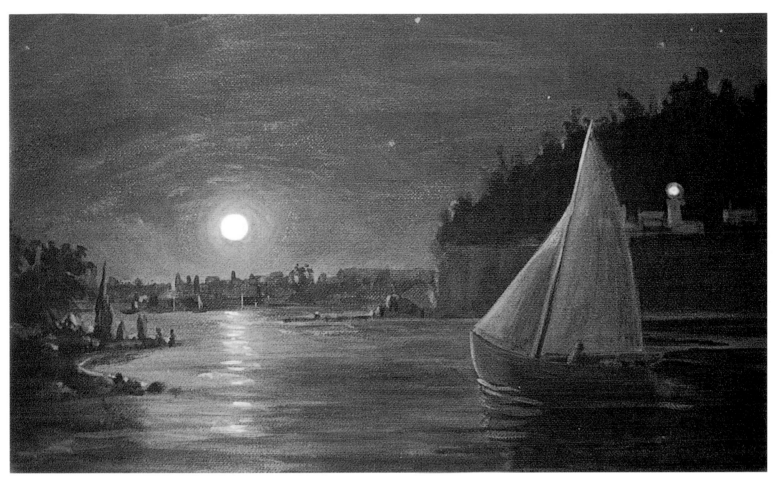

STEP THREE As a final touch, I paint a glaze of burnt sienna over the foreground to show how moonlight adds a dull warmth.

STEP ONE Using a flat brush and a night-sky palette (right), I tone a sheet of primed canvas paper, leaving a luminous warm area where I then put the moon. I paint the city and pine trees with a mixture of ultramarine, burnt sienna, and raw sienna.

Raw sienna

Night-Sky Palette

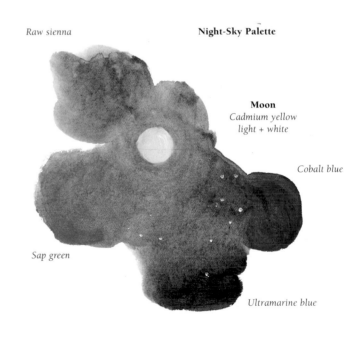

Moon
Cadmium yellow light + white

Cobalt blue

Sap green

Ultramarine blue

STEP TWO With the sky painted in, I add an invented background, the moon, a sailboat, and a bank of pine trees. Next I paint in the cliff with raw umber and ultramarine blue. I mix burnt sienna and white for the halo on the distant beacon, and I use a mixture of white and burnt sienna to show moonlight on the city.

DEPICTING THE NIGHTTIME SKY

Night isn't black, and it isn't just dark blue either. If you really look from the horizon to the zenith (directly overhead), you will see that the night sky is a mixture of deep ultramarine blue, cobalt blue, sap green, and—when the moon is out—raw sienna. Just as it is during the day, the horizon's color is a little lighter and warmer than the zenith's, with an addition of raw or burnt sienna. I use the same group of colors for foliage, structures, or anything else in a nighttime scene. For the bright accents and the translucent moonlight, I add white and yellow to the mix.

FOCUSING ON STRUCTURES

Buildings can be just as stimulating to paint as forms found in nature. In fact, I really think a successful painting hinges more on composition and lighting than it does on a particular type of subject. For example, paintings like the ones shown here do not depict extraordinary pieces of architecture, but they do demonstrate how somewhat ordinary buildings painted from various viewpoints can still have unique compositions, vivid patterns of light and shadow, and interesting design qualities all their own.

Overlapping I use sketches to work out the natural framing created by the pines. They give a feeling of being there—an intimate view of the scene.

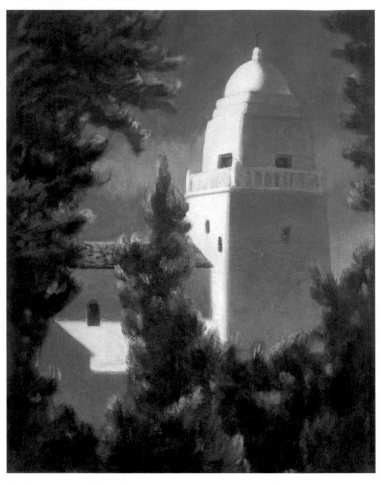

SHOWING DIMENSION IN BUILDINGS

I have three main methods of creating a sense of depth in my paintings, which I use either singly or, more often, in combination. I use *linear perspective* to lead the viewer's eye into the distance. (See page 10 for more on perspective.) I overlap objects, which makes objects in front come forward and objects behind recede, creating a feeling of space. And I apply *atmospheric perspective* (the fact that distance tends to obscure details and make things look bluer) to make background elements recede. One of the great things about acrylic is that you can use thicker paint for objects in the foreground, and you can use thin transparent glazes to show the effects of atmosphere in the distance.

Taking a Closeup View When working up close, your subject will be large and the perspective more subtle. With this viewpoint, I have a chance to focus on the textures, and I use dramatic lighting to accentuate the architectural lines of the structure.

Using Atmospheric Perspective Here I use both color and detail to enhance the sense of depth. Note how the warm greens make the grass come forward, while the cool purples cause the skyline to recede. I also add details to the foliage in front and make the distant buildings soft and hazy.

Ultramarine blue with a little alizarin crimson and white

Sap green and cadmium yellow light

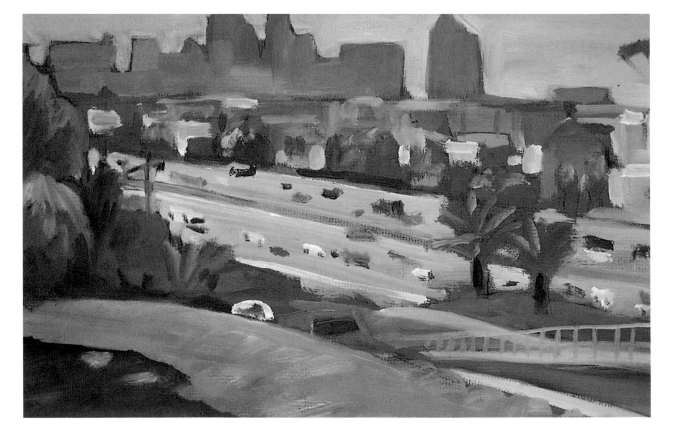

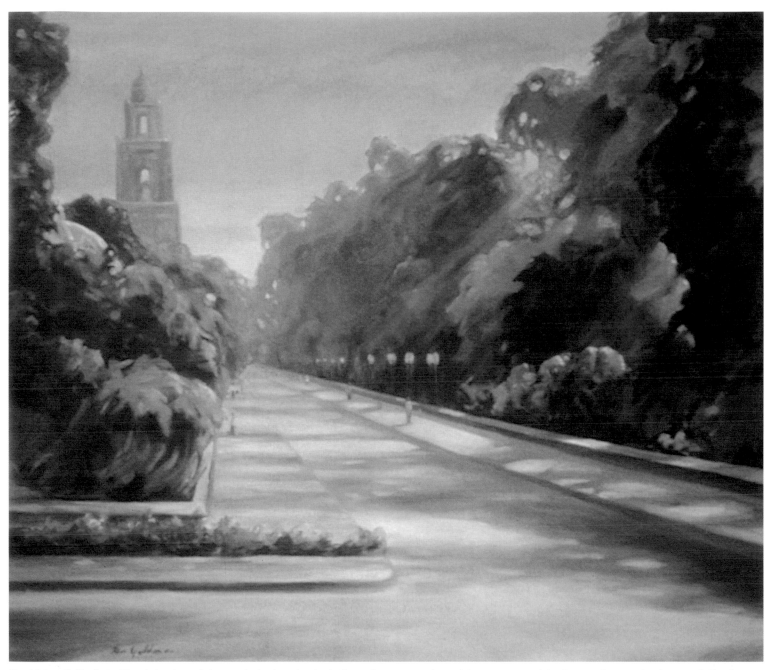

Combining Methods In this painting, I use all three methods of creating depth. The road is an example of linear perspective, the blurred trees and tower demonstrate atmospheric perspective, and the arrangement of the elements shows overlapping at work. The distant light rays are glazed in with transparent blue, green, and violet.

MAKING LIVELY STILL LIFES

Still lifes offer a great opportunity to learn and practice new painting skills. I can experiment with new strokes, test out a variety of color combinations, apply interesting textures, and practice setting up dynamic compositions. I can work whenever I want without concern about the light changing, and I don't have to worry about my subject staying still. And, because acrylic dries so quickly, I don't have to wonder whether my flower subjects will wilt while I wait for a section to dry—I can finish an entire painting in one session!

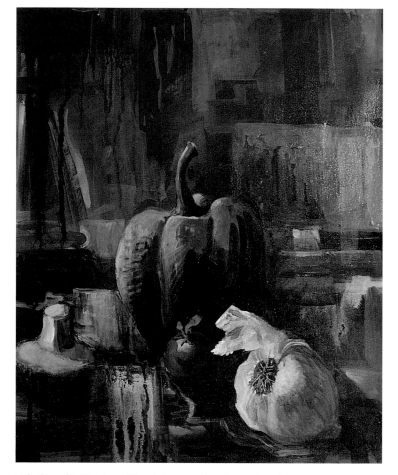

Painting with Washes This painting went through a number of changes, and part of its richness is due to the remnants of a blue background under the warm colors on top. Most of this painting is done with thin, drippy washes of very diluted paint, but I add texture with brushstrokes of thicker paint in the upper right, and I make patterns on the bottom by scraping with a palette knife for variation.

TAKING ADVANTAGE OF NEGATIVE SPACE

Have you ever had a drawing exercise where you drew everything *around* an object, rather than drawing the object itself? That is called drawing the negative space, as shown in the example below. Actually, I think these should be called "definitive spaces" because they not only define a form, they also set off a more active area of a painting by serving as a passive contrast. Just as in music there would be no composition without silence between the notes, still lifes (and other paintings as well) need calm areas to set off the active focal points. Sometimes when faced with a complicated still life to paint, the basic shapes are hidden by all the different patterns and textures. Drawing the negative spaces first allows me to find the outlines that seem to be hidden in so much visual information—it's another way to think and see things "outside the box."

Embracing Accidents
Here is an example of the kind of "happy accident" that occurred in the painting above, which added interest and texture. To encourage these accidents, I render the forms realistically at first, then deliberately lose some of the hard edges with washes. I made the drips shown here by squishing a brush loaded with wet paint into a wet area and seeing what happened.

LETTING THE PAINT CREATE TEXTURE

I like the fast drying time of acrylic for my still lifes because I can change my mind and quickly paint over an area without being concerned about wet paint mixing into my new color. An added advantage is that the underlying paint creates extra texture that I wouldn't have had otherwise. But what I especially like about acrylic is the accidental textures I get when I let the paint drip and clot on its own. I used this to my advantage in the still life at upper left, where many of my favorite touches were accidents! Also try out impasto, drybrushing, and other texturizing methods shown on pages 12–13 to create interesting backgrounds that will enhance your still lifes.

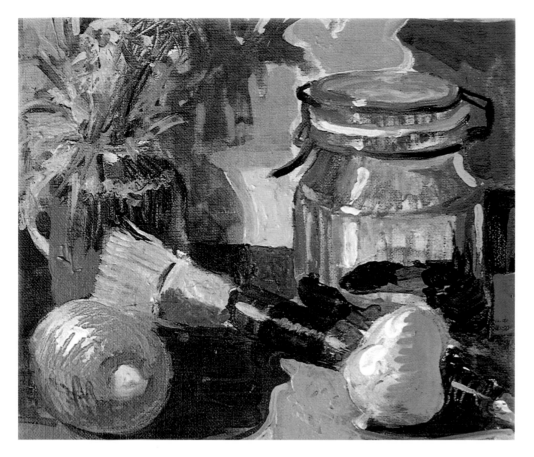

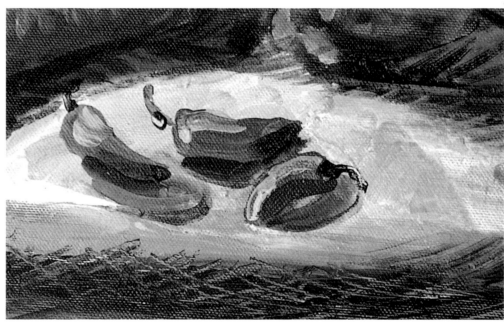

Using a Knife I finished this painting with a palette knife. For the flowers in the brown pot on the left, I used the knife to scrape away paint and to add texture. For everything else, I used the knife to pile on thick color.

Sometimes the best still lifes are "found." Paint whatever happens to be on the table, mantel, kitchen counter, or window sill for a spontaneous grouping.

LIVENING UP A SIMPLE STILL LIFE

You don't have to contrive complicated setups to make an interesting still life. There is just as much beauty and life in a simple grouping of objects, such as the peppers to the right, which I helped make lively by using three peppers instead of four. (There is more excitement in an odd-numbered grouping than in an even one.) What makes a still life "lively" is largely a matter of creating some visual excitement by using (either singly or in combination): asymmetrical composition, diagonal lines, varying shapes and sizes, dynamic lighting, complementary colors, and interesting brushstrokes. When you look at the two drawings below, you will see how asymmetry is used to create interest.

Creating Contrasts This little painting works because it has just about every contrast imaginable: in color, texture, form, angles, and value.

Working with Asymmetry This thumbnail shows how basic forms placed unevenly create interest and movement. In our culture, we read from left to right, so the eye looks first to the fruit on the left, then to the vase, and on to the mug.

Using Too Much Symmetry When all the same objects are too evenly spaced, the eye does not circulate. The eye goes from left to right and then straight out of the picture frame! Too much symmetry does not encourage the viewer to linger.

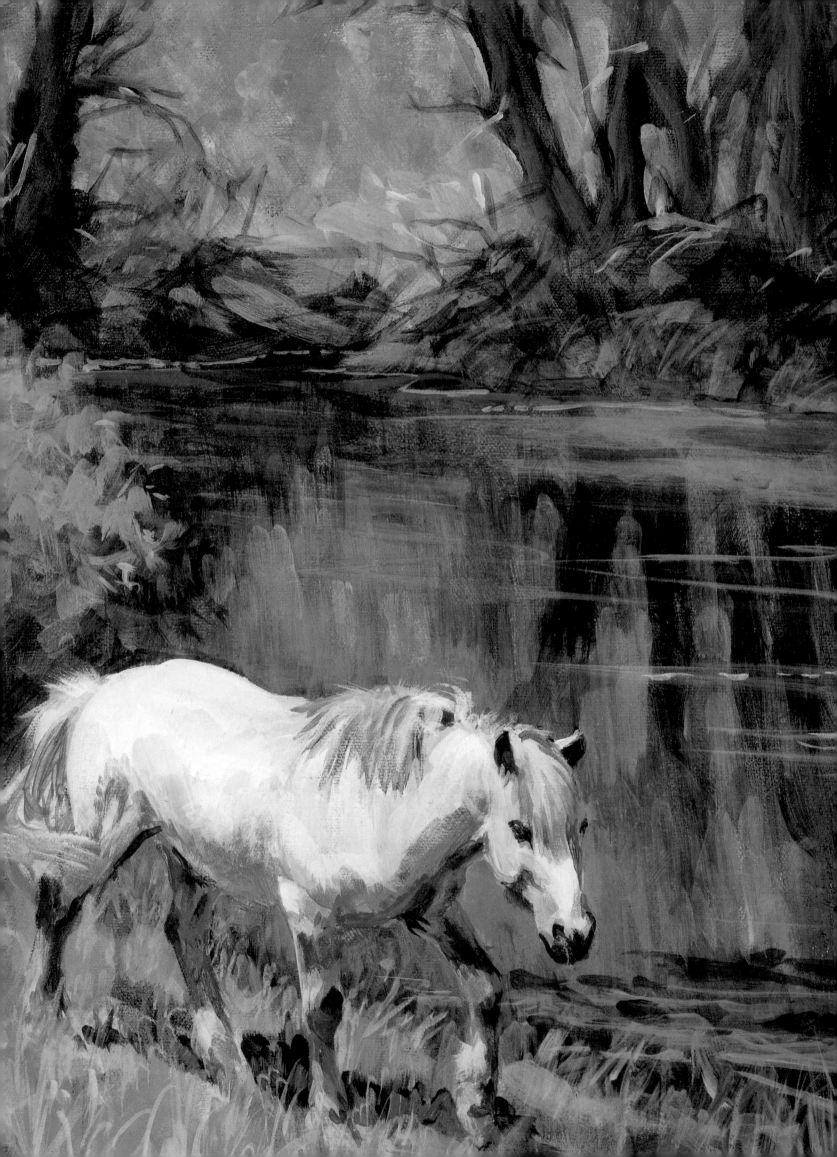

PAINTING WITH ELIN PENDLETON

Elin Pendleton has been painting since the age of 9, and she has been selling her paintings since 1983. When she was in her teens, she was recognized for her artistic talent by the late Millard Sheets, and since then she has studied and painted in South America, Central America, and Mediterranean Europe. She is traditionally trained, with a bachelor's degree in fine art from San Diego University. Elin's award-winning paintings are found in both private and corporate collections throughout the United States and Europe. She has studied with noted artists, and she is a skilled teacher who conducts workshops for aspiring painters. Elin's home and studio are located in the mountainous terrain north of the Temecula wine country of southern California. She lives with her husband, a university professor, and a variety of domestic animals, all of which have found their way into her paintings.

Gray Horse

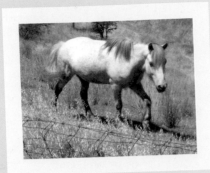

Portraying Time of Day This photo captures an early morning light, with its soft colors and the long shadows thrown by the low sun. To create an afternoon scene, I change the colors and the shape of the shadows.

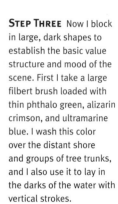

Step One First I establish the base colors with an underpainting. I use a large filbert brush to cover the entire canvas with loose strokes and washes of cadmium red light, azo yellow, and ultramarine blue. To make the horse stand out, I paint the distant areas with dark blue-green and use mid-value tones where the gray horse will be.

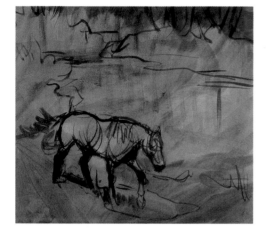

Step Two Next I sketch the scene with a small round brush and dark mix of alizarin crimson and phthalo green. I place the horse on a diagonal, counterbalanced by the more horizontal water and trees. As needed, I make corrections by painting over unwanted lines with an opaque pigment. (White, cadmium yellow, and cadmium red all work well.)

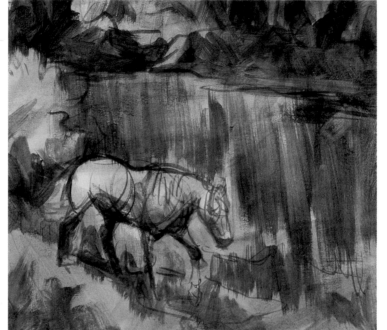

Step Three Now I block in large, dark shapes to establish the basic value structure and mood of the scene. First I take a large filbert brush loaded with thin phthalo green, alizarin crimson, and ultramarine blue. I wash this color over the distant shore and groups of tree trunks, and I also use it to lay in the darks of the water with vertical strokes.

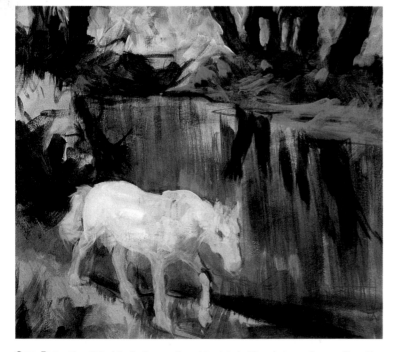

Step Four Next I block in the horse using white tinted with cadmium yellow medium. The distant foliage is azo yellow mixed with white; its reflections are mixes of cadmium orange and cadmium yellow medium. For tree trunk reflections, I mix phthalo green, alizarin crimson, and ultramarine blue.

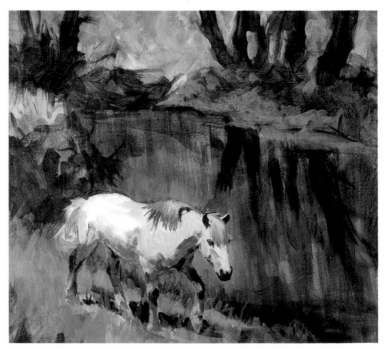

Step Five I apply an ultramarine blue glaze over most of the canvas, including spots on the horse. Then I apply burnt umber over the shore and trees, white mixed with cadmium orange over the foreground, and cadmium orange and yellow in the grasses. I add a gray mix of alizarin crimson, phthalo green, and white to the horse.

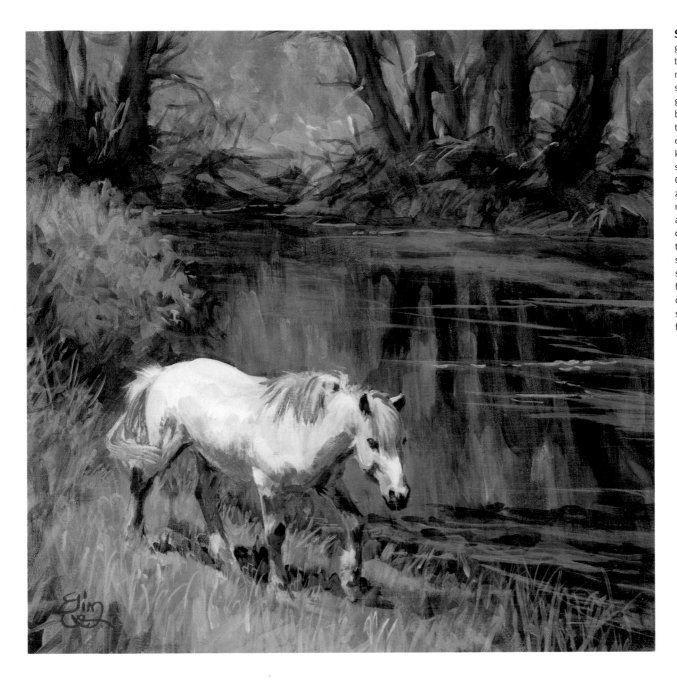

STEP SIX Next I glaze green over the water for the algae and for the reflections on the water's surface. Then I brush glazes of azo yellow and burnt umber across the tree trunks and leafy parts of the forest, taking care to keep the muted colors that set the mood of this piece. On the water, I apply horizontal strokes of ultramarine blue and white, adding burnt umber in the darker areas. Next I paint the light upper edge of the shrubbery on the left with sap green and azo yellow, flicking my brush to indicate leaves. Then I use a small round brush for the final grass details.

Horse Warm Midtones
Cadmium yellow medium + white

Horse Cool Midtones
White + alizarin crimson + ultramarine blue

Horse Shadows
White + ultramarine blue + alizarin crimson + burnt umber

UNDERSTANDING THE BASIC GAITS

Horses and ponies have four natural gaits: the walk, trot, canter, and gallop. Not only do the horse's legs move, but also its tail, head, shoulders, and ears all change position according to the gait. Familiarizing yourself with the position of the horse's body while moving at these varied speeds can enhance your paintings by lending them a greater sense of realism. (Note: Although these four basic gaits apply to all horses, several breeds—such as the Icelandic Horse, the Foxtrotter, the Tennessee Walking Horse, and the American Saddlebred—also have their own specialized gaits.)

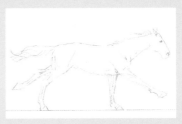

Walk The walk is the slowest of the horse's gaits. Its long, four-beat stride typically follows the sequence of off (farthest) hind leg, off foreleg, near (closest) hind leg, and near foreleg. When walking, the horse always has two or three of its feet on the ground.

Trot After the walk, the next slowest gait is the trot. With this two-beat "jog," the horse moves diagonal pairs of its legs together in unison—far hind leg with near foreleg and near hind leg with far foreleg. There are two moments of suspension before the diagonal hooves touch down.

Canter The canter is a fast, three-beat gait. The horse pushes off a hind leg; the opposite hind leg and its diagonal foreleg hit the ground at almost the same time, followed by the remaining foreleg. There is a moment of suspension where all four feet are off the ground.

Gallop The fastest natural gait for a horse is the gallop. An extended version of the canter, this gait follows the same sequence of footfalls, but the horse has a longer stride and a longer suspension time during which all four feet are off the ground.

WILD HORSES

Emphasizing Depth I use my sketch to work out the scale before I begin painting. For example, I make sure the sizes of the animals in the distance are in proportion to the larger stallion's. I also roughly indicate the detail and texture the nearer horse will feature.

STEP ONE To create a warm backdrop for this scene, I cover my canvas first with a mix of gesso and cadmium yellow medium. When this layer dries, I add a thin application of cadmium yellow medium mixed with white and a touch of cadmium orange—giving the canvas a more textured appearance. Then I mix phthalo green with alizarin crimson to roughly sketch the scene, first marking the horizon line along the base of the distant trees.

HORSE COLORS

Palomino Warm Midtones
Cadmium orange + cadmium yellow medium + burnt sienna + white

Palomino Shadows
Yellow ochre + burnt umber

Bay Base Color
Cadmium red light + burnt umber

Chestnut Base Color
Burnt sienna + cadmium orange + burnt umber

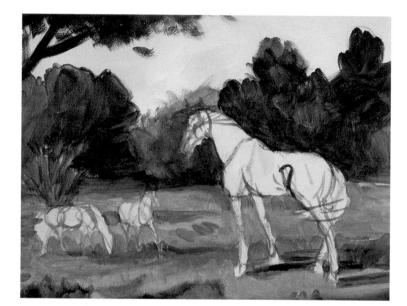

STEP TWO I begin by applying a dark green mix of phthalo green, ultramarine blue, and a touch of burnt umber to the distant trees and shadows on the hill, adding more burnt umber to paint the overhanging branch (which has a darker value because it is nearer). For the pasture, I begin with a turquoise mix of ultramarine blue, white, and sap green in the distance, gradually adding cadmium yellow medium as I move toward the foreground.

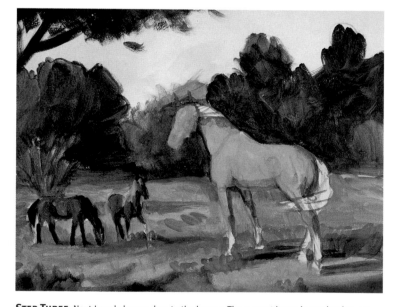

STEP THREE Next I apply base colors to the horses. The nearest horse is a palomino, so I use cadmium orange for the sunlit areas and yellow ochre mixed with burnt umber for the shadows. For the other two horses—a bay and a chestnut—I use darker values of the umber mix, with the addition of cadmium red light for the sunlit portions.

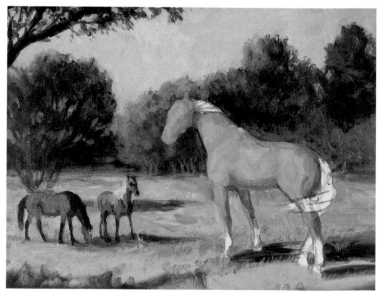

STEP FOUR I mix white, ultramarine blue, alizarin crimson, and yellow ochre for the sky, adding more blue as I move right, away from the light. For the trees, I add a warm sap green and yellow ochre glaze over sunlit areas and a cool phthalo green and ultramarine blue glaze over shadows. Using mixes already on my palette, I also develop the trees, grass, and horses.

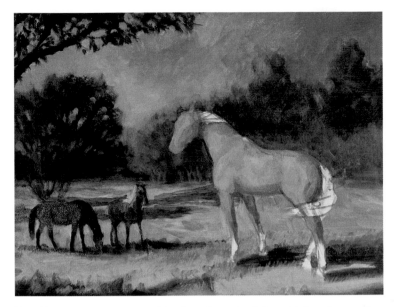

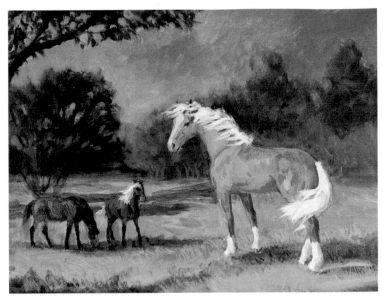

STEP FIVE I notice that the color of the distant horses is a little too bright and pure, so I tone down the color by glazing burnt umber over the sunlit hides. The resulting grayed dark orange visually pushes the horses into the distance. I also use glazes of phthalo green mixed with burnt umber to add shadows to the middle-ground tree and under the two horses.

STEP SIX After adding lighter glazes to the sky, the background is complete. Now I concentrate on the horses. I build up the palomino's form using layers of cadmium orange mixed with cadmium yellow medium, adding white for highlights. Then I paint the horse's stockings, tail, and mane using white mixed with ultramarine blue and a little yellow ochre.

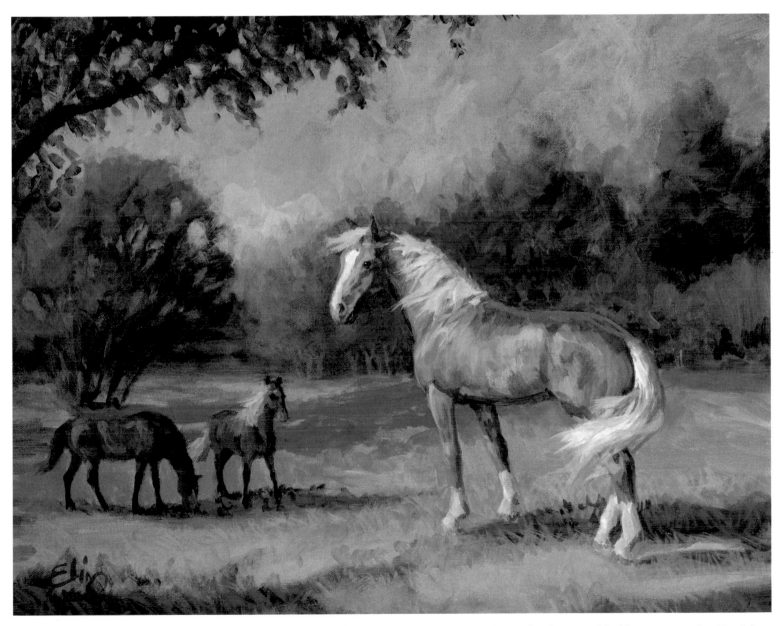

STEP SEVEN At this stage, I realize something's not quite right with the composition. For a fresh perspective, I look at the painting in a mirror. This new viewpoint reveals areas that could use some adjustment. I mix gel medium with azo yellow and glaze it over the sky, creating more visual interest with interweaving colors. Then, using the background greens, I paint over the edge of the palomino's front leg to move it back into a more natural position. I also clean up the legs of the two distant horses, and I tame the palomino's mane. Then I paint a few more leafy, overhead branches. Finally I touch up the palomino, using white mixed with cadmium yellow medium for highlights and burnt umber mixed with gel for more darks.

CLYDESDALE TEAM

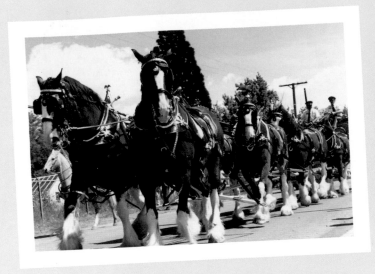

Creating Drama I chose an angled viewpoint for this subject for its dramatic impact. An extreme viewpoint such as this one—where the viewer is looking sharply up—further accentuates the size of the lead team, making the horses seem more powerful. I never feel obligated to paint exactly what I see; instead I use my artistic license, allowing my artistic sensibilities and my imagination to influence my paintings! For example, in this painting, I used my artistic license to create an even stronger sense of drama, changing the scene from the city on a warm, sunny day to a rural setting in cold, winter weather. By using artistic license, I've added to the painting's appeal!

STEP ONE I begin by covering the canvas with a thick mix of white gesso tinted with yellow ochre and alizarin crimson; this backdrop will give warmth to subsequent layers I will add to the snowy scene. Next I loosely sketch the placement of the teams of horses. To emphasize the size and strength of the lead team, I've placed them above eye level. The lines drawn above and below the horses show the steep angle of the perspective, increasing the sense of the horses' power and presence.

STEP TWO Next I use a small filbert brush and mix of ultramarine blue, phthalo green, and alizarin crimson to block in the first group of dark values. I use this first application of darks as a way to map and plan the basic value structure and balance of the total composition. Although I plan to use these blocks of values to guide the placement of colors and values for the rest of the scene, that doesn't mean I can't modify this "map" as I develop the painting.

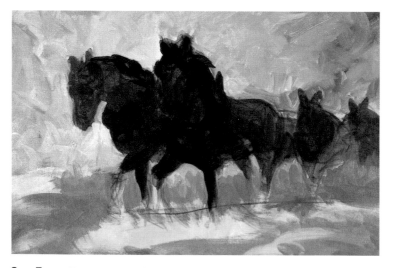

STEP THREE Next I cover a good portion of the canvas, painting the sky, distant field, and snow shadows with a mix of white, ultramarine blue, and a touch of yellow ochre. I apply additional snow shadows using ultramarine blue mixed with white and grayed with touches of alizarin crimson and yellow ochre. Then I mix alizarin crimson with burnt umber to paint the horses; for the lead pair, I also apply a dark mix of alizarin crimson and phthalo green.

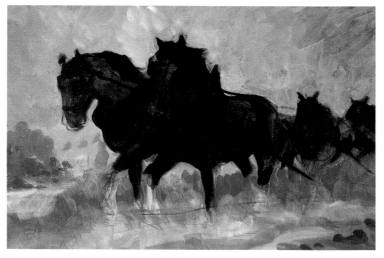

STEP FOUR Now I use a large filbert to add a unifying glaze over the sky, snow, and shadows under the horses using 50% matte medium with a mix of white, ultramarine blue, alizarin crimson, and yellow ochre. Then I use the edge of a medium filbert and the black mix of phthalo green and alizarin crimson to add darks to the harnesses, manes, and shadows. And I apply two small patches of vegetation using glazes of sap green mixed with phthalo green.

Snow Shadows and Sky
Ultramarine blue + yellow ochre + white

Lighter Snow Shadows
Ultramarine blue + white + alizarin crimson + yellow ochre

Horse Base
Burnt umber + alizarin crimson

Horse Darks
Phthalo green + alizarin crimson

Horse Highlights
Cadmium red light + burnt sienna

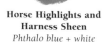

Horse Highlights and Harness Sheen
Phthalo blue + white

STEP SEVEN To create harmony in the composition, I want to repeat the red hues of the horses in the background, so I mix a reddish glaze of burnt sienna and ultramarine blue to accent the snow shadows. Then I apply the final touch—the horses' steamy breath. My reference photo doesn't contain this element, but I want to include it to make the cold environment I've created more realistic. It's important that I add this detail last because I want the other colors on the canvas to show through. I use a very small filbert and white with a touch of cadmium orange for the steam, mixing one part color to about nine parts medium for a very thin mix. In my glazes, the medium acts as a flow improver, so I use whichever "runny" medium I have on hand—gloss, matte, or satin. (If you make a mistake, you can use a damp paper towel and a water spray bottle to quickly remove the extra paint before it dries.)

STEP FIVE I add interest to the sky and snow using lively brushstrokes to touch in mixes already on my palette. Next I develop the harnesses and tack, starting with burnt umber for darks and phthalo blue mixed with white for sheen. I add the brass accents last, using a mix of yellow ochre, cadmium yellow medium, and cadmium orange. Then, with a red-toned mix of cadmium red light and burnt sienna, I add large areas of midtones on the horses' hides.

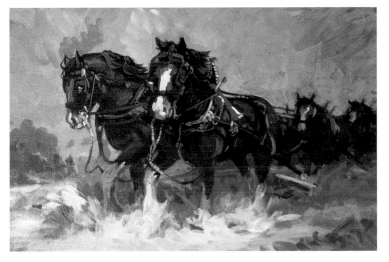

STEP SIX Now I paint the red ribbons with pure cadmium red light, adding alizarin crimson in the shadows. For the white areas of the horses, I use white mixed with cadmium yellow medium for highlights and ultramarine blue mixed with white for shadows. Next I apply white tinted with ultramarine blue in some places and phthalo blue in others to create highlights on the snow underfoot. Then I add highlights to the horses and tack where appropriate.

ARABIAN PORTRAIT

Working from a Photo It's rare for an animal to stay still for a portrait, so I use a photo reference so I can study the sizes and relationships of the features. I measure from the top of the eye to the top of the head, using this as a basis for the size and placement of everything else.

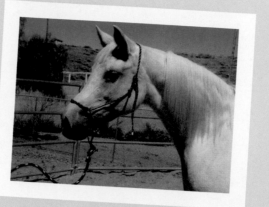

STEP ONE I set the cool tone for this portrait with an underpainting of phthalo green and burnt umber. I cover the canvas quickly, mixing the colors loosely in some places and keeping them pure in others. Then I randomly press a ball of plastic wrap into the wet paint; the mottled texture will create interest wherever it shows in the finished painting.

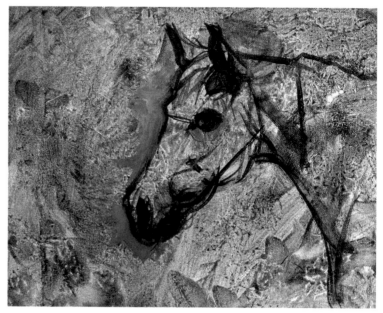

STEP TWO I sketch the head with a black mix of alizarin crimson and phthalo green, paying careful attention to the eye placement, ear width, and muzzle length. Then I add water to the black mixture to establish the darks, washing over the nostril, muzzle, eyes, and ears. Finally I adjust the sketch using the background colors mixed with white.

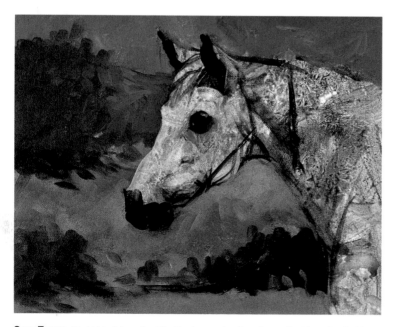

STEP THREE Next I block in a simplified background, using ultramarine blue mixed with white for the sky, phthalo green mixed with sap green for the foliage, burnt sienna mixed white for the ground, and ultramarine blue mixed with alizarin crimson and white for the mountains.

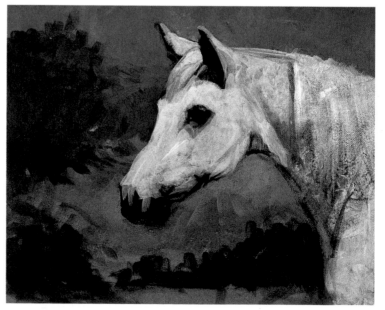

STEP FOUR Now I stroke in the base colors of the horse using pure white paint. For light values, I mix in cadmium orange and cadmium yellow medium. For shadows, I use a grayed purple mix of alizarin crimson, ultramarine blue, and yellow ochre with pure yellow ochre accents.

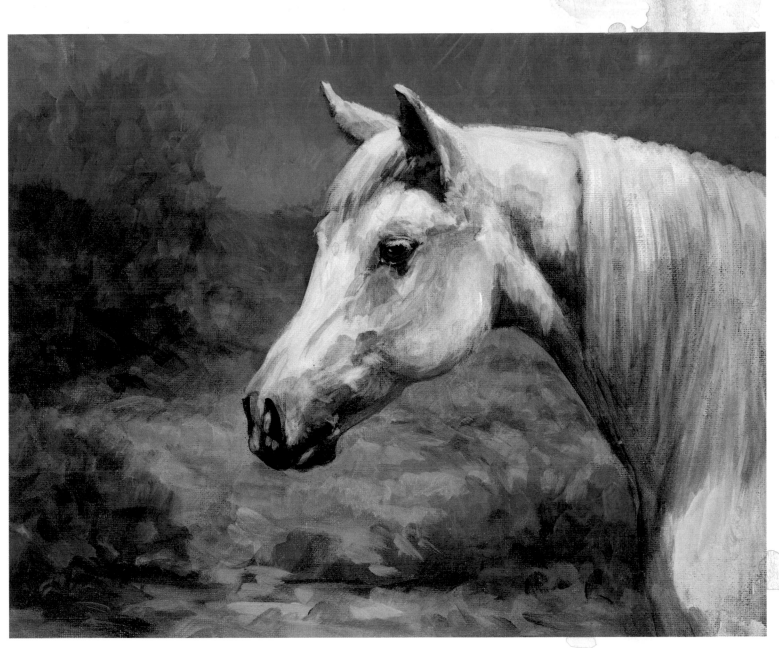

STEP SIX Now I add white to the original background colors to produce lighter values, and I work them into the sky and distant mountains. Then I add a little cadmium orange to warm the bushes and bring them forward. Next I finish the horse, starting with the eye. (See the details below right.) Using a medium filbert, I deepen the shadows and refine the horse's form with another glaze of grayed purple. I use the same glaze over the background to push it back in the distance. Next I pull out details on the hide using lighter glazes. Then I solidify the shape of the head and neck with another, lighter glaze of white mixed with a touch of cadmium orange. To finish, I lighten the sky further with ultramarine blue and white.

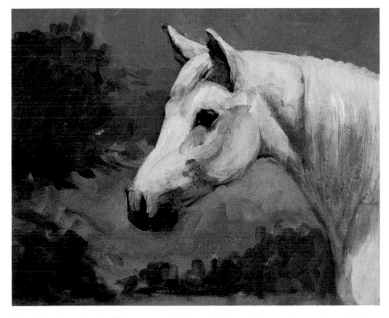

STEP FIVE Next I apply thicker coats of white, mixing in cadmium yellow medium for highlights. Then I glaze a 50/50 mix of matte medium and the grayed purple to add detail to the shadows. To create form, I also glaze white mixed with cadmium orange over the highlights.

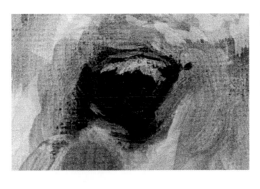

Eye Detail 1 After I establish the basic eye shape, I paint a flattened oval pupil using alizarin crimson mixed with phthalo green. Then I paint the iris under the pupil with a brown mix of burnt umber and ultramarine blue. I also add lashes and a bluish glaze around the perimeter to suggest moisture.

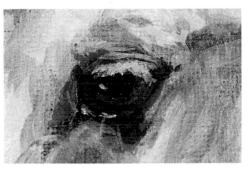

Eye Detail 2 Now I add warmth to the reflected light on the iris using a mix of yellow ochre, cadmium red light, and burnt sienna. Then I lighten the cast shadow of the eyelashes with ultramarine blue mixed with white. To finish, I highlight the cornea opposite the lightest area of the iris and add a few faint lashes.

39

HORSE AND GROOM

STEP ONE After quickly underpainting the canvas with a thin wash of cadmium red light, I use a medium filbert to layer a dark mix of phthalo and ultramarine blue over the background, starting in the upper-right corner; as I move left and down, I add azo yellow to the mix. Working quickly, I sketch in the position of the groom and his shadow with the green background mix, and I add the horse and its cast shadow with alizarin crimson and phthalo green.

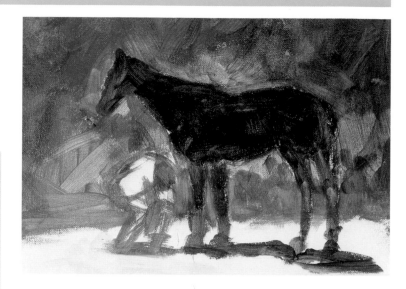

IDENTIFYING COLORS

Almost every horse's coat color begins with one of two base colors—red or black. A few of these color and pattern variations are illustrated and explained here to help you distinguish one "brown" horse from another. Such knowledge goes a long way toward creating realistic paintings!

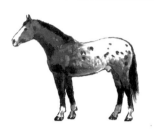

Appaloosa Appaloosas have varied patterns, most with spots. This blanket appaloosa has a smoky buckskin body with spots and a bald face marking.

Cream Although creams may appear white, they actually have light, milky colored hair. Sometimes it's possible to see faint, white markings on a cream.

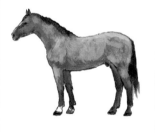

Buckskin Buckskins have light, tan coats and black legs, manes, and tails. Buckskin duns also have a black stripe along the back.

Red Roan Roans have hair consisting of more than one color, such as this mix of white and red. Manes and tails are always variations of the body color.

Chestnut The chestnut has a red body, without black points. It may have white markings, like the white stockings shown here. The mane and tail are the same color as or lighter than the body.

Bay The bay is red like the chestnut, but its coloring is darker. There are both light and dark variations of bay coloring, but every bay has black points (legs, mane, and tail).

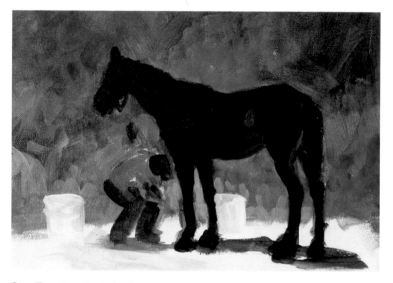

STEP TWO Next I begin developing shapes and colors. I apply a mix of phthalo green and alizarin crimson over the horse, blocking in yellow ochre reflections. Then I paint with the background colors around it to refine its shape. I brighten the sunlit bushes using sap green mixed with cadmium yellow. I also add white buckets tinted with alizarin crimson and phthalo green. Then I block in the figure's clothing: ultramarine blue jeans and a cadmium red light shirt.

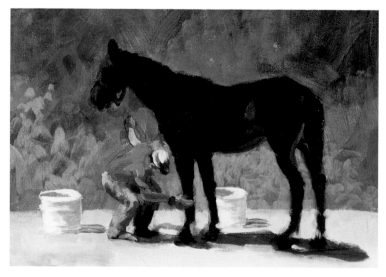

STEP THREE Now I apply cadmium orange highlights and alizarin crimson shadows to the groom's shirt. I use phthalo blue for the glove and jeans and alizarin crimson mixed with white for skin. I also cover the ground with a mix of white, burnt sienna, and a touch of phthalo green. Then, before the light shifts, I quickly place the shadows on, in, and around the buckets with ultramarine blue. Next I add yellow-green to the light areas of the bushes.

**Blue-Green
Background Trees**
*Phthalo green +
ultramarine blue*

Yellow-Green Bushes
*Sap green + cadmium
yellow medium*

Dark Value of Horse
*Alizarin crimson +
phthalo green*

**Horse's Underbelly
Highlight**
*Cadmium orange +
yellow ochre*

Ground
Burnt sienna + white

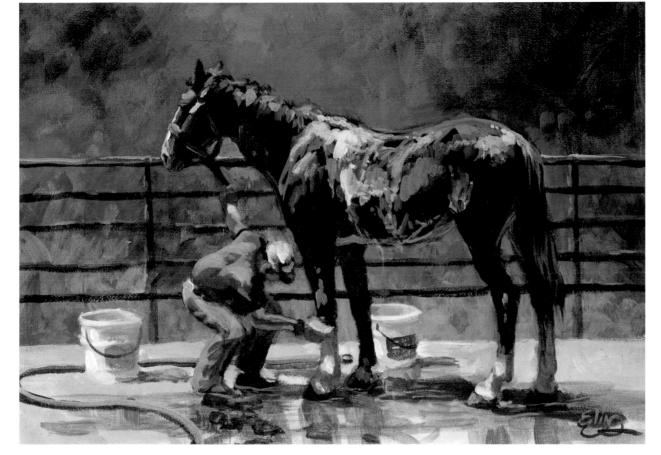

**Water Highlights
on Horse**
Phthalo blue + white

**Water Darks
on Horse**
*Ultramarine blue + white
+ alizarin crimson*

**Water Mid-Range
Values on Horse**
*Ultramarine blue + white
+ alizarin crimson*

STEP SIX When I evaluate my "finished" painting, I discover a flaw in the composition: I made the fence the same height as the distance between the top of the fence and the top of the painting. When the elements of the composition are too uniform and evenly spaced, the composition becomes boring and stagnant. To liven things up, I use my artistic license to divide the background trees with a patch of sky, painting over them with a mix of ultramarine blue, white, and a touch of cadmium red light. The V shape of the sky aids the composition by directing the eye down toward the red shirt and the arm that leads the eye to the horse. Now the painting is complete!

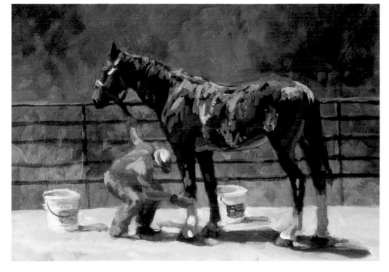

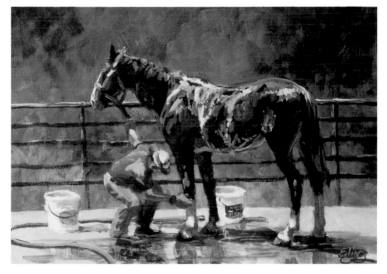

STEP FOUR With background colors, I further define the horse and buckets by painting the negative space, or the dark areas surrounding the objects. Then I add an alizarin crimson and white fence with cadmium orange and yellow ochre highlights. I add the horse's markings with ultramarine blue for shadows and a mix of white and cadmium yellow medium for highlights. I also add a highlight under the belly and water over the body. (See color samples.)

STEP FIVE Now I add the standing water and ground reflections using a series of glazes, starting with phthalo blue and moving on to a variety of grays mixed from reds and greens. Next I add detail to the halter and face, and I further develop the water on the horse's hide. The initial blocking must be done quickly, but now I have time to refine the shapes and colors. I mix sap green, phthalo green, and white for the hose, which harmonizes with the greenery.

PLOW TEAM

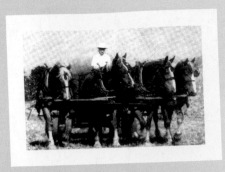

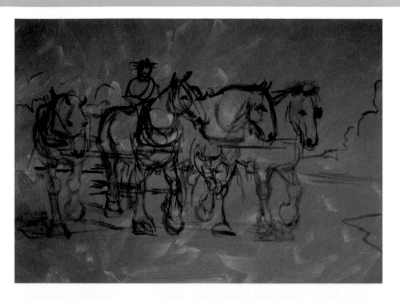

Exercising Creative License Even though this photo is black and white, I still think it makes a fine reference for a painting. I use the photo to determine the basic shapes and positions of the horse team; but I used my imagination to add color—including a dramatic, stormy sky!

STEP ONE First I cover the canvas with gesso tinted with ultramarine blue and grayed with a touch of yellow ochre. Then, with a mix of phthalo green and alizarin crimson, I roughly sketch the composition, starting with the slightly darker focal point—the figure and the central horse.

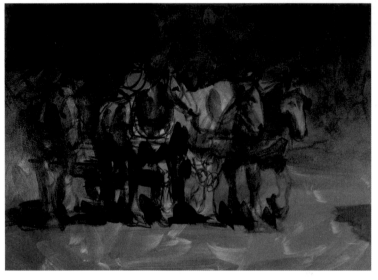

STEP TWO Using a medium filbert and a mix of alizarin crimson and ultramarine blue, I lay in the first darks of this high-contrast painting—the shadows on the team. Next I place storm clouds hovering on the horizon and a small ground shadow at the right for balance.

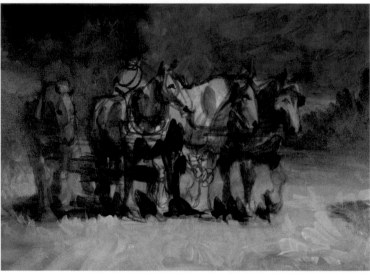

STEP THREE Now I soften and gray the sky with cool white mixes of ultramarine blue, yellow ochre, alizarin crimson, and phthalo green. I also block in the field with white, cadmium yellow medium, and cadmium orange. For the trees, I mix leftover greens and yellows.

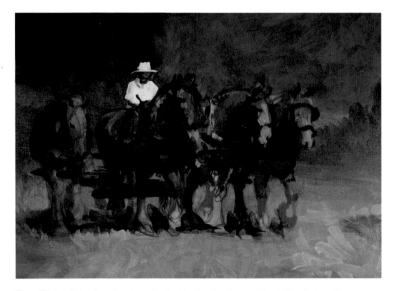

STEP FOUR Using burnt umber mixed with alizarin crimson, I lay in the darks of the horses. At this stage, I make some quick corrections, adjusting the shape and position of the horses' legs and heads where needed to properly convey the sense of motion. When I'm satisfied with the changes, I switch to burnt umber to add the base brown color, and then I use burnt sienna for the first highlights. I also touch in the driver's white clothes.

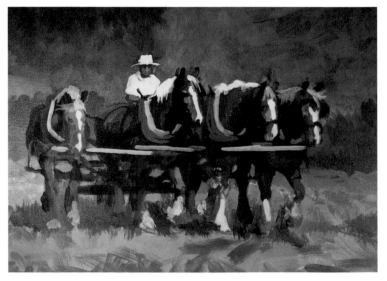

STEP FIVE I use burnt umber and ultramarine blue for brown shadows and cadmium orange mixed with white for white markings. I also apply blue-green brushwork to the foreground, field, and trees. I fill in the wooden neck yokes using a mix of burnt umber, white, and burnt sienna. Then I add the collars of the harnesses with a light brown mix of burnt sienna and burnt umber. Next I use burnt sienna mixed with white for the man's face and arms.

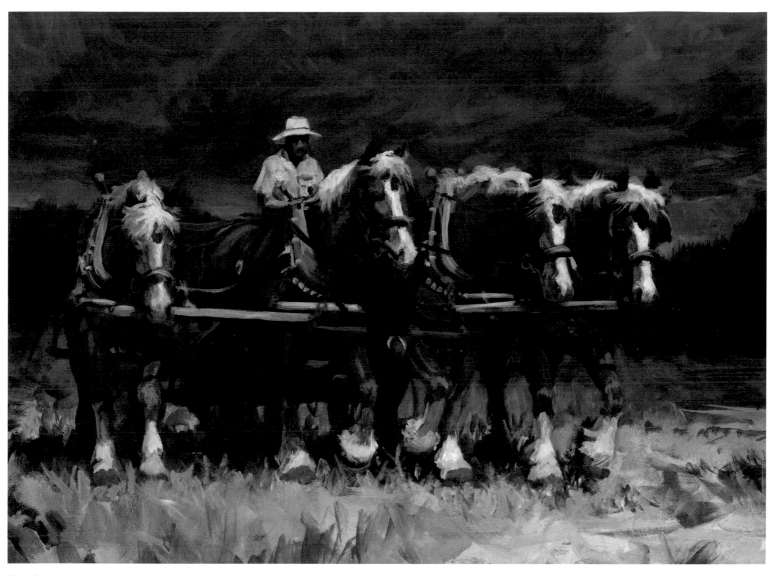

STEP EIGHT Here you can see that the horses' slow movement is captured by the subtle, upturned strokes in their feathers and forelocks. Now I add a few final touches to tie the elements of the scene together. First I finish the driver's shirt with alizarin crimson mixed with white—a color repeated near the horses' muzzles and in the foreground for unity. Next I blend medium into the mixes already on my palette and glaze over the shadows. I also glaze over the sky, enhancing the clouds with a reflection of the ground's yellow ochre.

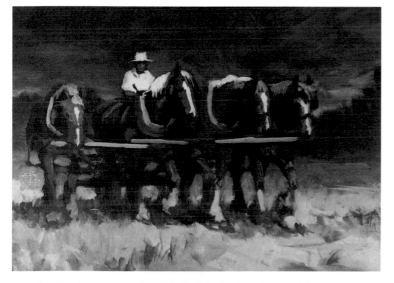

STEP SIX Now, for contrast, I place dark clouds in the sky with a mix of alizarin crimson, yellow ochre, white, and ultramarine blue. Then I lighten the ground with burnt sienna mixed with white. For the cast shadows underneath the horses, I mix ultramarine blue and white with a touch of burnt umber; I paint a loose pattern on the grass that creates visual interest as it unifies the painting, balancing the blue tones of the sky.

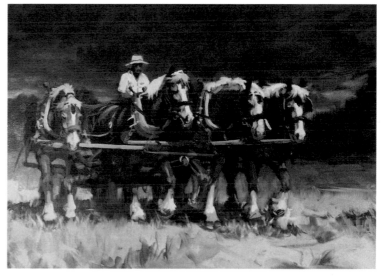

STEP SEVEN I add white to the legs and face markings; then I add shadows with alizarin crimson and ultramarine blue. For the brass, I mix yellow ochre with cadmium orange; the leather is burnt sienna mixed with burnt umber. For the collar pads and remaining hardware, I use mixes of ultramarine blue and white, graying the shadows with burnt umber. For the shadows on the neck yokes, I use ultramarine blue mixed with alizarin crimson and white.

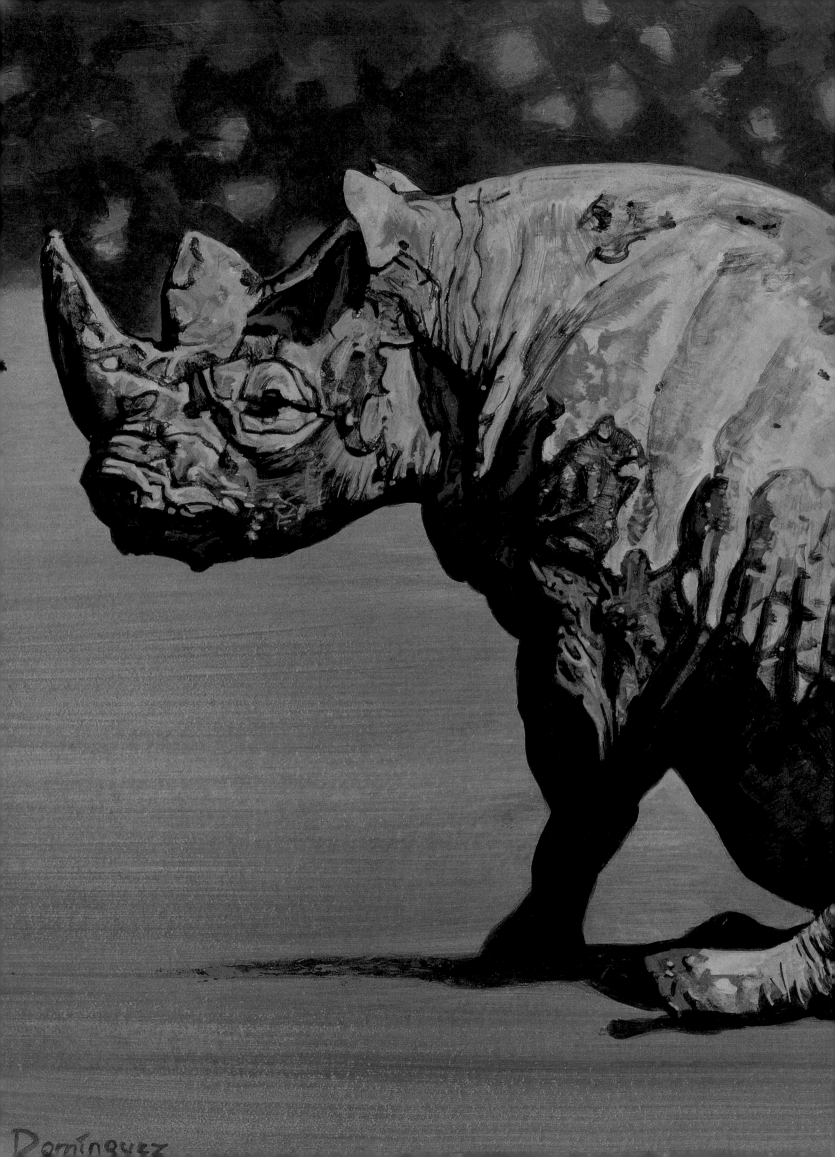

PAINTING WITH
PABLO DOMINGUEZ

Pablo Dominguez began drawing at the age of 4. Although he received some formal training, Pablo's art education primarily comprised informal classes and artists' workshops, such as those given at the Beartooth School of Art in Montana. In pursuit of his art, Pablo travels to zoos, wildlife refuges, and state and national parks across the United States, spending hours observing, sketching, and photographing wildlife and landscapes. A resident of Michigan since his birth in 1961, Pablo and his wife, Charlene, share their home with two Labrador retrievers and four cats.

Mountain Lion

Puma Shadows
*Raw umber +
Payne's gray*

Tip of Nose
*Alizarin crimson +
cobalt blue + white*

Darkest Shadows
*Raw sienna +
burnt sienna +
raw umber*

**Nose Bridge/
Back of Neck**
*Cobalt blue +
raw sienna + white*

Iris
*Chromium oxide green +
raw umber +
raw sienna + white*

Pupil
*Raw umber +
Payne's gray*

STEP ONE I prefer to paint on untempered hardwood board, as it allows a bit more control than canvas does for painting details. After priming my board with several coats of gesso, I carefully transfer my sketch. Then I outline the puma with raw umber and a small flat brush.

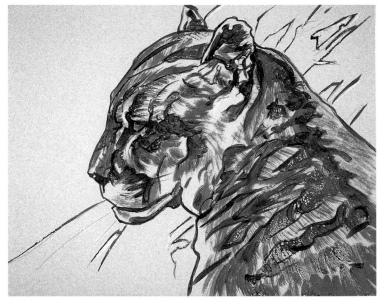

STEP TWO Next I establish the variations in value, always painting in the direction of the fur's growth. First I block in the midtone values with raw umber and a medium flat brush. Then I add a bit of Payne's gray to the raw umber and block in the shadow areas.

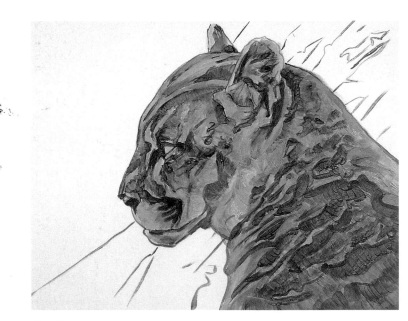

STEP THREE Now I continue to develop the deepest shadows, still using the mix of raw umber and Payne's gray. Next I switch to white mixed with a little raw umber to establish the highlights. As you paint, keep in mind that working with acrylic requires some patience; although the paint dries quickly, it can take several layers of paint to achieve more opaque colors. At the completion of this stage, I've developed a map of the puma's main values.

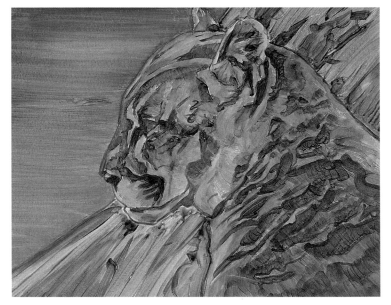

STEP FOUR Because this puma is going to be a warm color, I keep the background cool to add depth and contrast. I paint the green background with a large filbert and chromium oxide green, using long, horizontal strokes. Then, with a medium flat brush, I apply a thin wash of raw sienna to the puma to warm up its overall color. With the same brush, I block in the tree trunk with diagonal strokes and an equal mixture of Payne's gray and cobalt blue.

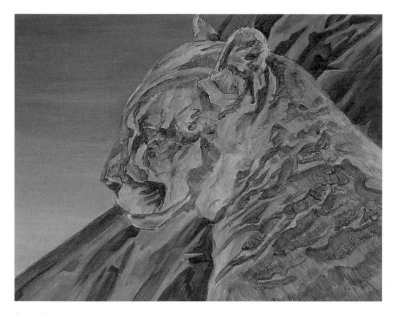

STEP FIVE I continue to work with the Payne's gray and cobalt blue mix, both building up the opacity and deepening the shadows on the tree trunk. And I also build up the background; for the lighter areas, I add white to chromium oxide green. Next I add highlights of the tree, using white mixed with the Payne's gray and cobalt blue mix.

STEP SIX Next I apply three washes: white over the tree, white and raw sienna over the background, and raw sienna over a few highlights on the cat. Then I load a flat brush with raw sienna and white, splaying the bristles to paint the fur. I paint the ears and white fur with a mix of Payne's gray and white. For shadows, I use a cobalt blue and Payne's gray mix.

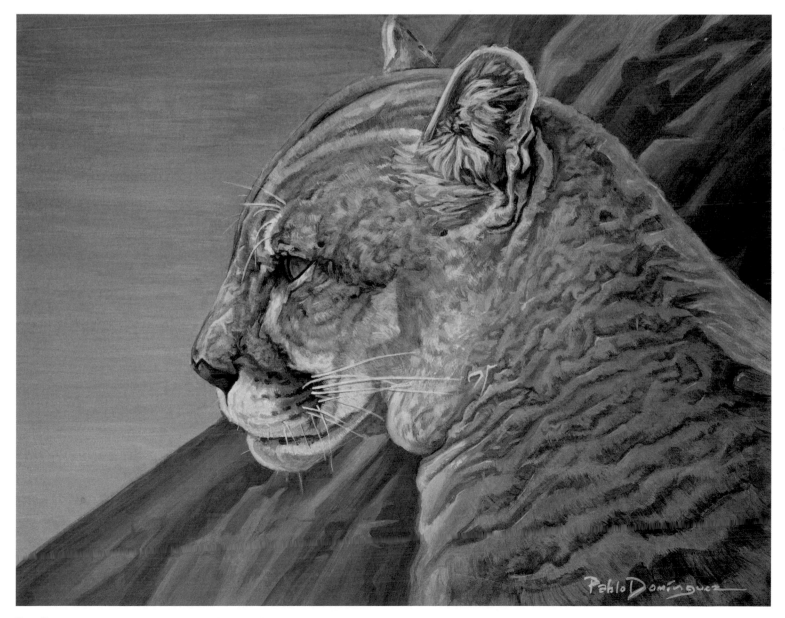

STEP SEVEN I even out the puma's color with both a wash of raw sienna and white over the darker areas and a wash of raw sienna over all but the highlights. With a small round brush, I paint the tip of the nose, adding more white for the highlight. Next I apply a thin coat of cobalt blue to areas that need a grayer cast, mixing in raw umber for the ears. I wash burnt sienna sparingly around the eye area and neck and darken the underside of the chin with a mix of Payne's gray and white. After refining the white areas of fur, I mix equal parts of Payne's gray and raw umber to paint the darkest areas of the cat, such as the small crevices in the neck fur. To finish the puma, I add the whiskers with white and a small round brush; then I use the same brush to complete the eye. The final touch on the tree is a thin wash of white mixed with raw sienna.

BROWN BEAR

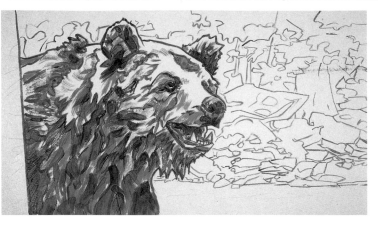

Bear Shadows
Raw umber + Payne's gray

Bear Midtones
Raw umber + raw sienna

Tongue
Alizarin crimson + cerulean blue + white

Rock Shadows/ Midtones
Payne's gray + cerulean blue + white

Light Foliage
Cadmium yellow medium + chromium oxide green + white

Foreground Tree Texture
Raw umber + Payne's gray + cerulean blue

STEP ONE First I paint the basic outlines of the scene in raw umber. For the bear, I use a small flat brush; for the background, I use a small round brush. Next I block in the bear's basic values with raw umber and a medium flat brush. For the smaller areas of the eyes and mouth, I use a small round brush.

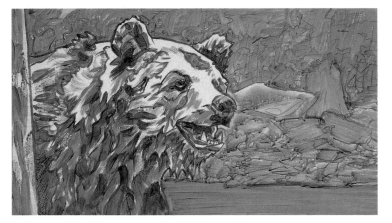

STEP TWO Next I apply a Payne's gray and cerulean blue wash over the rocks. With a medium flat brush, I stroke chromium oxide green and raw umber over the foliage in the background. To add texture, I wash uneven vertical strokes of raw umber over the trees, again using my medium flat brush. Then I paint over the river with a mix of chromium oxide green and raw sienna.

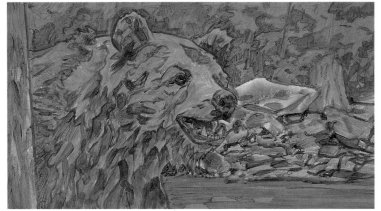

STEP THREE With a medium flat brush and the same colors, I add more layers to the river. Then I define the trees with a mix of chromium oxide green and raw umber, adding cadmium yellow medium and more green for lighter vegetation. I wash raw sienna over the bear's coat; then I wash a mix of Payne's gray and cerulean blue over the left tree; the bear's lips, nose, and eyes; and the rocks. I also add strokes of raw umber to the trunk on the right.

STEP FOUR I continue to build the tree shadows with the chromium oxide green and raw umber mix, adding white for midtones. I paint the thin trunks with raw umber, chromium oxide green, and white. Next I move on to the rock shadows and midtones, using a small flat for the dark crevices between the rocks. Then I fill in the bear's nose and mouth with a Payne's gray and cerulean blue mix, and I create texture on the foreground tree with a large flat and varied strokes.

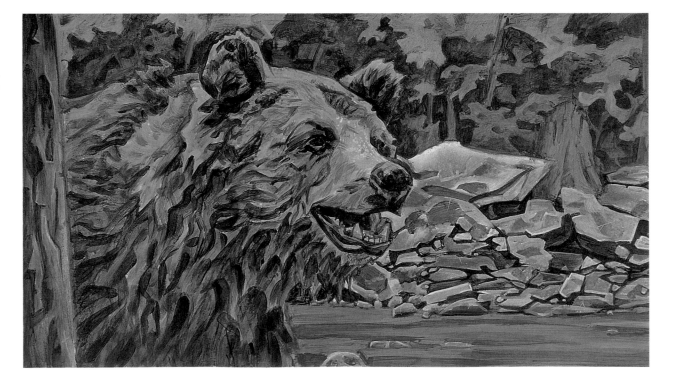

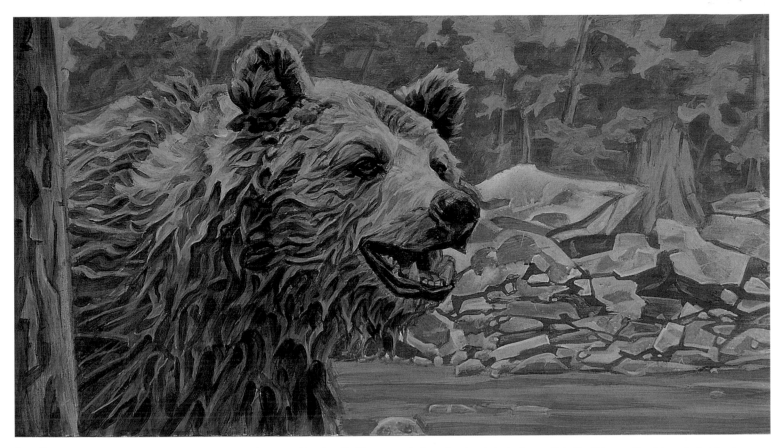

STEP FIVE I paint the lightest rocks with the midtone mix plus more white; then I build the shadows with darker gray. (See the samples on page 48). I layer more chromium oxide green and raw sienna mix on the river, adding white for highlights. I render the dark tones of the foreground tree with raw umber mixed with cerulean blue, adding white for the lighter tones. I also stroke some raw sienna onto the trunk and cerulean blue over the

shadows. Next I push the background into the distance with a thin wash of white plus chromium oxide green. With a small round, I define dark areas of the bear's coat and delineate the lighter areas with a raw sienna and white mix, adding more white for the highlights. With a Payne's gray and cerulean blue mix, I also paint the bear's nose, mouth, and eyes.

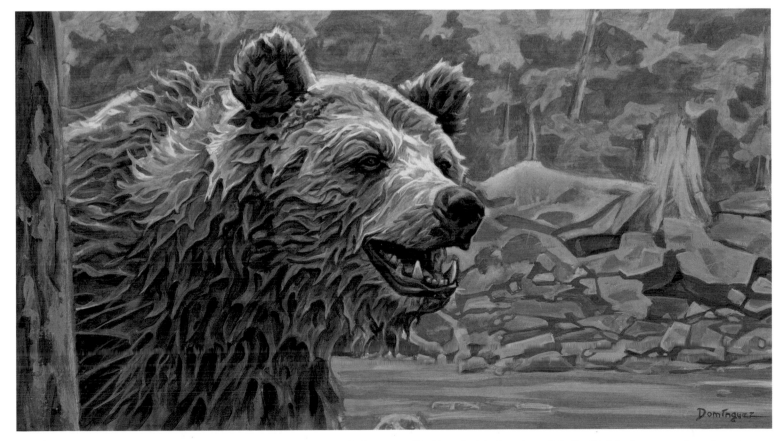

STEP SIX Next I wash raw sienna over the bear with a medium flat. Then I define shadows in the fur by deepening the edges near the lighter tips of the fur to create contrast. With raw umber and cerulean blue, I tone down the lighter sections of fur that fall in the lower, shadowed area of the bear's coat. I then paint a thin raw sienna and white wash over the darker fur in the sunlit parts of the coat. I use my small round brush to pick out the tips of the fur

with white and a dab of raw sienna. To further detail the lips, eyes, and nose, I combine cerulean blue, Payne's gray, and white, following with a raw sienna wash over a few sections of the nose and lip. Finally I paint the teeth with cadmium yellow medium, raw sienna, and white and a small round brush, adding the dark areas with a mix of raw umber and cerulean blue. My last touch is to add a wash of cerulean blue over the foreground tree.

RHINOCEROS

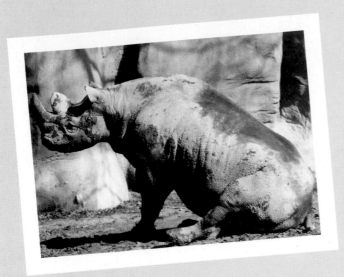

STEP ONE Because there is enough detail in the rhino's texture to keep the eye busy, I use a simplified background, using only the overhang from an acacia tree. I paint the outlines with a mix of Payne's gray and cerulean blue. Then, with a mix of raw sienna and burnt sienna and a large filbert, I paint the background with sweeping horizontal strokes.

Sparking an Idea I was attracted to this photograph because of the rhino's unusual pose. He is pictured seated, having just risen from a roll in the mud and dust to rid himself of ticks and other parasites. This seemed an appropriate pose for a rhinoceros spending a lazy day in a hot, dry climate.

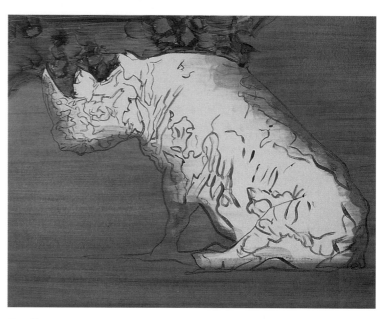

STEP TWO I continue working on the background, layering two to three more applications of the same paint mixture from step one and allowing the paint to dry between layers. This warm color will help create a sense of dryness in the background; it will also contrast nicely with the cooler colors of the rhinoceros. Next I paint in the overhanging tree with the large filbert, using chromium oxide green mixed with raw umber.

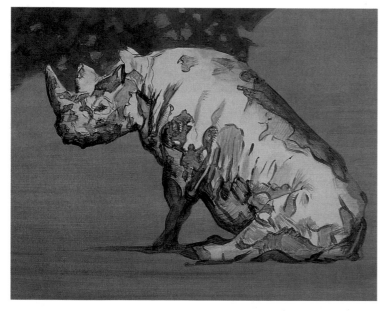

STEP THREE I build the background with a mix of raw sienna, burnt sienna, and white. Then I develop the tree with the chromium oxide green and raw umber mix, adding white for highlights and strokes of raw umber for shadows. Next I mute the colors of the background by applying a watery white. When dry, I block in the rhino with a mix of Payne's gray and cerulean blue.

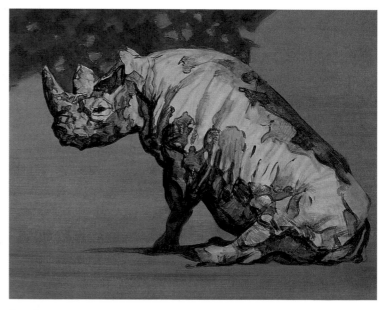

STEP FOUR In this step, I continue to refine the rhino's hide texture using a mix of ivory black and cerulean blue. I use a small flat brush, varying the direction of the strokes to follow the contours of the rhino's body. Then I add white to the mix to paint the lighter areas of the hide.

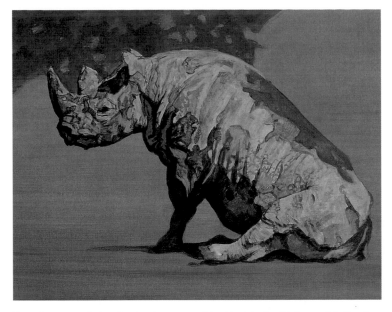

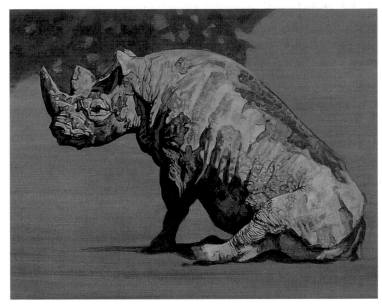

STEP FIVE Now I further develop the texture of the rhino's body with the small flat brush and a mix of ivory black, cerulean blue, and Payne's gray for dark tones, with white added to the mix in varying degrees to paint midtones and highlights. I detail smaller areas with a small round brush, paying close attention to my reference material to capture the texture.

STEP SIX Switching to a medium flat, I apply a wash of raw umber to suggest dust on the rhino. Next I use a small flat and a mix of ivory black, raw umber, cerulean blue, and a small amount of white to deepen the shadows on the rhino, as well as to establish the shadow cast on the ground. Then I continue developing texture on the rhino with the small round.

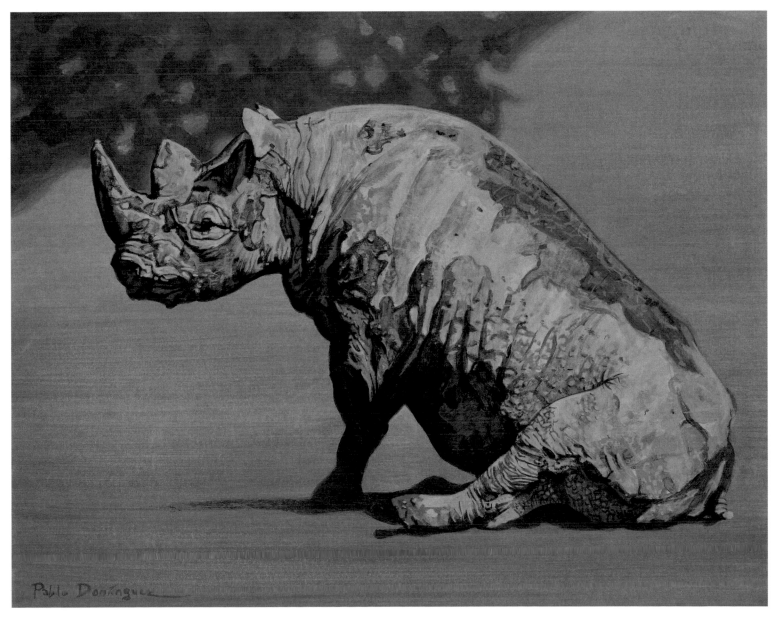

STEP SEVEN I finish building up the detail on the rhino using the previously mixed colors from my palette; I enhance the crevices, cracks, and bumps on its hide with the small round. I also dab a few spots of raw sienna on the rhino's back. Then I touch up any gaps between the rhinoceros and the tree by filling them in with a mixture of chromium oxide green, raw umber, and white. Finally, using a large flat brush, I mix a bit of white with ivory black to create a dark gray; after removing most of this color from my brush with a paper towel, I drybrush the remaining color on the base area of the rhino's legs and its cast shadow to lighten them slightly.

LIONESS

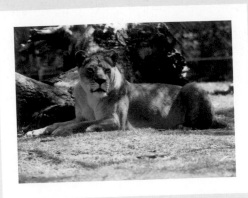

Taking Artistic License I photographed this lioness at a zoo as she responded to the sound of the zookeeper approaching with her meal. For a more exciting painting, I decided to take artistic license and change the background elements and colors. Don't be afraid to adjust your painting to suit yourself; you don't need to be a slave to your references.

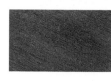

Tree Trunk
*Cerulean blue +
Payne's gray + white*

**Lioness Midtones/
Shadows**
*Raw umber +
cadmium yellow medium +
burnt umber*

Lioness Highlights
Raw sienna + white

Lioness Darks
*Payne's gray +
raw umber*

Eyes
*Chromium oxide green +
raw sienna*

Lioness Darkest Areas
*Raw sienna +
raw umber +
Payne's gray*

Chin Highlight
*White + raw sienna +
cadmium yellow medium*

Nose
*Alizarin crimson +
cerulean blue + white*

Eye Refinement
*Chromium oxide green +
raw umber + raw sienna*

STEP ONE Using raw umber, I paint the outline of the lioness with a small flat brush and the other lines with a small round brush. Then I apply a raw sienna and cerulean blue mix over the background. I also wash a mix of raw sienna, cadmium yellow medium, and white over the foreground, using long, horizontal strokes. I paint the lioness with raw sienna and a large filbert, keeping the paint thin so that the underdrawing remains visible.

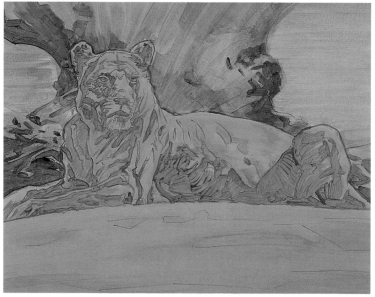

STEP TWO Now I begin developing values in the tree trunk, applying mixes of cerulean blue, Payne's gray, and white with a large flat brush. I establish light and dark values in the lioness with mixes of raw umber, cadmium yellow medium, and raw sienna. Next I add a raw sienna and cadmium yellow medium mix under the lioness and apply it in a thin wash over her body.

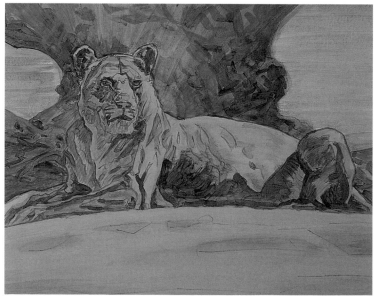

STEP THREE Next I paint chromium oxide green into a few shadows on the lioness with my large filbert. I also continue refining the tree trunk with a mix of Payne's gray and cerulean blue, using a large flat brush. Then I concentrate on the midtones and shadows on the lioness (see the samples above); I use a small flat brush for the facial features and a medium flat brush for all other areas.

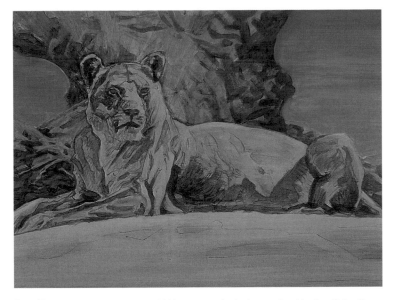

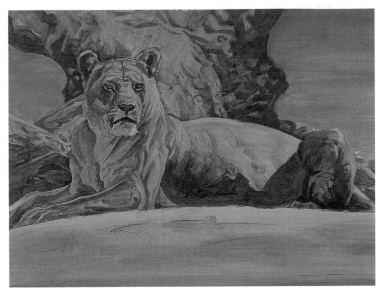

STEP FOUR With the trunk mix, I add blue-gray to the background and begin refining the tree. I then apply a wash of alizarin crimson over shadow areas on the trunk, and I wash over the lioness with raw sienna. Next I add highlights and darks to the lioness, followed by another raw sienna wash. Then I apply a thin layer of raw umber below the lioness and fill in the eyes.

STEP FIVE I further define the highlights on the lioness using a medium flat brush. For the shadows, I use a mix of Payne's gray, cerulean blue, and raw sienna. Then I add a thin raw sienna and cadmium yellow medium wash over the highlights. Finally I apply a lighter value of the trunk mix to the tree's light areas and a Payne's gray and cerulean blue mix to the midtones and shadows.

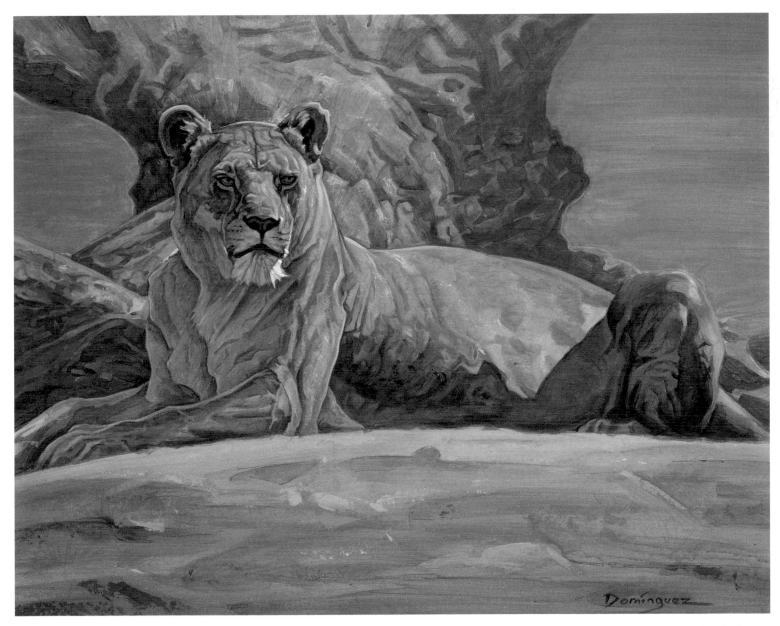

STEP SIX I refine the lioness with mixes of raw sienna, raw umber, and Payne's gray for the darks; raw sienna and raw umber for the midtones; and raw sienna, cadmium yellow medium, and white for the highlights. I paint the muzzle with a mix of Payne's gray and white, highlighting the chin. Then I dab chromium oxide on a few midtone areas before retouching lighter areas with a raw sienna and cadmium yellow medium wash, pumping up the highlights with a raw sienna and white mix. I also fill in the nose, and I paint the pupils with Payne's gray. Moving to the background, I add detail to the tree using a mix of Payne's gray, cerulean blue, and white, followed by a wash of alizarin crimson over a few midtone areas. Finally I wash a mixture of raw sienna and white over the entire background.

TIGER

Establishing Values To see the variations in value of your subject, try beginning with a black-and-white pencil sketch. The sketch can help you plan your use of color.

Face Highlights
Raw sienna + cadmium orange + white

Eyes
Chromium oxide green + raw sienna + cadmium yellow medium

Leaf Reflections
Chromium oxide green + phthalo green + raw umber

Wash for White Fur
Raw sienna + burnt sienna + white

Tiger's Back
Raw sienna + burnt sienna + raw umber + Payne's gray

Leaf Highlights
Chromium oxide green + cadmium yellow medium + white

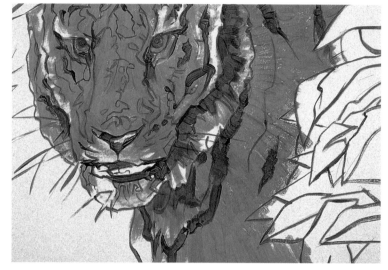

STEP ONE After transferring my drawing to the painting surface and going over the pencil lines with raw umber, I apply a thin mixture of raw sienna, burnt sienna, and cadmium yellow medium to establish the base color of the tiger's coat. For this step, I use a medium flat brush and paint with short strokes that follow the direction of the fur. Then I block in the dark stripes with a mix of raw umber and Payne's gray, using the same medium flat brush. Switching to a small flat brush, I establish the eye color with a mix of raw umber and chromium oxide green.

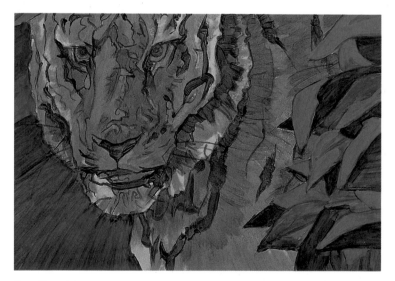

STEP TWO I block in the background with a mix of chromium oxide green and phthalo green, using a large flat brush and diagonal strokes. Using the same brush, I add raw umber to the mix and fill some of the background shadow areas. I also add the midtone to the tiger with raw sienna, burnt sienna, raw umber, and cerulean blue. To finish this step, I apply a mix of chromium oxide green, phthalo green, and raw umber to the shadow areas and a mix of chromium oxide green, phthalo green, and white to the highlights—all with the large flat.

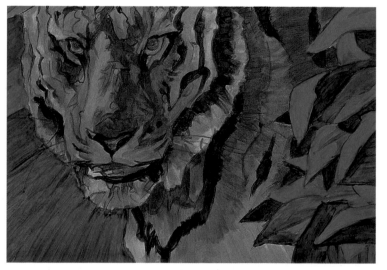

STEP THREE Using a medium flat brush for this entire step, I first return to the tiger to deepen the midtones with a mix of raw sienna, burnt sienna, raw umber, and cerulean blue. I paint the darkest sections of the tiger, including the stripes, with raw umber plus Payne's gray. Then I paint the white of the tiger's coat with a mix of white and a little Payne's gray. Next I apply another layer to the midtone areas using raw sienna, burnt sienna, raw umber, cadmium yellow medium, and cerulean blue.

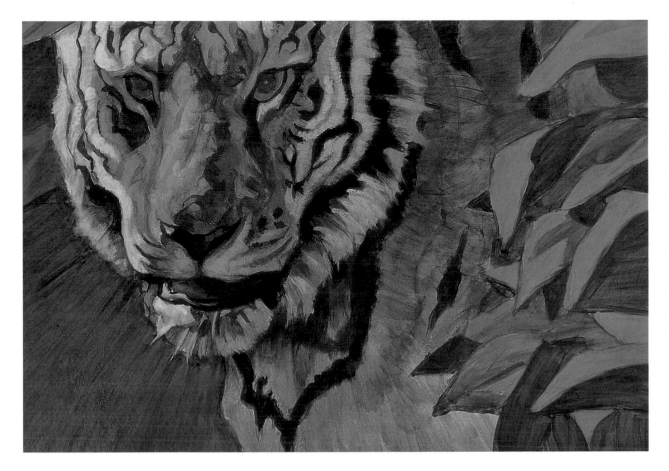

STEP FOUR I continue to paint the white areas of the tiger with a mix of white and Payne's gray, adding more gray to the mix for shaded areas of the fur. Next I use a darker gray to paint the dark stripes, nose, and mouth. I fill in the tongue with a mix of cerulean blue, alizarin crimson, and raw umber, adding white to the mix to paint lighter areas. Then I fill in the eyes with a raw umber and chromium oxide green mix. With raw sienna, burnt sienna, cadmium yellow medium, and white, I paint the highlights in the tawny areas of the face. To finish this step, I deepen the dark green background with a mix of chromium oxide green and raw umber.

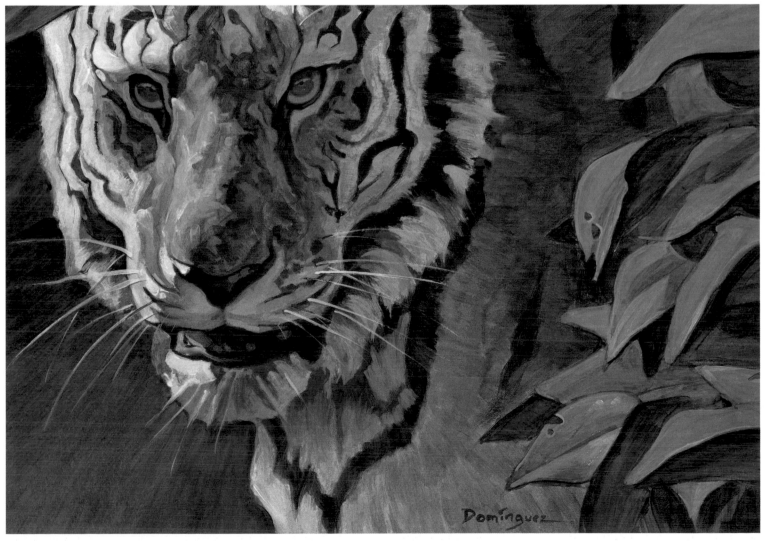

STEP FIVE To finish, I wash orange over the tawny fur. I then wash a tawny mix over some of the white fur, stroking a green wash over other white areas. Next I define the tiger's chin and nose, darken its eyes and mouth, and add the teeth and whiskers. I apply a mix of white and raw sienna behind the tiger, and I also darken the foreground leaf edges using a Payne's gray and raw umber mixture; I add white to the tips and some of the edges. Now I highlight the foreground leaves, deepening the undersides with a Payne's gray and cerulean blue mix. Finally I wash cadmium yellow medium mixed with green over the leaves.

55

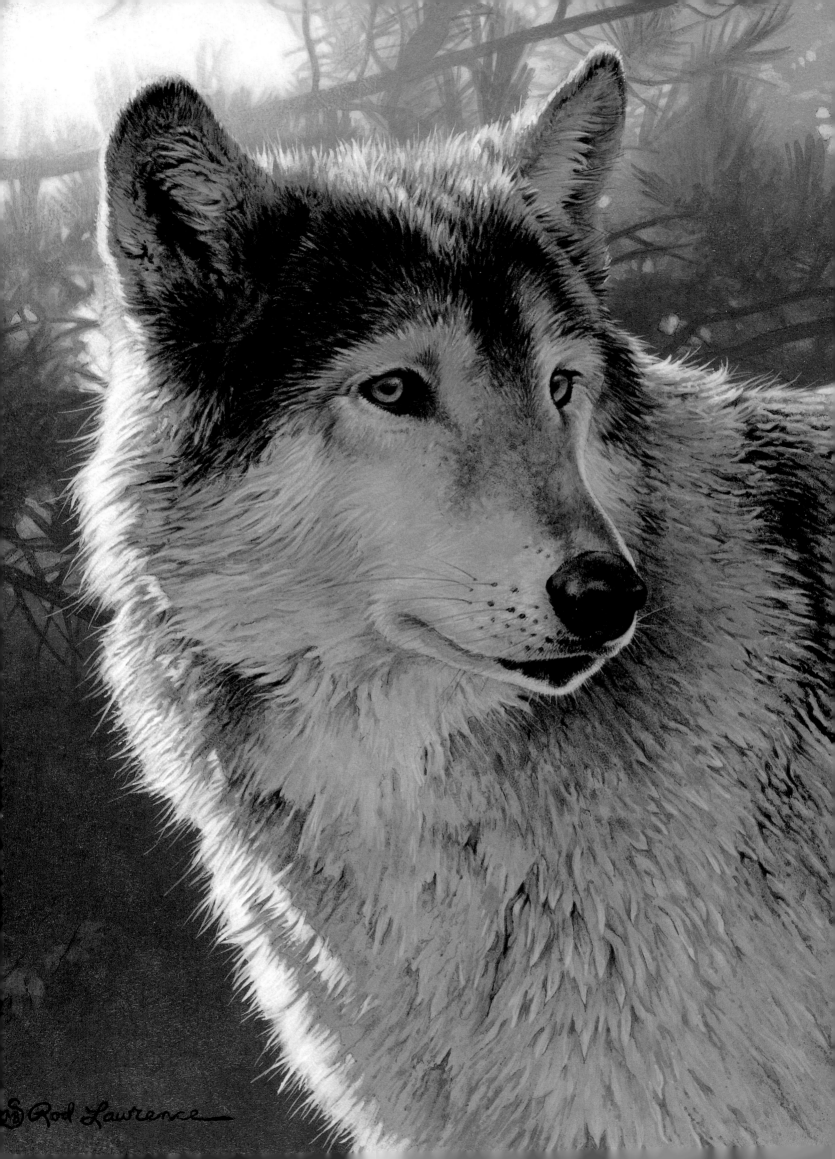

PAINTING WITH
ROD
LAWRENCE

Rod Lawrence graduated magna cum laude with a degree in fine art
from the University of Michigan in 1973. Since then, he has worked
full time as a professional artist. His credits include being named
the Michigan Ducks Unlimited Artist of the Year in 1979 and the
Michigan United Conservation Club's Michigan Wildlife Artist of
the Year in 1981. Rod has painted winning designs for Michigan
Duck Stamps and Michigan Trout Stamps. He has also exhibited
in many group and one-man shows, including the prestigious
Leigh Yawkey Woodson Art Museum's "Birds in Art" and "Wildlife:
The Artists' View" shows. Rod is an active artists' workshop instruc-
tor, and his art has appeared in many outdoor magazines and on
limited edition collector plates. Rod lives in a log cabin in northern
Michigan with his wife, Susan, and their sons, Matthew and Brett.

BALD EAGLE

Far Branch Shadows
*Cerulean blue +
ultramarine blue +
burnt umber +
violet + white*

Main Trunk
*White + buff + yellow
ochre + cerulean blue +
ultramarine blue*

Pine Branches
*Cerulean blue + burnt
umber + buff + white +
yellow ochre*

Pine Needles
*Cerulean blue +
burnt umber + white +
yellow ochre +
cadmium yellow light +
dab permanent green light*

Eagle Head and Tail
*Cerulean blue +
quinacridone violet +
burnt umber + white*

Feather Base
*Cerulean blue +
quinacridone violet +
burnt umber + yellow
ochre + buff + white*

Feather Main Values
*Yellow ochre +
quinacridone
violet + burnt umber +
cerulean blue + buff*

Feather Darks
*Cerulean blue +
burnt umber +
quinacridone violet
+ white*

STEP ONE After wetting only the areas I want painted, I wash the upper sky with a mix of cerulean blue and ultramarine blue. As I move down, I add permanent green light and more water to the mix, leaving some areas white for clouds and painting around the eagle and tree. Then I apply the branch shadows in thin washes. (See the mixes at left.)

STEP TWO Now I warm up some of the far branch and suggest cracks in the light side of the near branch with watery dabs of yellow ochre, burnt umber, and quinacridone violet. I add more cerulean blue, ultramarine blue, and raw umber to the shadow mix to paint deep cracks. Next I wash in the pine branches and needles.

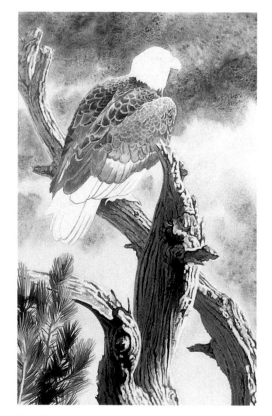

STEP THREE I add more yellow and brown to the needle mix washes, letting some of the lightest green and white show. Then I add more cerulean blue and burnt umber for the deeper shadows. Next I block in the feathers with the main value (see the samples at left), leaving the white edges unpainted.

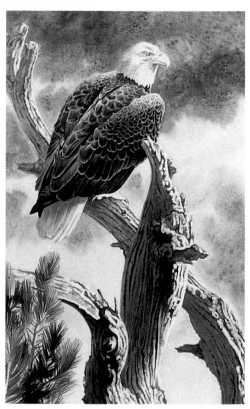

STEP FOUR Now I paint the shadows and dark feathers, suggesting gaps on individual feathers with quickly blended dabs and lines. Next I edge the dark feathers with the main value mix. Then, using a mix of cerulean blue, quinacridone violet, burnt umber, and white, I "draw" details and shadows on the tail.

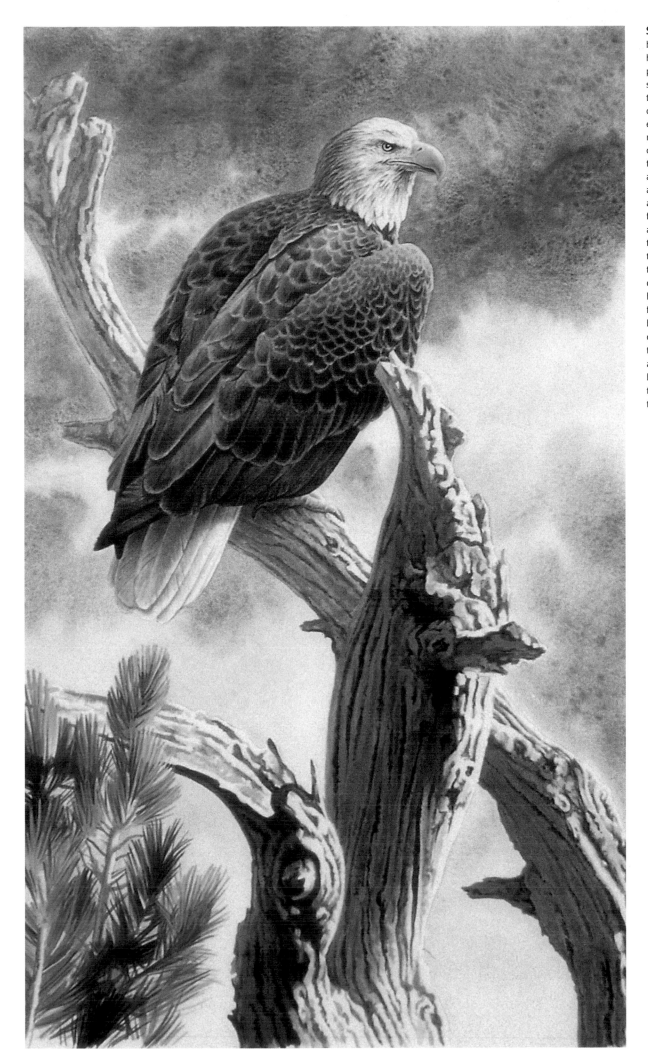

STEP FIVE Adding ultramarine blue and burnt umber to the head and tail mix (see the samples on page 58), I paint darker shadows and the spaces between the feathers, leaving the white of the surface. I wash in the beak, eye, and foot using watery cadmium yellow light plus yellow ochre, adding cerulean blue to the mix for the shadows. To accentuate the head, I paint around it with the cerulean blue and ultramarine blue mix I used for the sky, suggesting feathers and changing the contour of the bird. I do the same around the beak and the light edge of the tail. Next I darken the back of the body, especially near the head, with a wash of the dark feather mix, blending across the back and down the light edges of the right wing. Then I detail the feathers with darker washes, also adding darker areas on the back edge of the head. My final touch is a warm tan wash over the right "shoulder."

LEOPARD CUB

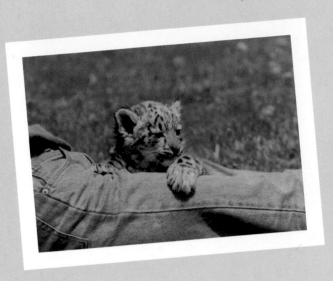

Selecting a Pose This cub was one of the subjects at an artists' workshop. This pose caught my eye: The three-quarter viewpoint and the draped paw will make a good composition, and there are strong lights and shadows.

STEP ONE After transferring the outline of my sketch to my painting surface, I use an old bristle brush to apply layers of splotchy paint behind the cub, creating a base coat that resembles rocks. For the background rocks on the left, I mix two warm browns with burnt umber, cerulean blue, quinacridone violet, buff, and ultramarine blue. I use the same mix for the background rocks on the right side, but I vary the amounts of each color to create two darker, bluer values.

STEP TWO By varying the amounts of each color in the background mixtures, I create three values for the bluish spots on the rocks and two values for the red-orange areas (see the samples below). I randomly dab on the bluish patches with a natural sponge, blending some spots with a brush and painting around others with darker values made from burnt umber, cerulean blue, quinacridone violet, white, and ultramarine blue. Next I add the two reddish mixes. To create the lightest background values, I add buff (at times tinted with violet and blue) to my lighter colors. For the darkest background values, I mix burnt umber, ultramarine blue, and a little violet. The rocks in the foreground are in full sunlight, so the colors will be brighter and warmer. I mix three foreground rock values by varying the amounts in each mix, and I apply these wet-on-wet with a small flat brush.

Bluish Rock Spots
Burnt umber + cerulean blue + cadmium yellow light + permanent green light + white + yellow ochre

Red-Orange Rock Spots
Burnt umber + cadmium orange + yellow ochre + white

Foreground Rocks
Burnt umber + cerulean blue + violet + white + yellow ochre

Snow Leopard Base
Burnt umber + cerulean blue + violet + white + ultramarine blue

Light Fur 1
White + burnt umber + cerulean blue + violet + white

Light Fur 2
Burnt umber + cerulean blue + violet + white

STEP THREE When the last layers of paint are dry, I transfer the main lines of the foreground rocks from my sketch. Then I use darker values made from burnt umber, cerulean blue, violet, white, and ultramarine blue to paint the shadows and cracks. I wash a yellowish mix of burnt umber, cadmium orange, cerulean blue, violet, white, and ultramarine blue into the shadows of the rocks. Then I paint a reddish mix of burnt umber, cerulean blue, violet, white, ultramarine blue, and yellow ochre into the darker shadows to represent the reflected light bouncing back from the rock surface. Next I add two light values of burnt umber, cerulean blue, violet, white, cadmium yellow light, and yellow ochre to the foreground rocks. Excluding the yellows, I mix two even lighter values of the same colors and apply them to the rocks.

STEP FOUR As the rock surface curves over the top and around toward the right, it catches more light and will be both lighter and brighter. I use thick paint and several coats to build these lightest values. The last thing I do on the rocks is mix a "black" using ultramarine blue, burnt umber, and a touch of violet; with this color, I darken the vertical crack leading to the paw and the horizontal crack on the bottom left. I also use this color as a watery wash on the small dark area in the bottom left corner—it needs to blend in more with the larger, darker area. To start painting the cub, I apply four coats of solid base color. (See the sample on page 60.) I keep the edges irregular, avoiding hard lines. As I move along the edges, I drag the paint back into the body of the cub to keep it from looking outlined. When this base coat is dry, I transfer the major details from my sketch that I want to block in. By adding yellow ochre to the base and varying the amounts of the other colors, I create four medium values that represent the main areas of the leopard.

Leopard Cub (continued)

STEP FIVE After suggesting the light tufts of hair along the edges that stick out from the fur, I focus on the key dark areas of the cub. I paint the spots in the light with burnt umber, cerulean blue, a little white, and ultramarine blue. Then, using burnt umber, cadmium yellow medium, cerulean blue, white, and ultramarine blue, I create a yellow tint, which I wash over areas near the ear and on the leading edge of the spots in the light. For the spots in shadow, I mix burnt umber, more cerulean blue, a touch of white, and ultramarine blue. To begin to create the fur texture and the shadow areas, I mix burnt umber, cerulean blue, violet, white, and ultramarine blue.

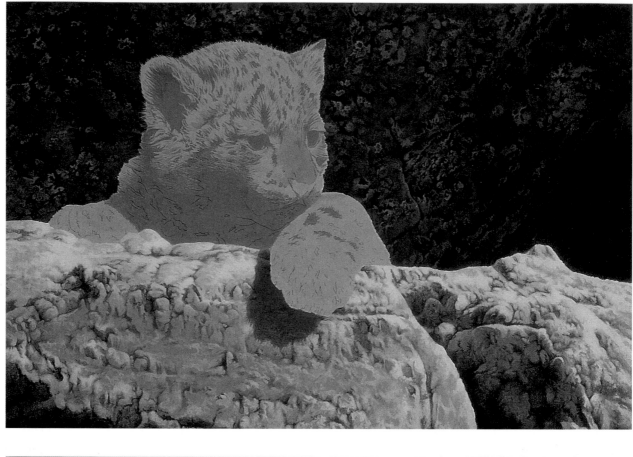

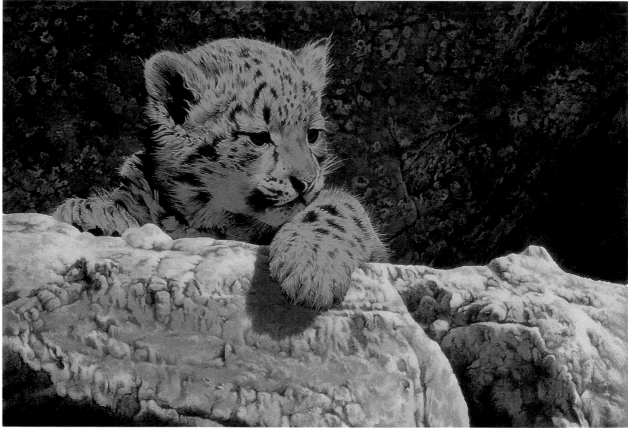

STEP SIX Once I've painted all of these areas, I begin working with color washes that are darker than the base colors but lighter than the dark values used on the spots. (See "Mixing Values" on page 63.) I use these colors to add details and shadows in the lighter areas of fur, such as between the spots. Next I mix a value that is in between the lighter original base coat and the dark spot colors. With this color, I paint fur details in the light base areas between the spots, especially on the paws. I also put it to use in shadows on the fur, where the light base fades into the shadows, as well as at the end of the paw hanging over the rocks. Then I mix this color with the dark spot color to darken shadows and the area on the bottom of that paw.

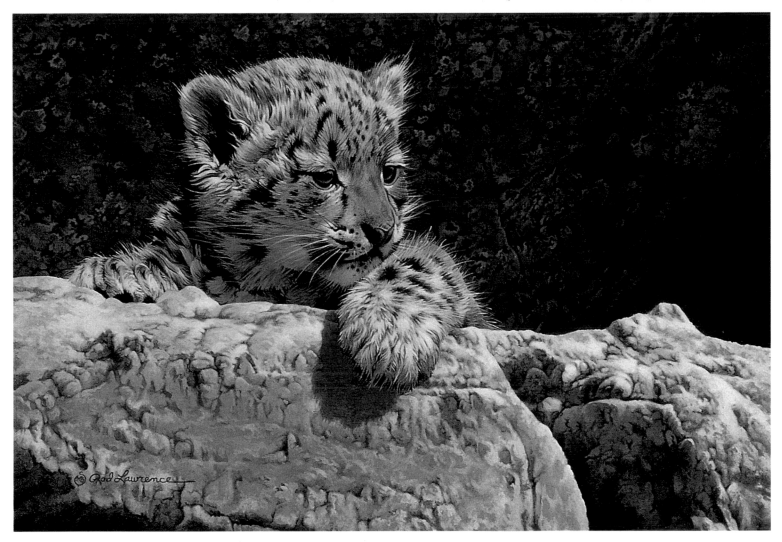

STEP SEVEN Next I add the light fur areas, building up the colors where the strongest light would be striking. Then I stroke bluish reflected light under the chin and nose and on the jaw. I add a touch of yellow ochre to make this mix greener and wash it on the upper left of the blue shadows. Now I mix a violet and yellow ochre wash for the nose, adding white and cerulean blue for the highlights. For the yellow-green irises, I mix cadmium yellow light, yellow ochre, and cerulean blue. For the top of the eyes, I blend cerulean blue, violet, burnt umber, and a dab of white, creating a bluish reflection. I add the lightest value (white plus dabs of cadmium yellow light and violet) to key fur areas. Next I mix the darkest value using ultramarine blue and burnt umber; I focus this color on the eyes, ears, muzzle, and under the left ear and paw. I also use this mix to paint the tiny hairs on the left side of the cub's head. Then I mix a burnt umber, yellow ochre, and violet wash for the inside top of the ear. My final touches are made using both the dark and light colors; I pull a few strands of fur into the cub's outline to draw the whiskers along the cub's muzzle.

MIXING VALUES

Often the subject you're painting will call for a range of values that are all within the same color family. To create a smooth transition along the value scale, keep mixing together the same colors but in varied proportions. For example, if you've mixed a green from blue and yellow, you might add more blue for a darker value and more yellow for a lighter one. This method allows you to create an endless variety of hues that will relate well to one another.

Background Rock Values
Each of these values is made up of the same five colors: burnt umber, cerulean blue, quinacridone violet, buff, and ultramarine blue. The difference in values is created by adjusting the amount of each color added to the mixes.

More burnt umber and violet

More burnt umber and even more violet than previous mix

More cerulean blue and ultramarine blue

More ultramarine blue and burnt umber

DRAKE WOOD DUCK

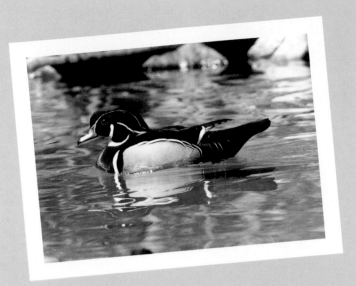

Capturing Reflections I photographed this beautiful drake wood duck at the zoo. The reflection especially intrigued me; the fluid image is appealing, as are the long, repeating head reflections. For my final painting, I referred to other photos to create a more alert head posture and a calmer body of water.

Duck Body Mixes

Permanent green light + cadmium yellow light + buff

Buff + cerulean blue + burnt umber + violet

White + cerulean blue + ultramarine blue + dab burnt umber

White + yellow ochre + cadmium yellow light

White + cerulean blue + ultramarine blue + dab violet + dab permanent green light

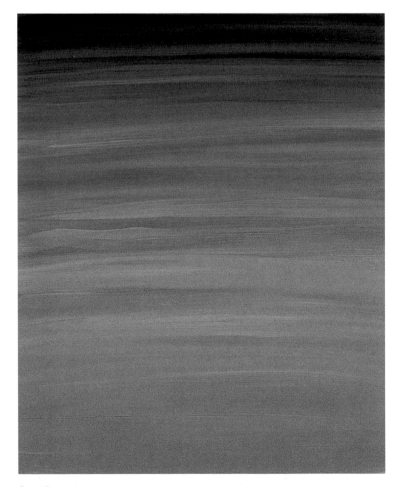

STEP ONE I begin by mixing five colors for the water: a very dark bluish mixture of ultramarine blue, burnt umber, phthalo green, and permanent green light; then four shades of green using yellow ochre, cadmium yellow light, cerulean blue, quinacridone violet, and titanium white. I apply the paint thinly wet-on-wet, working from dark to light and graduating from a blue-green to a brownish green, overlapping and blending each stroke. Next I use the edge of my soft flat brush and paint thick and thin lines for the water ripples. Then I lightly drag the flat of the brush over the lines to blend them slightly yet allowing the variations to show.

STEP TWO After transferring the main lines of the duck and its reflection to the painting surface, I begin to block in the base colors with a round brush, applying several coats of paint to represent each different mid-value color of the duck. (See the samples above.) This breaks the image down into simple color shapes.

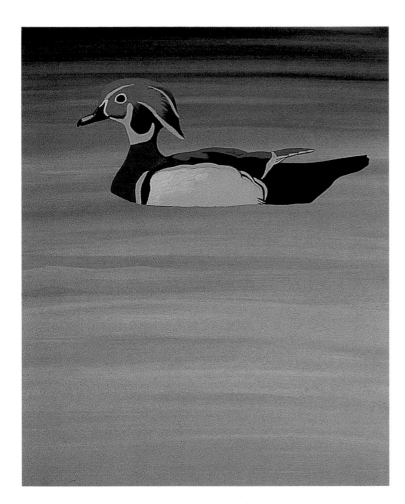

STEP THREE I continue blocking in by adding the red on the bill, the red for the eye, the orange around the eye, and the yellow around the bill. I also apply the darkest value—a mixture of burnt umber, ultramarine blue, and a little quinacridone violet—to the tail and other dark areas of the duck. Now I begin some suggestions of texture and detail, such as around the head and on the bars on the side pocket (the bluish feathers with the white bands). I paint more layers on the side pocket and then add pure buff to the front area to show that more of the light strikes there.

Painting the Duck's Reflection I paint the reflection with four values: two mixed from white, buff, cerulean blue, ultramarine blue, burnt umber, and violet; another a mix of buff, permanent green light, cerulean blue, umber, and ultramarine blue; and the last a mix of umber, ultramarine blue, cerulean blue, with small dabs of permanent green light and buff.

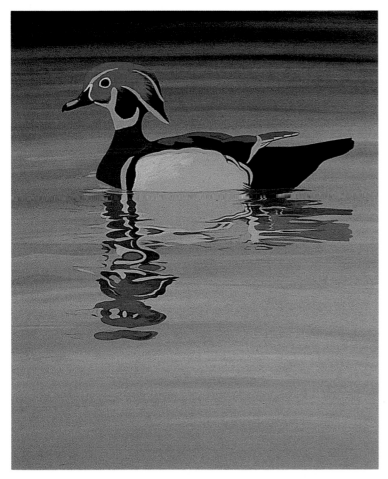

STEP FOUR I use the same blocking-in procedures for the duck's reflection. The colors in the reflection are more subdued than those of the actual bird (see the detail above right), and the contrasts between light and dark will be stronger in the actual bird than they are in the reflection. This will make the bird more prominent and draw more attention.

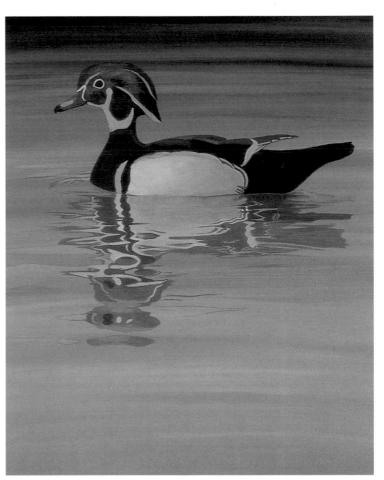

STEP FIVE To finish blocking in, I fill in the red and yellow areas around the reflections of the eye and bill. Now the process of developing the duck really begins. I add the next stage of values, which are both lighter and darker than the mid-values used for the blocking-in steps. These next value changes will give the duck a more three-dimensional look.

Drake Wood Duck (CONTINUED)

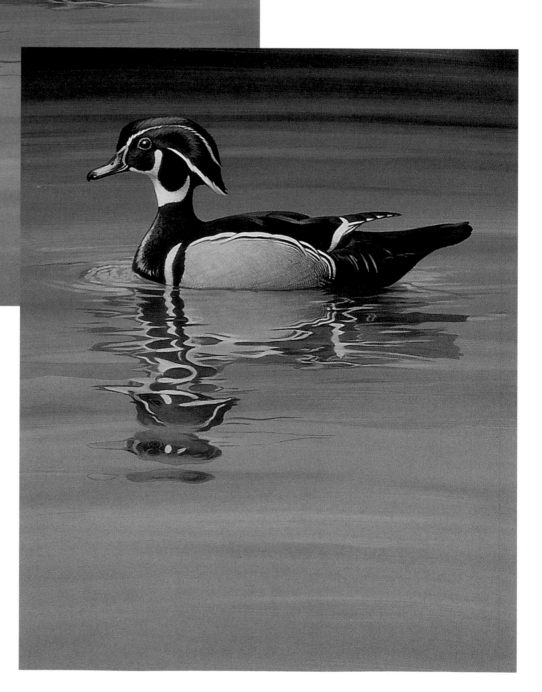

STEP SIX Here I slowly build up the white areas with a lighter, warmer mixture of white, burnt umber, violet, and cerulean blue. It takes three or four layers to achieve the really light values. I also use this mix to "draw" more details and make refinements. I build up the duck's reflection in the same manner but with more subdued colors. Then I build up the other light and dark values on the duck in the same way. For the breast, I use a mixture of violet, ultramarine blue, burnt umber, cerulean blue, and white, varying the amount of each color in the mixture to create subtle color shifts.

STEP SEVEN In this step, I pump up the colors wherever they need it, and I begin adding more detail to the eye, the bill, the wavy dark lines of pattern on the feathers, and the side pocket. (I work on the color enhancements first so that I can add the darker and lighter values over them.) I mix permanent green light, yellow ochre, and cadmium yellow light for a warmer yellowish green for the head. I add a light wash of yellow ochre on the side pockets and a light wash of violet by the tail. Then I apply a mix of yellow ochre, cadmium yellow light, and white to highlight the orange feathers. The warm, slightly yellow white on the duck is mixed with dabs of cadmium yellow light and yellow ochre. The darkest value is a mix of burnt umber, ultramarine blue, and a little violet.

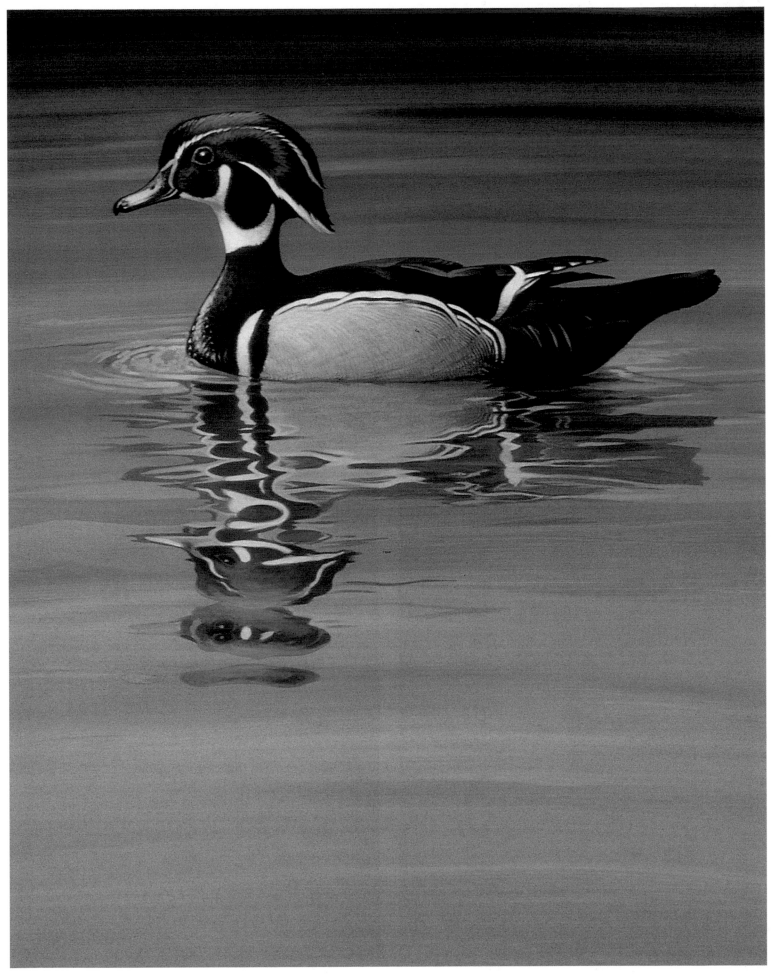

STEP EIGHT I use a mirror to review the final phase of my painting; the reverse image offers a different perspective, and it helps me pick out problem areas. I decide to increase the white areas using white plus a touch of cadmium yellow medium. I also paint the lighter whites in the reflection but with subtle changes. The reflected head also needs more color, and I noticed that I missed painting the orange rump feathers in the reflection! Two more things absent are the white triangular pattern on the breast and a suggestion of the duck's right wing. Next, to make the duck's head stand out a little more, I lighten its top and add a bluish-green accent using a mixture of white, permanent green light, and ultramarine blue. I also paint a few tufts of white down and then glaze over the white with pure permanent green light. Finally I soften the dark lines on the water above the drake's head with washes of yellow ochre, white, burnt umber, cerulean blue, ultramarine blue, and permanent green light.

Mule Deer

Deer Block-In Dark
White + cerulean blue + ultramarine blue + burnt umber + violet + yellow ochre

Deer Block-In Light
White + permanent green lt. + cerulean blue + ultramarine blue + burnt umber + violet + yellow ochre

Fur Shadows
Ultramarine blue + burnt umber + cerulean blue + quinacridone violet

Browner Fur
Burnt umber + cerulean blue + yellow ochre + cadmium yellow light + buff

Lighter Fur Value
Burnt umber + ultra. blue + cerulean blue + yellow ochre + cad. yellow lt. + buff

Antler Base
Burnt umber + cerulean blue + violet + ultra. blue + white + dab yellow ochre

Blue-Gray Lights
White + buff + burnt umber + cerulean blue + violet

Legs and Face
White + burnt umber + cerulean blue + yellow ochre + violet + permanent green lt.

White
White + cerulean blue + water tinted with violet

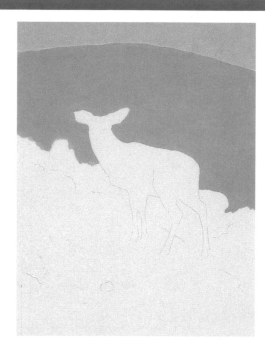

STEP ONE After transferring the major outlines of my sketch, I mix white and cerulean blue for the sky. Then I add trace amounts of cadmium yellow light, ultramarine blue, and violet. I use a flat brush to apply the paint in several coats. Then I block in the medium value for the background rocks with white, cadmium orange, yellow ochre, a dab of cadmium yellow light, and burnt umber, building a solid base color.

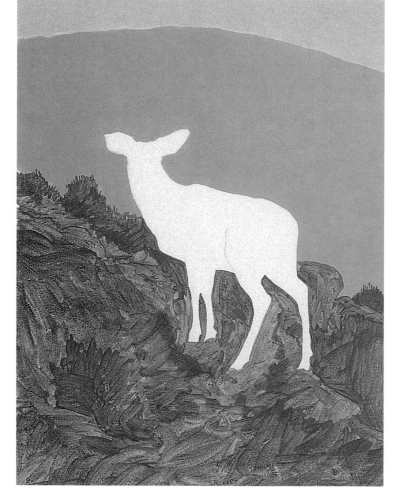

STEP TWO Next I block in the foreground sagebrush using white mixed with permanent green light, cerulean blue, ultramarine blue, and burnt umber. I also block in the browner rocks and ground with a medium round brush and buff, permanent green light, cerulean blue, ultramarine blue, and burnt umber. I use the tip of the brush to make sure the tops of the bushes are irregular shapes so I don't have to fight any hard edges later.

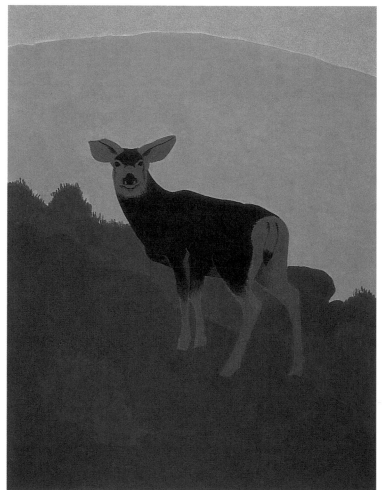

STEP THREE I continue to add layers to the foreground until it looks solid. When painting around an object, such as the deer, I avoid building up texture by keeping the paint thin and stroking out and away from the subject. Successive layers of paint will blend together better and eliminate a potential "outline problem." The deer is the last major area that needs to be blocked in. First I use the lighter value (see the samples above left) to cover the entire head, the rump, and the lower part of the legs. Then I block in the rest of the deer with the darker value. Next I transfer the lines from my sketch to add some detailed areas on the face, legs, and rump and then paint them with a small round brush.

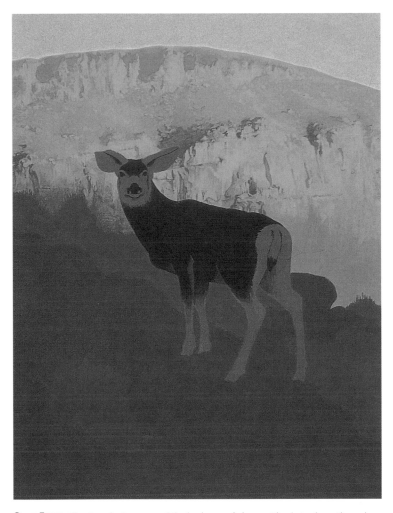

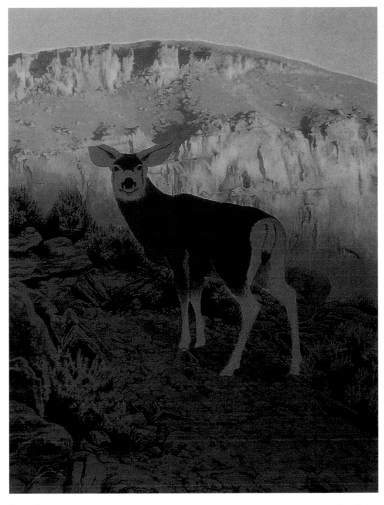

STEP FOUR After transferring some of the background shapes, I begin to shape the rocks using a mixture of white, buff, cerulean blue, ultramarine blue, burnt umber, and violet. Then I use the same colors in a slightly lighter value mix to paint the light areas on the mountain.

STEP FIVE Next I use white mixed with dabs of cadmium orange and cadmium yellow light to wash yellow-orange toward the bottom of the mountain and apply final highlights on the rocks. I also begin work on the foreground sagebrush and rocks and suggest a shadow under the deer.

COMBINING REFERENCES ON YOUR COMPUTER

When working with multiple reference photos, I like to scan the images into my computer and combine them with photo-manipulation software; then I can print out a single image for reference. This program also lets me adjust colors and values, delete unwanted details, and crop the image as I please.

The Background I captured the view of this sunrise reflecting off a mountain in Wyoming. Mule deer frequent this particular area, so it was a natural setting to serve as my backdrop.

The Foreground This is an interesting rocky area that I also photographed in Wyoming. Then I used my computer software to flop the picture horizontally; the red box shows the approximate area that I cropped to use in my painting. I erased the scene from behind the sagebrush on up, replacing it with the background photo at left.

The Subject This photo was taken in Montana a number of years ago. Although the deer are small and you can't see much detail, I liked the body position of the doe looking at the camera. For my painting, I added antlers and thickened the body to convert the doe to a buck.

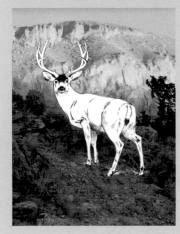

The Compilation Here I've combined the habitat photos on my computer and dropped in a sketch of the mule deer so I can see how it will fit the scene. After adjusting the colors and values and revising the mule deer drawing a bit, I printed the compilation photo to the actual size of my painting. This made it easier to draw my sketch on a transfer sheet (which I then transferred to my painting surface), and it served as a good reference while I was painting.

MULE DEER (CONTINUED)

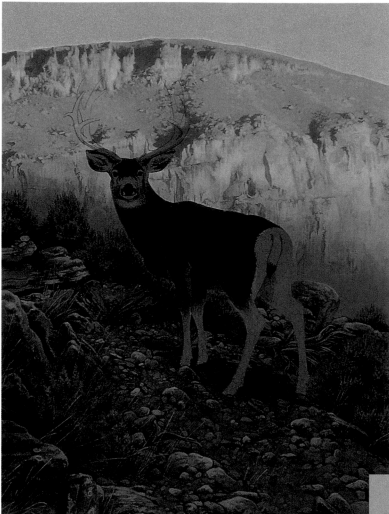

STEP SIX I paint the foreground rocks using varying mixtures of white, buff, cerulean blue, ultramarine blue, burnt umber, and violet, adding dabs of yellow ochre and more burnt umber for a darker value. I add more cerulean blue to the mix and apply it in the dark foreground areas; then I enhance the bottom of the foreground with my black mix (ultramarine blue, burnt umber, and violet).

Brush Detail I paint the sagebrush branches with varying mixes of white, cerulean blue, ultramarine blue, violet, and a dab of burnt umber. I create the foliage by adding dabs of cadmium yellow light and permanent green light to the previous mix. The sagebrushes need a few final touches, such as a lighter bluish hue to bring out some of their "leaf" structure and a yellowish green to indicate the vertical top pieces. With a small round brush, I add a few tufts of grass, and the foreground is finished.

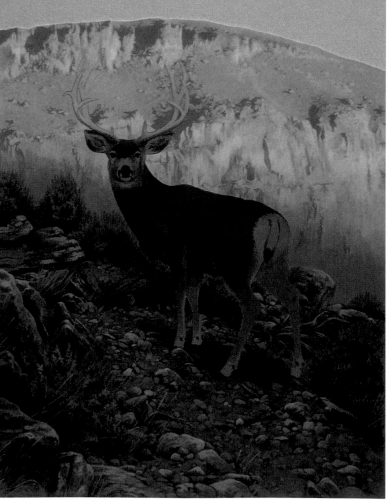

Rock Detail With acrylic paints, texture can be created one of two ways: physically or visually. For this painting, I use variation in value to give a visual impression of texture. I block in the medium values first. Then I shape the rocks with my darkest values. To give a more textured feel to the painting, I don't use one flat mixture; instead I continually alter the dark shadows, varying the amount of each color within the mix. Finally I work in the lighter values and highlights, again making sure that my mixtures aren't too even or consistent. When I'm finished painting, the variations between light and dark values imply the realistic form of the rocks, as well as their texture.

STEP SEVEN With the same mix of ultramarine blue, raw umber, cerulean blue, and quinacridone violet that I used to paint the fur shadows, I add shading and fur texture. I add some browner areas of fur around the legs and head, and I block in the antlers with buff to cover the background color. With the lighter fur value, I introduce tiny dots and lines of texture.

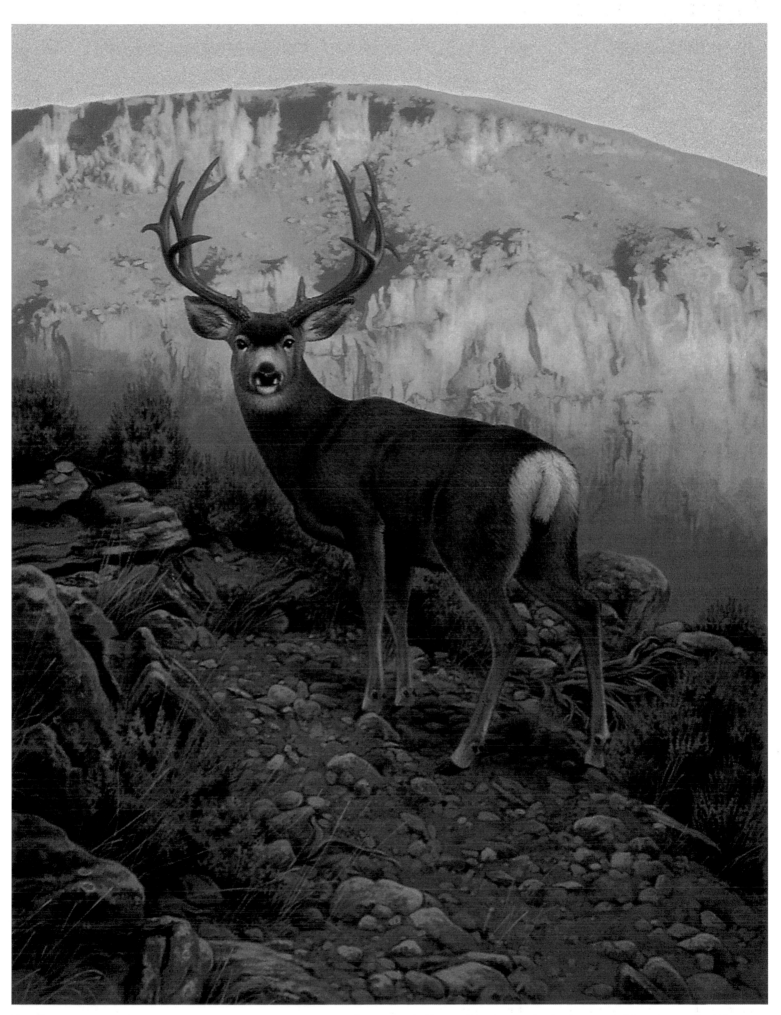

STEP EIGHT Next I add reddish, gray, and brown washes to the deer. With the shadow mix, I add shadows and the dewclaws on the legs and detail the antlers. Then I add the lights, starting with the legs and face and then highlighting the antlers and ears. I build up washes of the blue-gray light values, varying the mixtures and adding cadmium yellow light to create color shifts. I pop the white mix on the rump, muzzle, and chin and put a bluish reflected light on the fur. After applying final darks, I add reflected light and highlights in the eyes.

WOLF

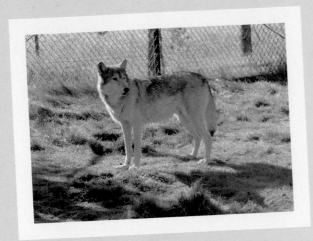

Cropping In I especially liked the angle of this wolf's head and the bright backlighting. When cropping in on the head, I left enough negative space around it to close in on the wolf without confining it too tightly.

STEP ONE First I mix the overall base color for the head using cerulean blue, white, and smaller amounts of burnt umber, violet, and ultramarine blue. For the background, I create several values using many different combinations of burnt umber, cerulean blue, ultramarine blue, white, and violet—sometimes adding yellow ochre and cadmium yellow light. I apply these mixes wet-on-wet, blending as I paint.

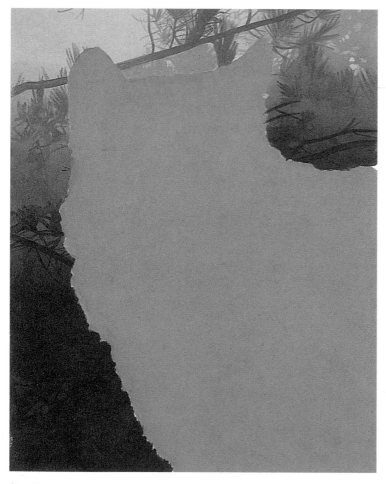

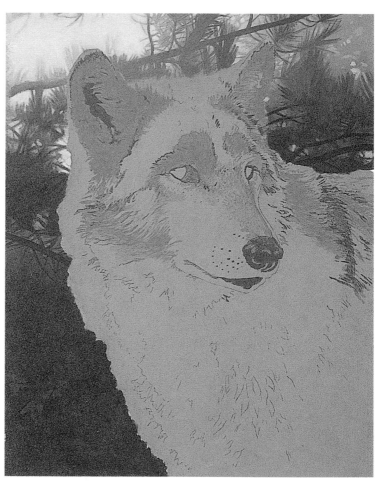

STEP TWO Now I transfer the main lines of the background branches from my sketch to the painting, beginning with the background mixes from step one. I apply washes of both lighter and darker values to soften the edges and slowly build up the foliage forms. Then I use a darker value on the area just to the left of the wolf, and I apply both light and dark values to the areas above and to the right of the wolf's head. In the lower-left corner, I start to add some lighter value "holes" (the negative spaces) to the background.

STEP THREE Now I wash in the background lights using a mixture of white, yellow ochre, and orange. I build the lightest areas using white mixed with yellow ochre, cadmium yellow light, and cerulean blue. Then I transfer the facial and fur details from my sketch, painting them with a slightly darker value than the base color; I also build up the eye and nose darks, applying several washes. And I add fur details with a value in between the base color and the darker washes.

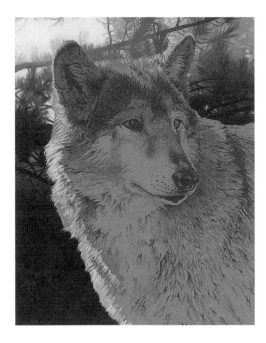

STEP FOUR When painting the lightest areas, I use thin washes and slowly build my paint into thicker layers. Then I lay on a darker value to create depth, indicating deeper areas of fur and dark markings. When painting fur, look for clumps of hair as well as color patterns. Fur varies in length and color, and it tends to clump in areas where it is thicker or where it is constantly compressed by movement. Take the time to really see how the clumps overlap, shadow each other, and weave in and out. This will help you paint fur more realistically.

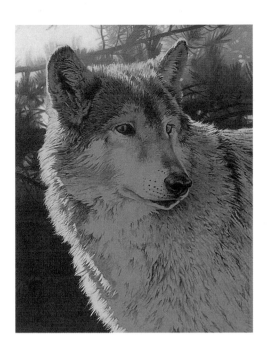

STEP FIVE Now it's time for color washes (see the samples below), which will enhance the wolf and begin changing the overall look of the base color in some areas. I use a lot of water, treating these mixes like subtle watercolor washes. When dry, these colors will look darker than they do when applied, so you must use some restraint when painting them. This wolf is primarily a grayish-white, so I do not want to add too much color to the body.

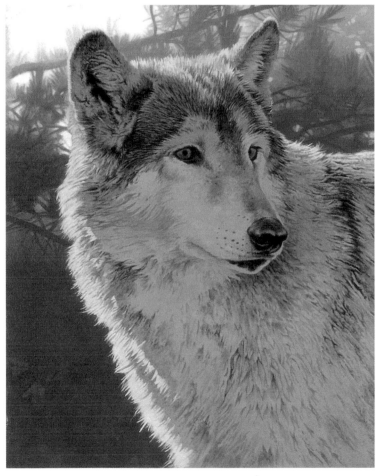

STEP SIX I establish the eyes with yellow ochre and add a cadmium yellow light wash around the wolf to warm the highlights. Then I paint the next darker value, adding cerulean blue where I want a more grayish-blue and adding more burnt umber where I want more intensity and warmth.

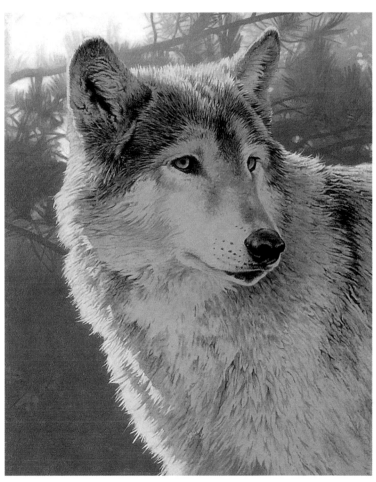

STEP SEVEN Now I've finished with the darker values. Next I apply yellow ochre washes to the head and chest, sometimes adding burnt umber and cerulean blue. For the eyes, which need subtle washes to make them look more realistic, I also add a tiny bit of white and cadmium yellow light.

Buff + white + cadmium yellow light

Burnt umber + cerulean blue + ultramarine blue + white + violet + dab of yellow ochre

More burnt umber + more cerulean blue + more ultramarine blue + white + violet + dab of ochre

Burnt umber + ultramarine blue + cerulean blue + violet + dab of buff

Burnt umber + cerulean blue + ultramarine blue + white + violet

More burnt umber + cerulean blue + more ultramarine blue + white + violet

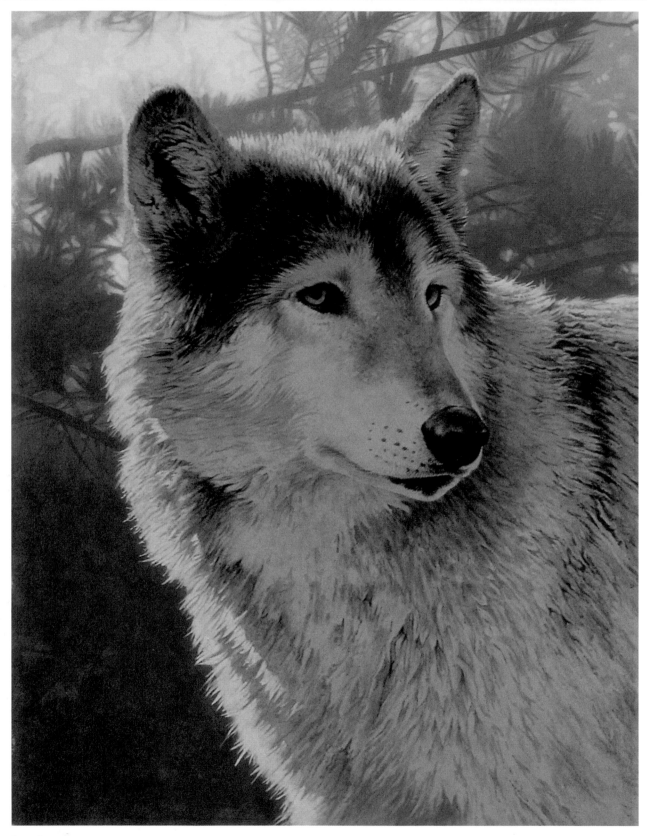

STEP EIGHT For more contrast, I emphasize the eyes, nose, and ears with a mix of cerulean blue, ultramarine blue, burnt umber, and violet. I start the wash above the eyes and between the ears, continuing over the base of the ear on the left. Next I use thicker paint to construct the darker areas. I continue adding the darker value throughout the wolf's head, applying washes for small changes and several coats of paint to cover really dark areas. Then I mix my darkest value—burnt umber, ultramarine blue, and violet—and apply it over the last wash.

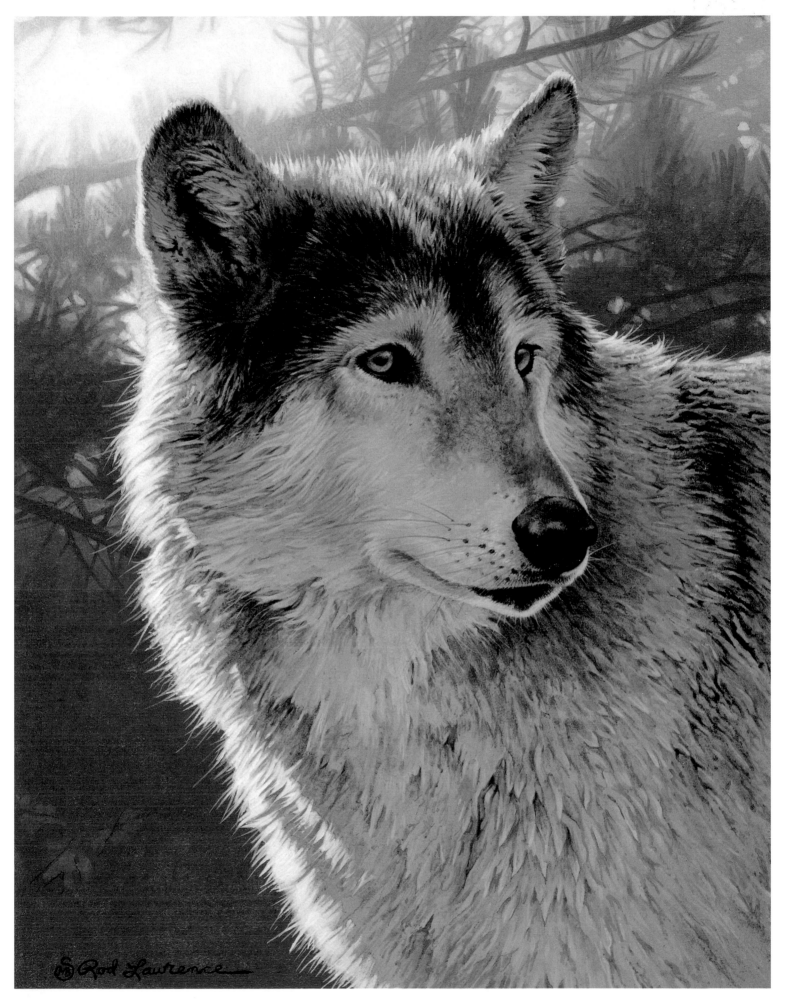

STEP NINE With a cerulean blue, yellow ochre, violet, and white mix, I punch up the detail of the fur tips around the eyes, in the cheek and muzzle, and on the chest. Next I use white with a hint of violet to paint the backlit edges, starting with washes and then switching to thick layers of paint. I drag the tip of my round brush into the background to create the finer hair highlights. Next I add the final details, beginning with washes of white tinted with yellow around the left ear. I also paint some darker and lighter fur in the cheek and throat area to emphasize contrast. I apply a bluish-purple tint on the nose; then I stroke in the fine, delicate whiskers.

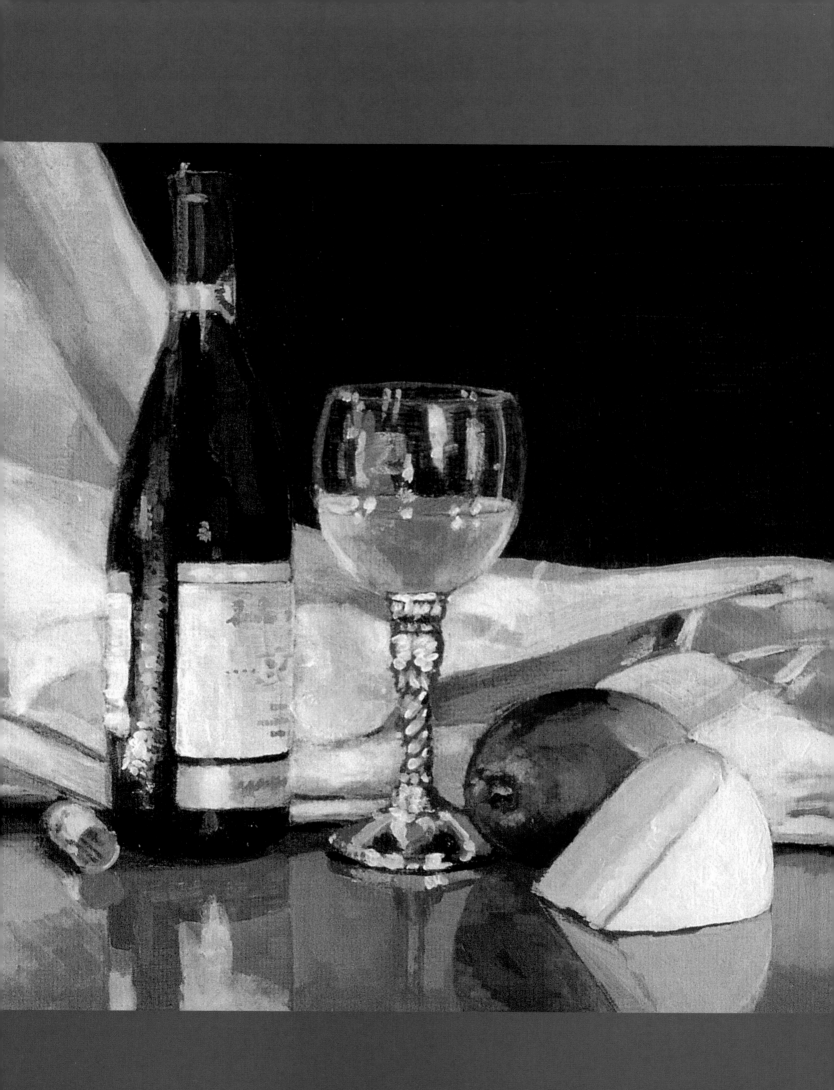

PAINTING WITH NATHAN ROHLANDER

Nathan Rohlander's bright, vibrant paintings have been featured in *Esquire* and *Shuz* magazines, on the cover of *Coast* magazine, in Super Bowl commercials, in numerous television shows, and even in MTV videos. Nathan was recently invited to exhibit his work at the Los Angeles Art Show; he made a splash in the southern California art scene with his highly acclaimed "Shoe Project"—a series of paintings focusing on feet and shoes for a unique perspective on the human figure. Nathan graduated with honors and a fine arts degree from the Art Center College of Design in Pasadena, California; he is currently working toward a master of fine arts at California State University, Long Beach. Nathan lives and works in Los Angeles, but he has spent considerable time in Europe, South America, and Asia, where he gained creative inspiration and refined his global perspective.

Japanese Tea Set

STEP ONE I begin by applying an even wash of water-diluted burnt sienna to the canvas with a large flat brush. When the underpainting is dry, I sketch in my composition with a pencil, placing the objects slightly off center. I also indicate the shadows cast by the teapot handles and the rough outline of the patterns on the tea set, wall, and tablecloth.

STEP TWO Painting from light to dark (see the detail on page 80), I add the lightest values to the sketch. I apply a mix of yellow ochre and titanium buff to the rims of the teacups, the spout and rim of the teapot, the flowers of the table-cloth, and the lightest parts of the placemat. Then I blend yellow ochre with titanium white to begin creating the bamboo grids on the wall.

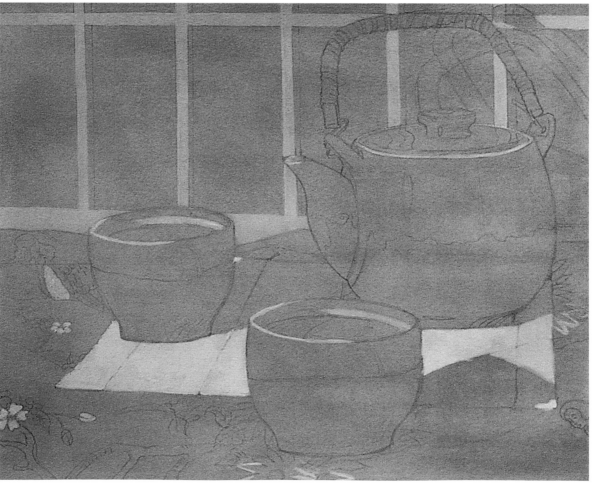

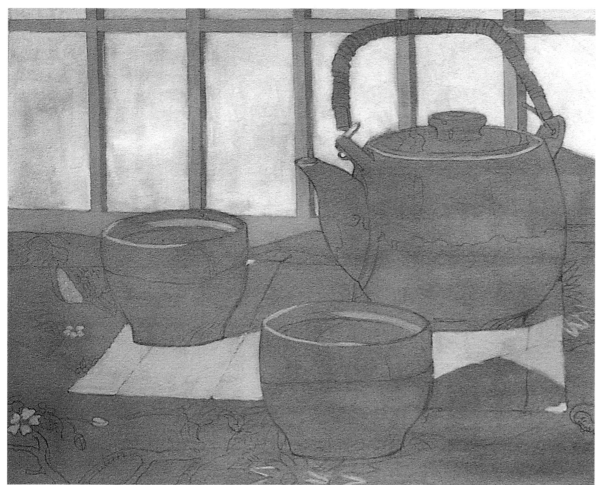

STEP THREE Switching to a medium flat brush, I build up the background by painting the negative spaces (see "Painting Negative Space" on page 80) with a mixture of titanium white, ultramarine violet, and acra violet. Then, using a small round brush, I apply additional layers of titanium white mixed with yellow ochre to bring out the color of the bamboo grids.

Tea Set Highlights
Yellow ochre + titanium buff

Light Background Values
Titanium white + ultramarine violet + acra violet

Shadow Highlights
Titanium white + ultramarine violet + acra violet + ultramarine blue

Shadow Midtones
Titanium buff + burnt umber

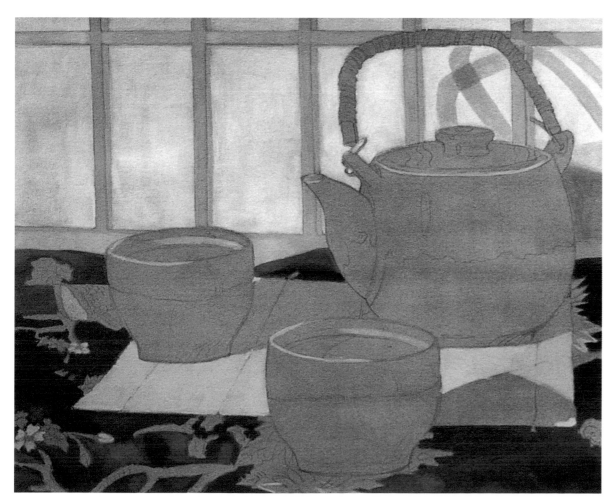

STEP FOUR After continuing to build up the background with variations of titanium white, ultramarine violet, and acra violet, I blend light and dark values of the same mixture for the cast shadows of the teapot handles. I quickly and loosely block in the reds of the tablecloth, still using a medium flat brush but with a mixture of cadmium red light and acra violet.

Tablecloth Midtones
Cadmium red light + acra violet

Tablecloth Darks
Cadmium red light + acra violet + burnt umber

Tablecloth Pattern Darks
Burnt umber + yellow ochre

Japanese Tea Set (CONTINUED)

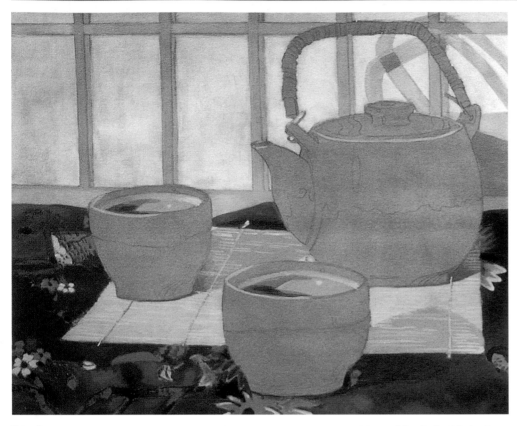

STEP FIVE Now I add details to the tablecloth, including the flowers, the branches, and the small face in the right-hand corner. I also bring out the pattern of the placemat by applying vertical strokes of titanium buff mixed with yellow ochre. I use titanium buff with hints of yellow ochre for the tea, and then I add shadows inside the teacups by applying titanium buff mixed with burnt umber and a little ultramarine blue. Using very faint dabs of titanium white, I add highlights to the tea, and I also lighten the cast shadows of the teapot handles.

Painting Negative Space In this painting, focusing on the negative space can be very helpful. (See page 28 for more on negative space.) If an object appears to be too complex or if you are having trouble "seeing" it, try squinting your eyes to blur the details so that you can see only the negative and positive spaces. You'll find that drawing the negative shapes around an object is sometimes a much easier way to create the edges of the object itself.

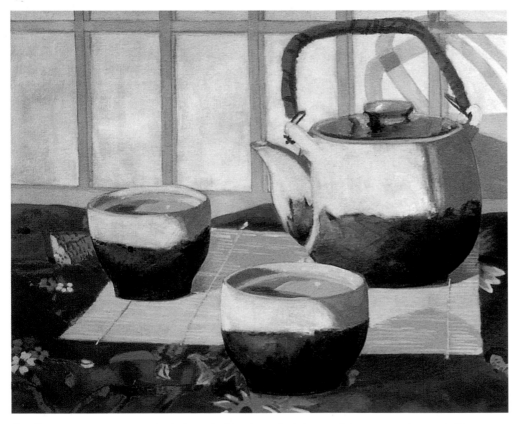

STEP SIX Using burnt umber mixed with ultramarine blue, I paint the dark areas of the teacups and teapot. I add water to this mixture to create the lighter values of the dark blue, giving dimension to the tea set. Next I use a mixture of titanium white and ultramarine blue for the light areas of the tea set, and I apply burnt umber to the handle of the teapot to darken it. With a small round brush, I intensify the shadows of the teacups with darker values of the yellow ochre and titanium buff mixture, also applying yellow ochre to emphasize the reflections in the tea.

Working from Light to Dark I break my subject down visually into three categories: dark values, mid-range values, and highlights. Then I establish these values in layers, painting from light to dark. Here, in the tablecloth, first I apply the lighter values of the branches and flowers; then I build up the darkest values—the reds—of the floral pattern last.

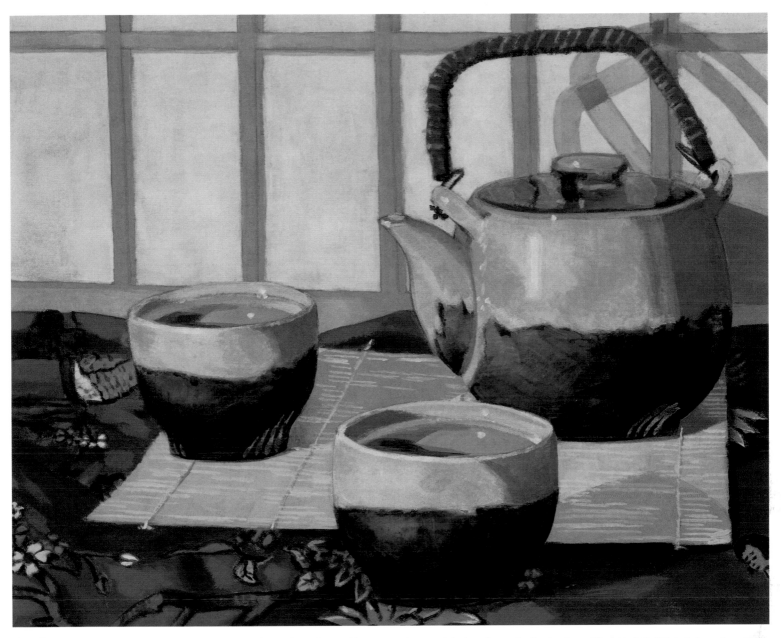

STEP SEVEN Finally I use a clean, dry, flat brush to blend and smooth out the transitions between colors. Then I bring out the highlights in the teapot and teacups and touch up the highlights in the lightest values of the tablecloth using titanium white. Next I use burnt umber to outline and refine the darkest values of the painting, including the dark areas of the tea and the branches on the floral pattern of the tablecloth. This technique of emphasizing my lights and darks ensures high contrasts of values for dramatic effect. I take one last look at the painting as a whole, making sure that the final values of the composition lead the eye on a path straight to the focal point. And then my painting is complete!

CREATING A VISUAL PATH

By planning the visual path that the objects in your composition will create ahead of time, you can help ensure that your painting will be successful. I often place objects in diagonal lines to lead the viewer's eye around the painting, and I avoid evenly spacing objects in a row, as horizontal lines tend to lead the eye out of the picture. I also make the objects relate to one another by overlapping them and staggering them on different planes.

Good Setup The still life setup to the left shows a good balance of elements of varying shapes and sizes. It also shows effective use of spatial planes and diagonal lines. The objects are overlapping one another, creating a dynamic composition that draws the viewer's eye in and around the painting.

Poor Setup This setup is an example of a poorly placed composition, with unimaginative lines and dull viewing angles. The objects are spaced evenly apart from one another, creating a horizontal line. And because the objects in this setup aren't placed at differing angles, the objects have no relation to one another.

SILVER PLATTER WITH FRUIT

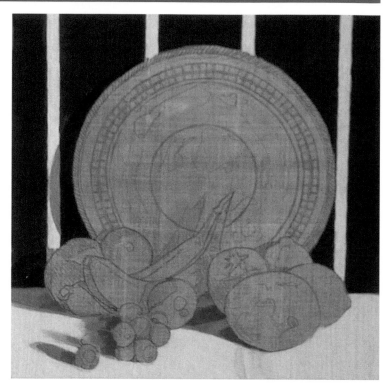

STEP ONE First I use a large flat brush to apply an even underpainting of water-diluted burnt sienna. After the paint is dry, I sketch the composition of the scene with a pencil, using my reference photos for accuracy. After sketching the fruit and silver bowl, I add the cluster of grapes to the left of center to create more visual interest.

STEP TWO With titanium white paint, I color the whites of the background stripes and the tablecloth. I fill the negative space with thick applications of cadmium red medium, using a medium flat brush. Next I begin work on the shadows, adding hints of ultramarine blue and burnt umber to a mix of burnt sienna, cadmium red medium, and titanium white.

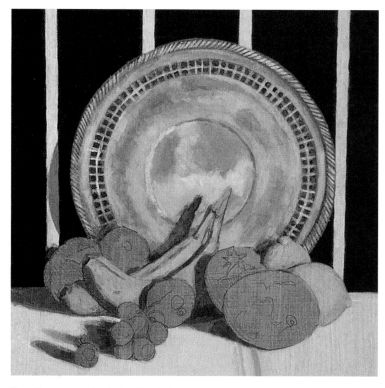

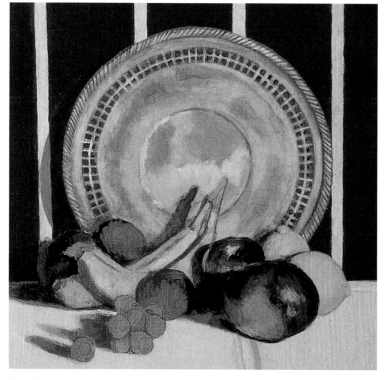

STEP THREE Now I begin detailing the bowl. First I simplify the shadows and highlights into basic shapes, creating a pattern of reflections. For the metal, I apply a mixture of titanium white, burnt umber, and ultramarine blue. I switch brushes and brushstrokes when painting the bowl to add variation. Then, using titanium white, I add dramatic highlights, finally bringing in some yellow ochre to give the metal an antiquated look.

STEP FOUR I begin developing the shadows of the fruit by blocking in their shapes, but I am careful to soften them around the edges. Next I begin painting the fruit: I use cadmium yellow medium, yellow ochre, burnt umber, and titanium white to paint the bananas and lemons. Then I apply a mixture of quinacridone crimson, cadmium red medium, burnt sienna, cadmium yellow medium, ultramarine blue, and burnt umber to the nectarines. For the limes, I mix brilliant yellow-green, medium green, and ultramarine blue; and for the grapes, I apply quinacridone crimson, cadmium red medium, ultramarine blue, burnt umber, burnt sienna, and titanium white. I paint the mango with a mixture of cadmium red medium, cadmium yellow medium, medium green, ultramarine blue, and titanium white.

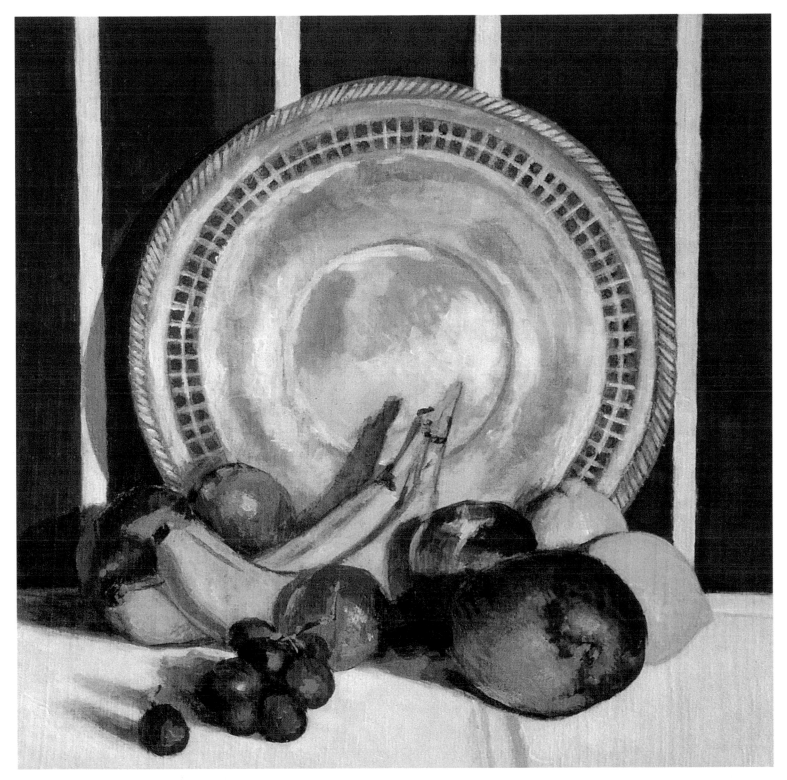

STEP FIVE Next, using a medium flat brush, I add loose applications of titanium white to the metal bowl, emphasizing the lightest areas. I want to show that the light source is coming from above, so I add quick strokes of titanium white to the upper halves of the surface of each piece of fruit. Then, using the edge of a small round brush, I finalize the mango, grapes, and limes, and I apply darker values to the shadows of the fruit and bowl. I am careful to maintain the crisp separations between the colors of each fruit, making sure that my blending is not smoothing the transitions between paints so much that the colors and lines become blurred. When I'm finished, I use my detail brush to trace along the edges of the fruit and clean up the outlines, sharpening the realistic qualities of the painting. Then I add final details to the stems of each fruit, paying close attention to the mango, as it is in the foreground of the composition and thus has the most detail. Finally I strengthen the darkest values of the painting, making the most of the play between light and shadow in the setup.

Wine and Cheese

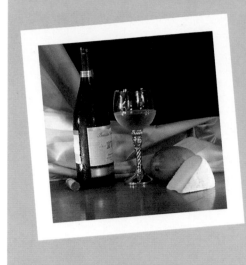

Using Dark Backgrounds
When painting complex forms and symmetrical objects like these, it is a good idea to use a dark background with a strong light source. This creates bright highlights that help the subjects stand out, so they don't blend into their surroundings.

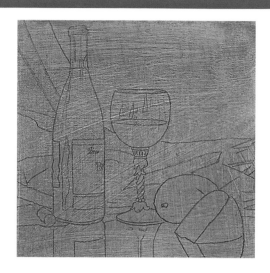

Step One First I use a large flat brush to tone the canvas with an even wash of ultramarine blue. Then I sketch the scene with a pencil, carefully mapping out the reflections and highlights on the wine glass, the wine bottle, and the wooden tabletop.

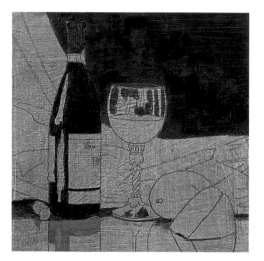

Step Two Next I paint the background using a mix of ultramarine blue, burnt umber, and titanium white. I use a mixture of quinacridone crimson, burnt umber, and ultramarine blue for the wine bottle; burnt sienna for the neck of the bottle and parts of the table; and yellow ochre for the reflections.

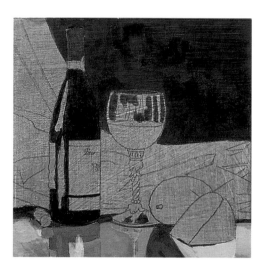

Step Three Using titanium white and burnt sienna, I block in the wooden tabletop, adding a little yellow ochre, cadmium red medium, and ultramarine blue to create the reflections. Using acrylic retarder while blending helps to keep my paints wet and smooths the color transitions.

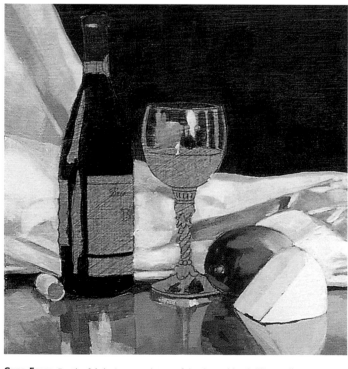

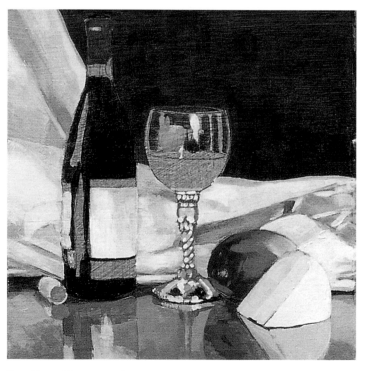

Step Four For the fabric, I use a mixture of titanium white, brilliant yellow-green, and cobalt blue. Then I mix cadmium red medium with cadmium yellow light for the mango, and titanium white with yellow ochre for the cheese. I apply ultramarine blue to build up the reflections in the glass.

Step Five With a mixture of ultramarine blue, burnt umber, and titanium white, I paint the stem of the wine glass, applying small touches of titanium white where I want to show the fabric behind the glass. Next I paint the label of the wine bottle using a thick application of pure titanium white.

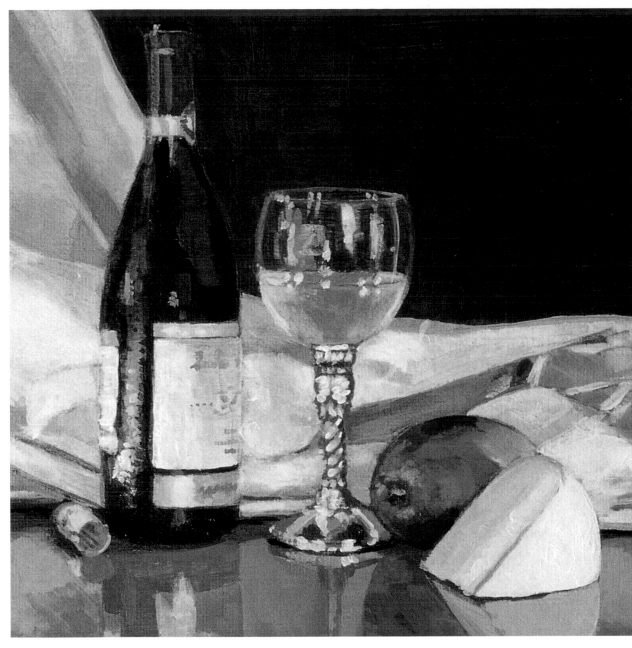

Light Fabric Values
*Brilliant yellow-green +
cobalt blue + titanium white*

Wine Bottle Highlights
*Brilliant yellow-green + cobalt
blue + titanium white + cadmium
yellow light + burnt umber +
ultramarine blue*

Wine and Cheese Highlights
*Titanium white +
cadmium yellow light*

Tabletop Midtones
*Titanium white +
burnt sienna*

Label Midtones
*Cadmium red medium +
burnt sienna + titanium
white + yellow ochre*

Label Darks
*Ultramarine blue +
quinacridone green +
burnt umber*

Shadow Values
*Ultramarine blue +
quinacridone green + burnt
umber + burnt sienna*

STEP SIX Finally I use a mix of cadmium yellow medium and titanium white to paint the wine in the glass, and I add a very diluted wash of burnt umber to the center of the glass to suggest depth. After the paint has dried, I refine the label on the bottle with heavier applications of cadmium yellow medium mixed with titanium white. I lightly suggest the lettering of the label using a small detail brush and variations of the following mixtures: ultramarine blue, quinacridone green, and burnt umber; and cadmium red medium, burnt sienna, titanium white, and yellow ochre. To build up the color of the cheese, I mix titanium white with cadmium yellow medium, then I add lighter values to the wine glass, fabric, and table to sharpen the focus and highlight the subjects.

Rendering Reflections
I paint the reflections on the wooden tabletop a little more loosely and with less detail; this is because the reflection of an object on a tabletop isn't as distinct as it would be in a mirror. I then load the brush and pull the color down from the reflected area. I maintain the symmetry, making sure the shapes of the reflections are consistent with the shapes of the bottle and glass.

MUMS IN GLASS VASE

Setting Up a Floral Still Life

When painting flowers—or any subject—it's helpful to follow the basic guidelines of good composition. For example, avoid placing the center of interest directly in the middle of the canvas; it is more interesting visually to set it slightly off center, as with these mums. And vary the sizes and angles of your flowers, so the eye is drawn into and around the painting. For added appeal—and to create contrast—this painting includes plenty of blue, the complementary color for the orange mums. As you can see, pairing complements this way makes your composition lively and vibrant!

Light Background Values
Titanium white + cobalt blue

Shadow Values
Ultramarine blue + titanium white + burnt umber

Flower Stem Midtones
Yellow ochre + chromium oxide green + brilliant yellow-green

Flower Petal Midtones
Cadmium orange + titanium white

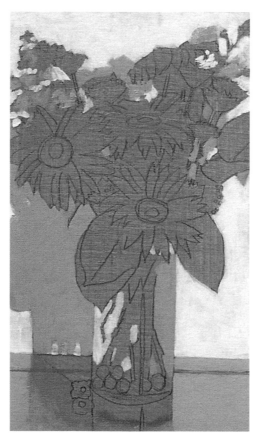

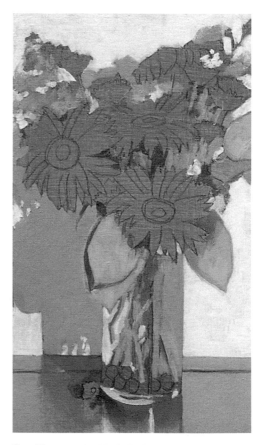

STEP ONE First I apply a diluted wash of ultramarine blue. Then I sketch the floral still life in pencil, being very careful to vary the shapes and sizes of the individual flowers while keeping in mind the shape of the bouquet as a whole. I also sketch the shape of the vase's reflection on the tabletop and the shapes of the flowers' shadows.

STEP TWO Next I apply thick layers of titanium white with hints of cobalt blue. With ultramarine blue, burnt umber, and titanium white, I paint the shadow shapes in and around the vase and flowers. I use a medium flat brush to paint the tabletop with a mixture of burnt sienna, yellow ochre, and titanium white.

STEP THREE With a blend of yellow ochre and chromium oxide green, I paint the stems of the flowers, working up into the leaves with the same mixture. I quickly dab green around the fallen flower on the table. Then I add streaks of titanium white to the bottom of the vase and the tabletop to suggest its shiny, reflective surface.

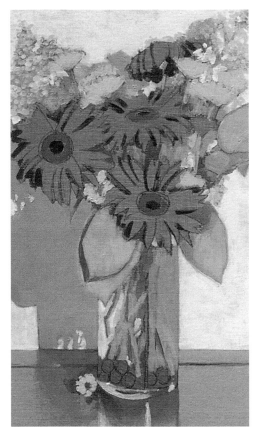

STEP FOUR Next I begin work on the smaller flowers, applying a mixture of yellow ochre, chromium oxide green, and brilliant yellow-green. Then, using a small round brush with a mixture of ultramarine blue, quinacridone crimson, and burnt umber, I create depth by painting the shadows of the darkest petals and their centers.

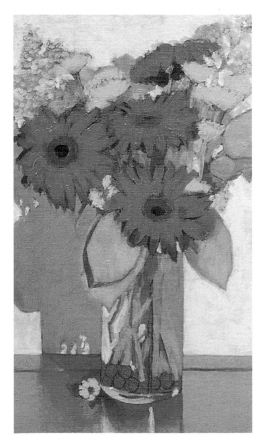

STEP FIVE For the large flowers, I apply cadmium orange mixed with a little quinacridone crimson and titanium white. I paint following the direction of the petals, stroking downward with my brush toward the tabletop. Then I darken the shadows around the large flowers with my previous mixture of ultramarine blue, quinacridone crimson, and burnt umber.

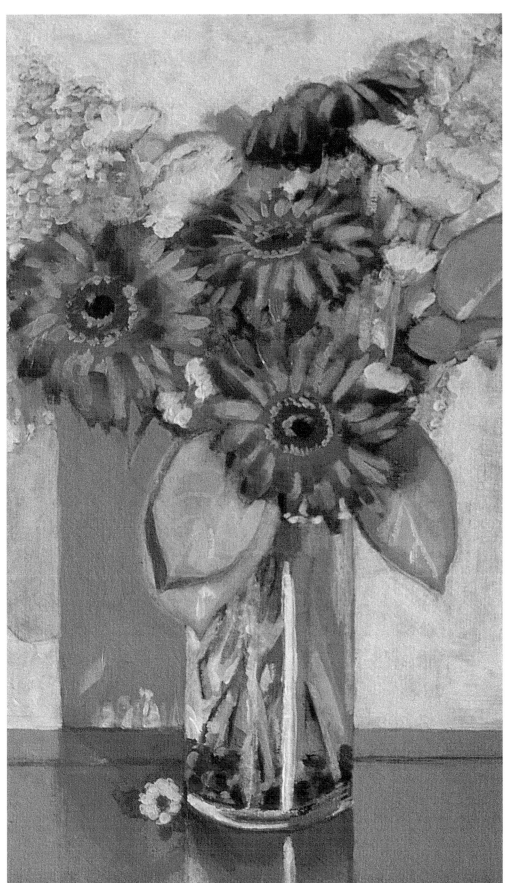

STEP SIX Using a medium round brush, I apply light tints of cadmium orange and titanium white to add highlights to the petals. I use bold applications of this lighter mixture and paint in the direction of the petal. I then emphasize the reflective surface of the tabletop by using different values of my previous mixtures of burnt sienna, yellow ochre, and titanium white. I darken the shadows on the table with the darkest values of this mixture. Finally I add highlights with layers of titanium white. My painting is finished when I am pleased with the final composition and the contrast of the warm-colored flowers against the cool blue background.

DAISY IN COBALT VASE

STEP ONE After using a large flat brush to evenly tone the canvas with a thin wash of ultramarine blue, I draw the composition. Using a straightedge, I create horizontal, sloping lines to suggest the baseboard and floor shadows. I block in the shadow of the glass bottle and apply lettering so that I'll have a guideline for my applications of paint.

Bottle Highlights
Titanium white + cobalt blue

Bottle Darks
Cobalt blue

Background Darks
Burnt umber + ultramarine blue

Daisy Midtones
Brilliant yellow-green + cadmium yellow light

Daisy Highlights
Cadmium yellow light + titanium white

Foreground Highlights
Titanium buff + titanium white

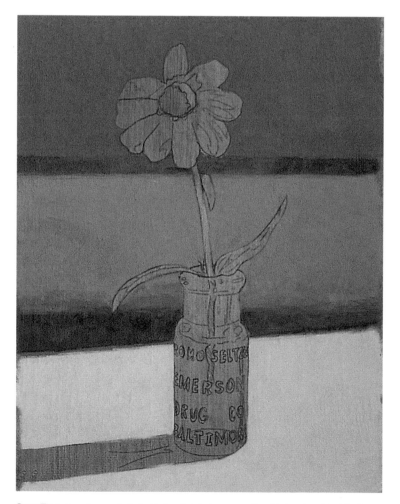

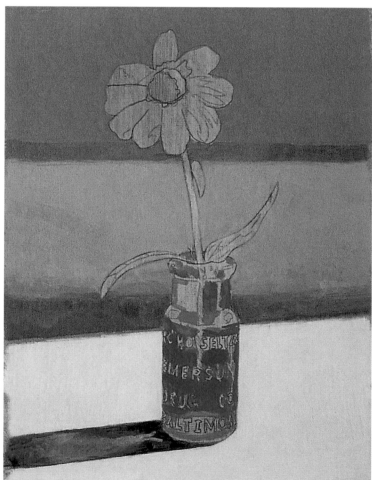

STEP TWO Once I am satisfied with the sketch, I use a medium flat brush to block in the foreground with a mixture of titanium buff and titanium white. For the upper half of the background, I mix burnt umber and ultramarine blue, adding titanium white to the mixture for the bottom half. I then create the shadows using a mix of cobalt blue, burnt umber, and titanium white, adding retarder to smooth out the transition between colors.

STEP THREE Next I build up the cast shadow near the bottle with cobalt blue, mixing in titanium white where I want to suggest that light is shining through the bottle. I then begin work on the bottle itself, using a small brush to apply bold applications of ultramarine blue for the dark values and cobalt blue for the lighter ones. I paint around the lettering on the bottle, around the highlight shapes, and around the stems in the bottle.

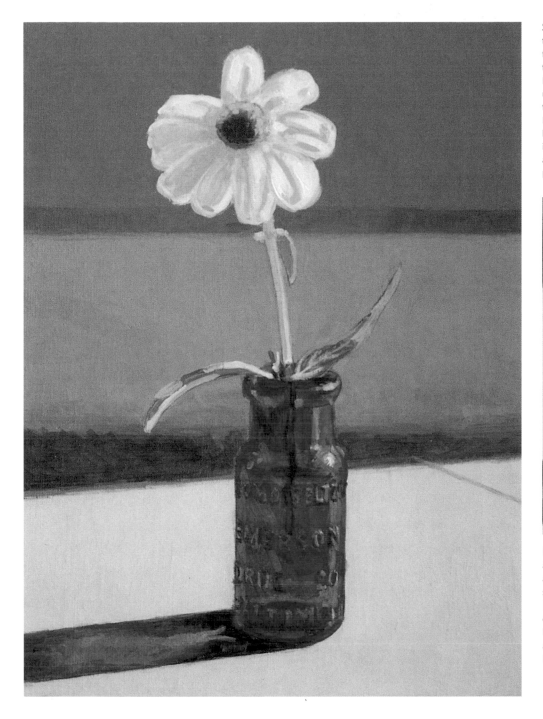

STEP SIX Finally I enhance the color of the petals and the highlights in the daisy's center and on the bottle surface using various light mixes of the following colors: titanium white, cadmium yellow light, and ultramarine blue. I apply pink to the daisy's petals using cadmium red medium mixed with titanium white, and I add the final details to the bottle using a small round brush and cobalt blue. I boost the highlights in the bottle's shadow by applying hints of titanium white to the previous layers. My painting is finished when I am satisfied with the attention the light and detail of the focal point receives against the cool, simple background.

Painting the Lettering As an artist, it is important to be able to give your paintings dimension and depth, as you are trying to re-create a three-dimensional object on a flat surface. After blocking in the embossed letters with white, I give them depth by painting dark to light. I start with a detail brush, applying darker values of cobalt blue to outline the letters. Then, once the paint has dried, I lightly dab a mixture of cobalt blue and titanium white over the letters, being careful to maintain their general shapes.

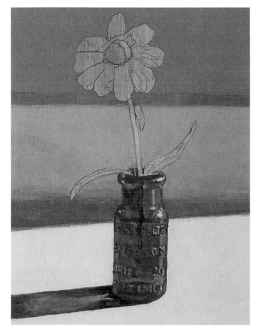

STEP FOUR Using a small round brush, I create the illusion of glass by adding highlights of titanium white to the blue of the bottle. By smoothly blending these white highlights with ultramarine blue and cobalt blue, I give the bottle its translucent quality. Still using the small round brush, I outline areas of the lettering with cobalt blue and ultramarine blue to give them dimension and depth. But I am careful not to add too much detail—I don't want to draw excessive attention to the glass.

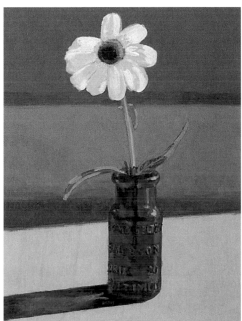

STEP FIVE Now I paint the stem of the flower using a mixture of brilliant yellow-green and cadmium yellow light. I add hints of ultramarine blue to the shadows on the leaves, and then I paint the daisy's petals using cadmium yellow light mixed with titanium white. With a mix of burnt sienna, quinacridone crimson, burnt umber, and cadmium orange, I create the shadow of the daisy's center. I switch to cadmium yellow medium mixed with cadmium orange and titanium white for the pollen's lightest values.

Garden Tools

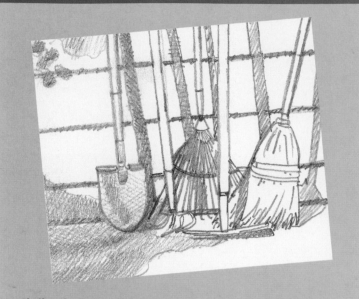

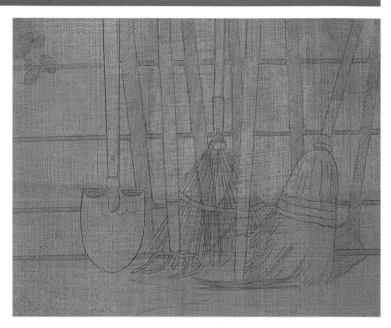

Finding the Focus I was instantly drawn to this everyday scene by the intriguing similarities among the disparate tools. While each tool has a very different shape, size, and purpose, the shadows that they cast on the shed are identically slender and vertical.

STEP ONE First I transfer my sketch to canvas, being careful to try to capture the patterns in the lines of each tool and their shadows, depicting as much detail in the sketch as possible. Then I cover the canvas with a thin wash of burnt sienna.

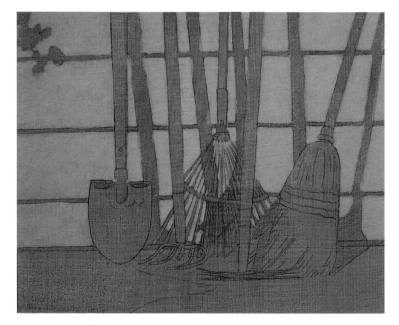

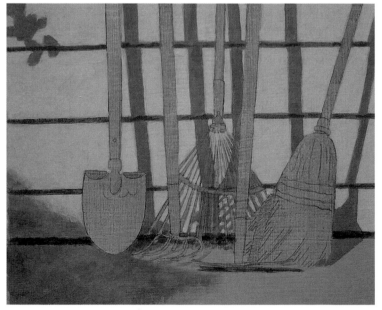

STEP TWO I then loosely apply a mixture of titanium buff, titanium white, and cadmium yellow light to the background with a medium flat brush, carefully painting the negative spaces—in this case, the spaces between the garden tools. I leave some areas of the canvas unpainted to represent the shadows cast by the tools and the panels of the shed.

STEP THREE Now, adding a little burnt umber to the cadmium yellow light, titanium buff, and titanium white mixture, I paint the cement. I blend burnt umber and ultramarine blue to build up the shadows of the tools, the image of the leaves in the corner, and the darker areas of the shed and cement. Then I use the same mixture for the lines between the shed's panels.

Broom Highlights
Titanium buff + cadmium yellow light

Metal Highlights
Titanium buff + burnt sienna + cadmium yellow light

Tool Handle Highlights
Titanium white + titanium buff + cadmium yellow light

Tool Handle Midtones
Titanium white + titanium buff + cadmium yellow light + burnt umber

Tool Handle Greens
Titanium buff + burnt sienna + cadmium yellow light + cobalt blue

Tool Handle Blues
Titanium buff + burnt sienna + cadmium yellow light + cobalt blue + titanium white

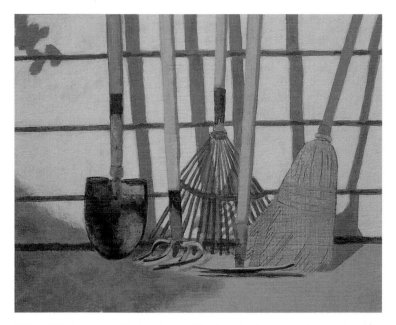

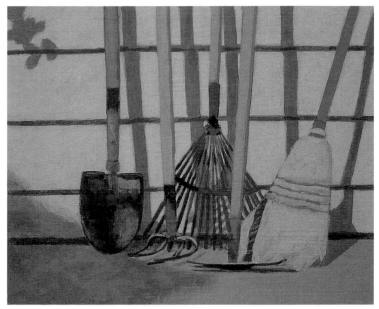

STEP FOUR To create the illusion of metal, I blend titanium buff, burnt sienna, cadmium yellow light, and cobalt blue, applying the paint with quick brushstrokes. I use variations of this mix for each of the tools, adding burnt sienna for rust. I then blend titanium buff, burnt sienna, cadmium yellow light, cobalt blue, and titanium white for the broom's details.

STEP FIVE Still using a small round brush, I use a mixture of cadmium yellow light and titanium buff to paint the broom. I paint downward with quick brushstrokes to create the broom's brush, being careful to paint around the blue stitching of the broom. Next I deepen the shadows on the rake and broom with variations of burnt umber and burnt sienna.

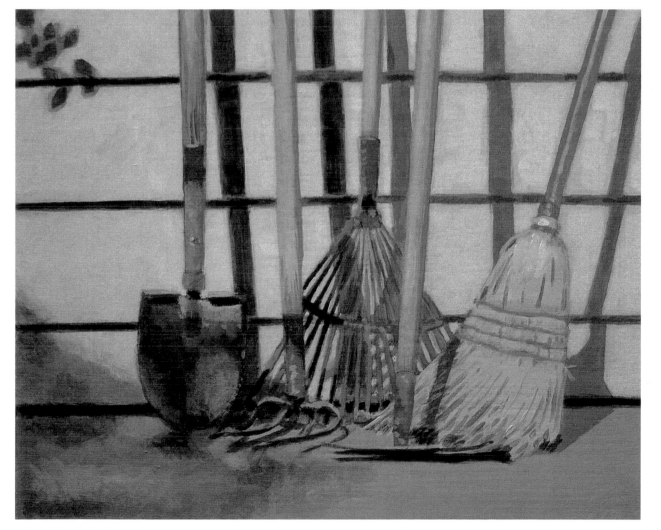

STEP SIX Now I bring out the darkest values in the composition by adding mixtures of burnt umber and ultramarine blue to the shadows. I use a small brush to add details to the handles of the tools, applying dabs of burnt sienna to suggest the wood of the shovel's handle. Next I boost the highlights in the metal and the handles of the tools by touching on titanium white with a small round brush. I blend a thin application of titanium white mixed with titanium buff to the shed to emphasize the light source. Then I stand back from my painting and make a few minor refinements to harmonize the color and the details.

RUBY SANDALS

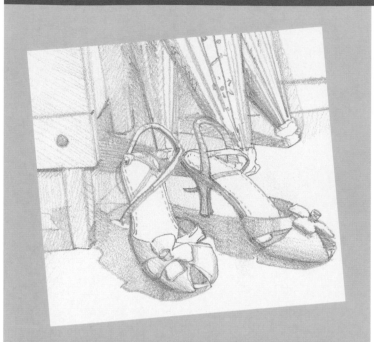

Starting with a Sketch When setting up a composition, some artists make quick, rough sketches to establish the basic shapes of a setup. But I prefer to take my time to carefully duplicate the details of this scene, paying attention to changes in value so as to provide a "map" for the subsequent layers of color.

STEP ONE After transferring my sketch to the canvas, I create an underpainting with a large brush and an evenly distributed, very thin wash of ultramarine blue. Then I carefully block in the shapes of the shadows cast by the shoes and the umbrellas with a deeper, more dramatic layer of ultramarine blue.

STEP TWO Mixing ultramarine blue, burnt umber, and titanium white, I paint the carpet with a medium flat brush. I blend light and dark values of the resulting gray and use retarder to slow the drying time of the paint. With the darkest grays, I block in the shadows cast by the shoes, the umbrellas, and the chest of drawers onto the carpet. Then I build up the shadows of the umbrellas by mixing burnt umber and titanium buff.

STEP THREE With titanium white, cadmium yellow light, and titanium buff, I paint the umbrellas, stroking downward with my brush to create the folds of the material. I then apply a mix of burnt umber and titanium white to emphasize the folds, and I thickly paint the tips of the umbrellas with pure titanium white. I bring out the darkest values of the shadows, carefully leaving the appropriate spaces unpainted to show the light source coming from above.

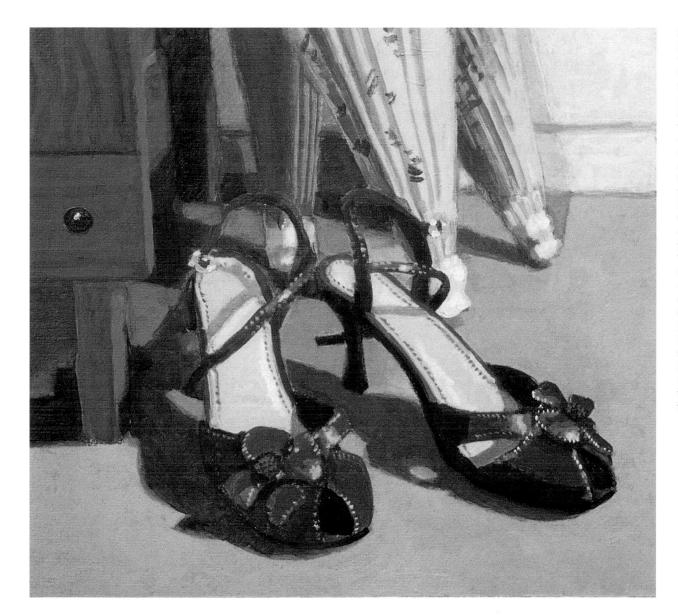

STEP SIX Finally I add hints of titanium white to the deep burgundy, again indicating the direction of the light source. I then use a detail brush to apply small dots of a lighter value of the mixture of quinacridone crimson, cadmium red medium, and burnt sienna along the edges of the soles of the shoe. With the same brush, I switch to pure white and apply small dots along the edges of the shoes and their straps. Then, using cadmium red medium mixed with titanium white and a few dabs of burnt umber and burnt sienna, I suggest a floral pattern on the umbrellas. I continue to darken the shadows and bring out the highlights of the painting until I am satisfied with the contrast of color in the composition.

STEP FOUR Next, with a mixture of quinacridone crimson, cadmium red medium, and burnt sienna, I paint the chest of drawers. I mix quinacridone crimson and ultramarine blue to create the shadows of the wood, and switch to burnt sienna for the knob. I paint the insoles of the shoes with a mix of cadmium red medium and titanium white, adding red to the white in small increments to create the soft pink color. I highlight the shoes with dabs of pure white.

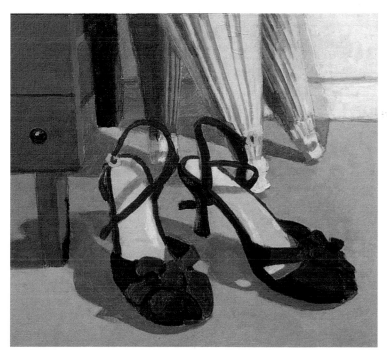

STEP FIVE Now I block in the burgundy color of the shoes and shoe straps using a mix of quinacridone crimson, cadmium red medium, and burnt sienna. For the shadows, I add more quinacridone crimson to the previous mixture. With a small round brush, I outline the floral shapes of the shoes using darker values of quinacridone crimson, cadmium red medium, and burnt sienna, being careful to ensure that the flowers retain their crisp shape and form.

BIRDHOUSE

STEP ONE First I apply an even wash of ultramarine blue to the canvas. Then I sketch the birdhouse and trees. Using a photograph of the scene as a reference, I take my time to re-create the details of the birdhouse. At this stage, I can just loosely sketch the shapes and placement of the leaves, rather than render them exactly. I spend more time on the tree branches, drawing thin parallel lines to represent pine needles.

STEP TWO Next I use a medium round brush and a mixture of burnt umber, titanium buff, and ultramarine blue to block in the shapes of the birdhouse shadows and the leaves behind and below it. I don't have to worry about precision when blocking in the shadows of the leaves, as I want the foliage to appear blurry and a little out of focus. I am more careful with the dark areas of the birdhouse, using smooth, steady brushstrokes.

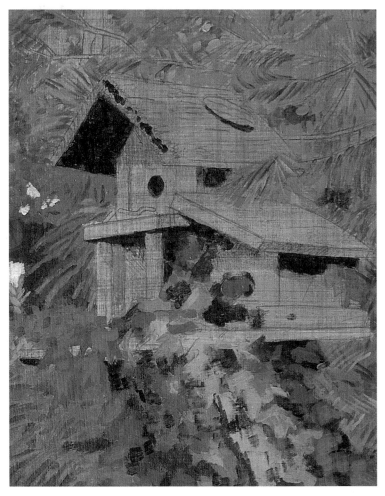

STEP THREE Now I begin creating the variations of green for the leaves. For the darkest values of the ivy, I use a mix of cadmium yellow light and ultramarine blue, blending the paint with titanium white as I apply it to the lighter areas of the ivy. For the pine needles, I use chromium oxide green and brilliant yellow-green, and I apply the paint using quick, thin brushstrokes. I then use small amounts of titanium white to block in the clouds to the left.

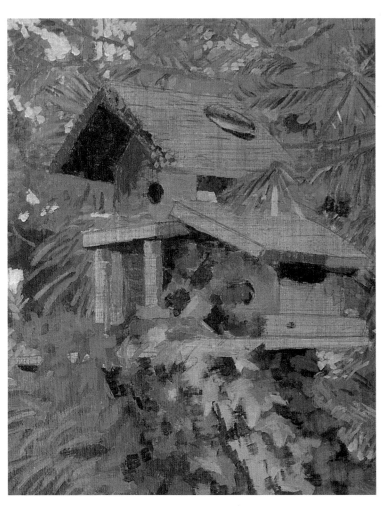

STEP FOUR I continue to build up the foliage by applying brushstrokes with a small round brush. I make sure that there is a strong contrast between the leaves by using different brushwork for each: quick strokes for the pine needles and longer, sweeping strokes for the ivy. I then stipple dots of titanium white on the areas of the background that can be seen through the trees. Finally I mix burnt sienna and titanium buff to paint the leaves that have fallen on the birdhouse.

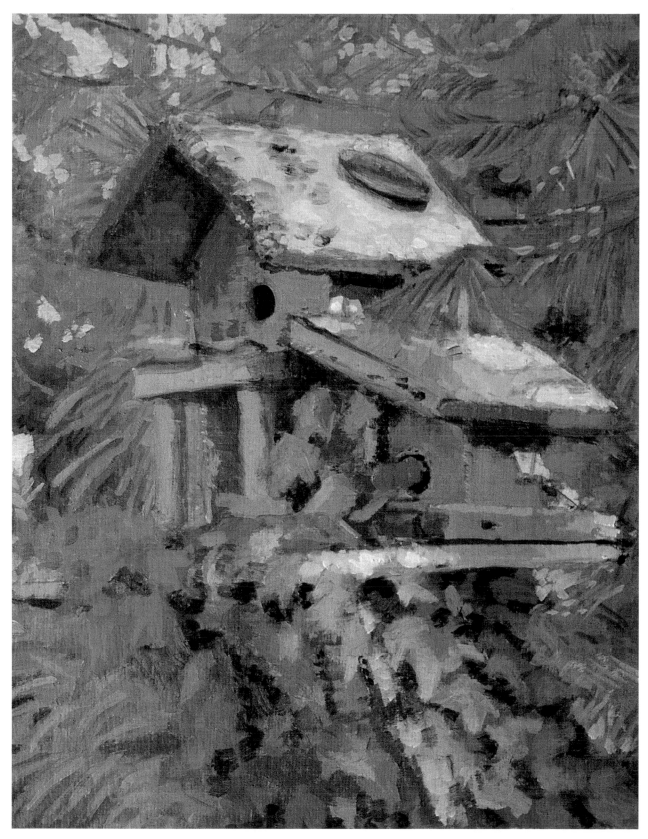

Foliage Highlights
*Brilliant yellow-green +
chromium oxide green*

Foliage Midtones
*Brilliant yellow-green +
burnt umber*

Foliage Darks
*Chromium oxide green +
cobalt blue*

Foliage Shadows
*Ultramarine blue +
brilliant yellow-green +
chromium oxide green*

Birdhouse Highlights
*Burnt umber + ultramarine
blue + titanium white +
cadmium yellow light*

Birdhouse Midtones
*Burnt umber + ultramarine
blue + titanium white*

Shadow Darks
*Burnt umber + ultramarine
blue + titanium buff*

STEP FIVE Next I block in the colors of the birdhouse, switching to a medium round brush to apply a mixture of burnt umber, ultramarine blue, and titanium white, which will bring out the highlights. I am careful to show that the light is coming from the right by adding the most dramatic highlights and lightest values to the right side of the birdhouse, while darkening the shadows to the left. This high contrast between light and shadow makes the composition more realistic, and it really allows the birdhouse to stand out from its surroundings!

Kitchen Scene

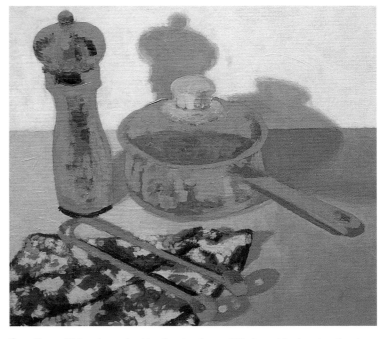

STEP ONE First I cover the canvas with a thin coat of burnt sienna. I begin drawing a rough outline of the setup, noting the proportions of the objects and faithfully drawing their different heights. I then block in the shapes of the shadows the objects cast on the wall and tabletop. I also begin to define the areas of reflection in the metal objects.

STEP TWO With a mixture of titanium white and titanium buff, I color the background. To paint the tabletop, I use a mix of cadmium yellow medium, ultramarine blue, and titanium buff. I then render the shadows using a mix of burnt umber and ultramarine blue, carefully leaving two small circles in the shadow of the tongs, where the light is shining through.

STEP THREE Next I develop the dark areas of the metal objects, mixing ultramarine blue with burnt umber. I add patches of cadmium red medium to the pepper grinder and pot to suggest reflections of the patterned dishcloth. When painting the dishcloth itself, I paint the background of the dishcloth with cadmium red medium; then I paint the flowers with a mix of titanium buff and cadmium yellow light, adding titanium white to bolster the highlights.

STEP FOUR Mixing ultramarine blue, burnt umber, and titanium white, I create a foundation for the metal objects. I take great care to paint around the areas of the pot and grinder that have been designated as reflective areas. I then detail the shape of the pepper grinder and the handle of the pot with lighter values of the previous mixture, and I paint the knob on the lid of the pot with cadmium yellow light mixed with titanium white.

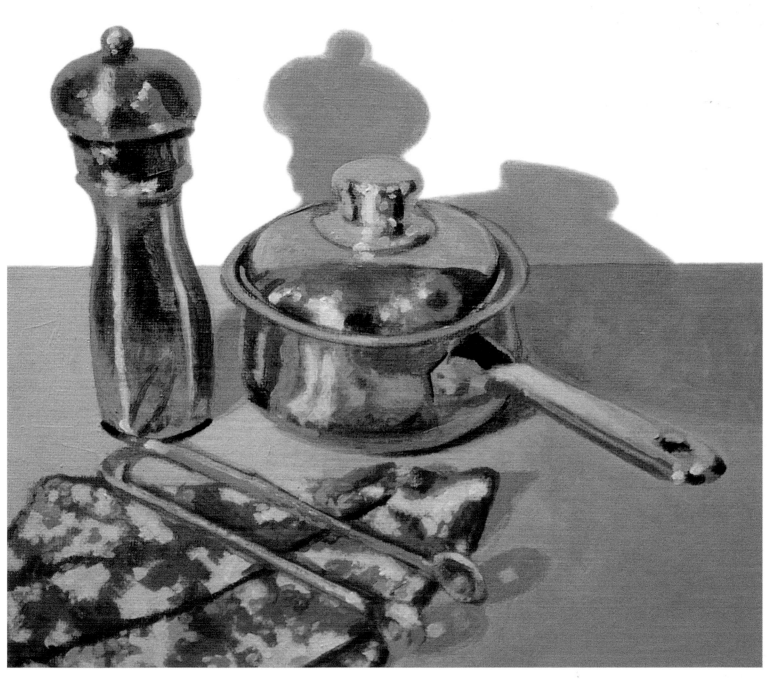

STEP FIVE Now I add embellishments to the reflective areas by applying more coats of a mixture of ultramarine blue, burnt umber, and titanium white to the surfaces of the pot, pepper grinder, and tongs. I then add patches of titanium white to the areas that I want to sparkle the most, but I am careful not to overpower the darkest areas. Notice that I use titanium white straight from the tube, layering it on top of the foundation mixtures. I add dark values to the lid and handle of the pot and the tongs, emphasizing the reflective qualities of both and making them shine. With a detail brush, I darken the shadow lines cast by the tongs onto the dishcloth using a mixture of burnt umber and ultramarine blue. I then refine the details of the dishcloth, adding touches of titanium white and titanium buff to pull out the lightest values of the floral pattern. Then my painting is finished!

Distorting Objects

If the tongs were placed in front of a flat mirror, I would paint an exact replica of them for their reflection. But the pepper grinder the tongs are reflected in is curved, so instead I paint two curved lines that show a distorted reflection. When adding the reflection of the dishcloth to the grinder, I eliminate the details and instead apply splotches of red and white.

Metal Darks
Burnt umber + ultramarine blue + titanium white

Metal Midtones
Ultramarine blue + titanium white + burnt umber

Reflection Midtones
Ultramarine blue + titanium white

Light Background Values
Titanium buff + titanium white

Shadow Values
Burnt umber + ultramarine blue

Tabletop Midtones
Titanium buff + ultramarine blue + cadmium yellow medium

Dishcloth Highlights
Cadmium yellow medium + titanium white

Dishcloth Midtones
Cadmium red medium + titanium buff

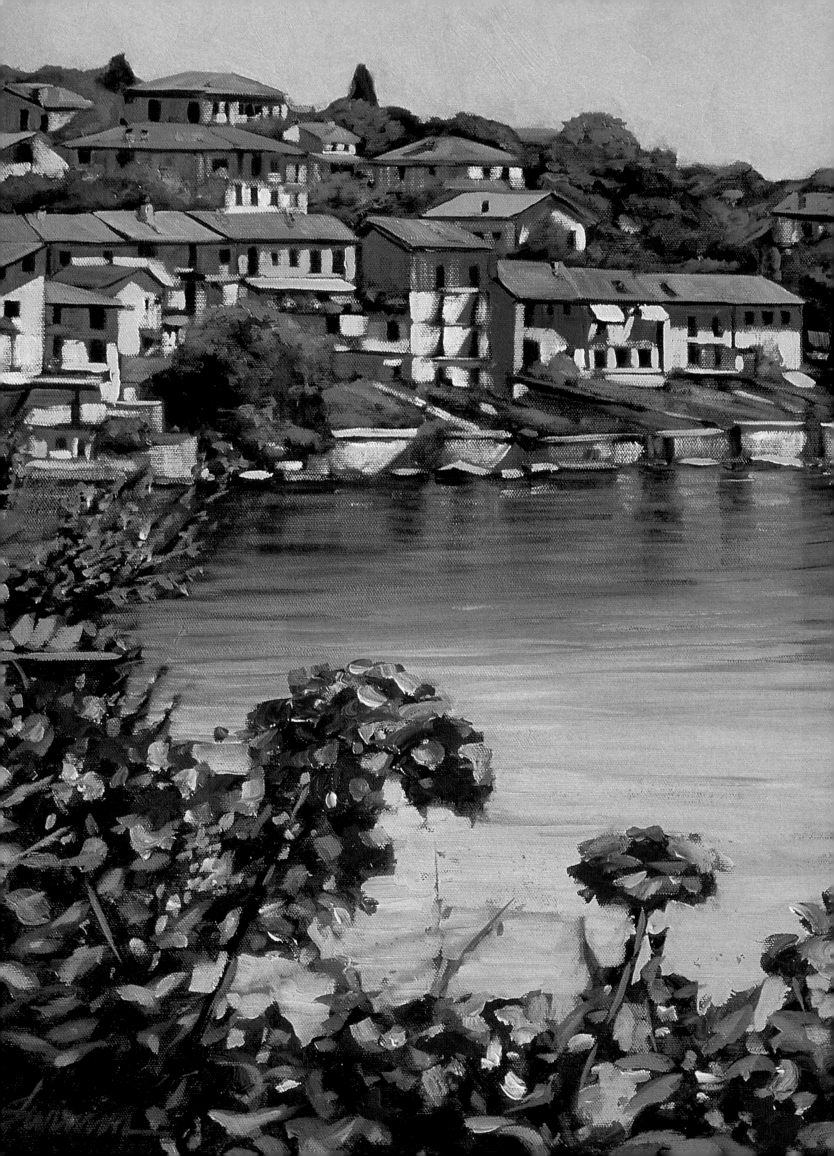

PAINTING WITH
TOM
SWIMM

Tom Swimm has felt an instinctive need to paint since his early childhood. A self-taught artist, his inspiration comes from the work of Van Gogh, Monet, and Hopper, whom he considers his teachers. Tom's first one-man exhibition was at the Pacific Edge Gallery in Laguna Beach, California. His work has been displayed in several California galleries, at ArtExpo New York, and at the APPAF Exhibition in Paris, France. Tom's paintings have appeared on the covers of Skyward Marketing's in-flight magazine and *Artist's Magazine*. And his work is currently featured in five Walter Foster Publishing titles. In the past, Tom has been awarded the People's Choice award at Echoes and Visions and the Art of California Gold Award. Born in Miami, Florida, and raised in New York, Tom currently resides in San Clemente, California.

Doorway

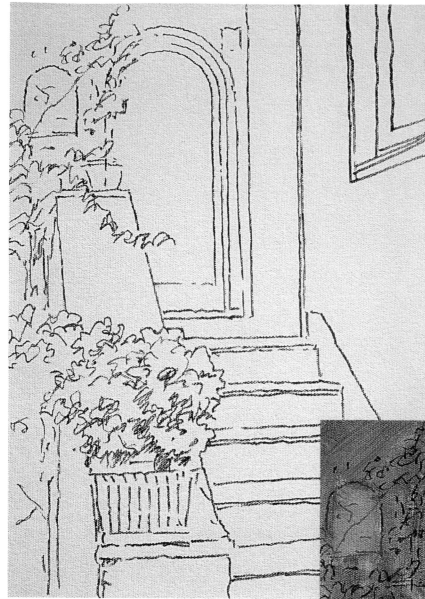

STEP ONE Using a photo as a reference, I create my sketch by outlining the most important shapes on my canvas with a permanent marker. Because I will be unifying the painting with several layers of glazes, I decide there is no need for a solid underpainting.

STEP TWO I dip a medium flat sable brush into acrylic glazing medium and load it with paint thinned with water. I use dioxazine purple, burnt sienna, raw sienna, deep magenta, and light blue-violet to fill in each shape with color. As I work, I blend the paint hues into one another for soft edges.

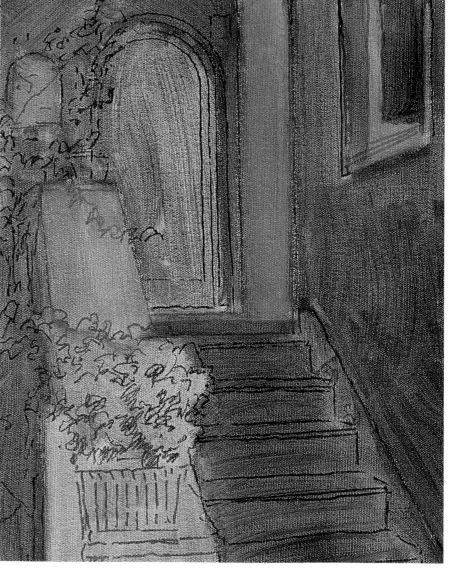

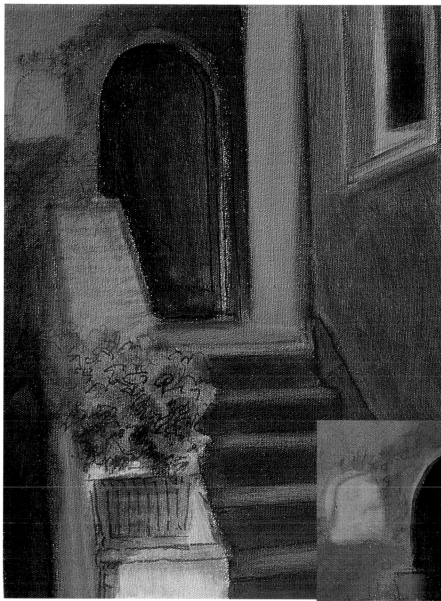

STEP THREE Acrylic dries quickly, so I don't have to wait long before I can begin applying glazes. I add another layer of deep magenta to the walls, some raw sienna to the flower pot, and a mixture of burnt sienna and Payne's gray to the stairwell and the window. With each successive layer, I bring out more details and intensify the color.

STEP FOUR Now I build the shadows by continuing to glaze with thicker paint. I concentrate on using warmer earth tones here to contrast with the cooler shades of purple. I darken and add a little definition to the doorway, adding shadows with a warm, rich burnt sienna glaze. I do the same for the bottom of the steps and the left side of the wall.

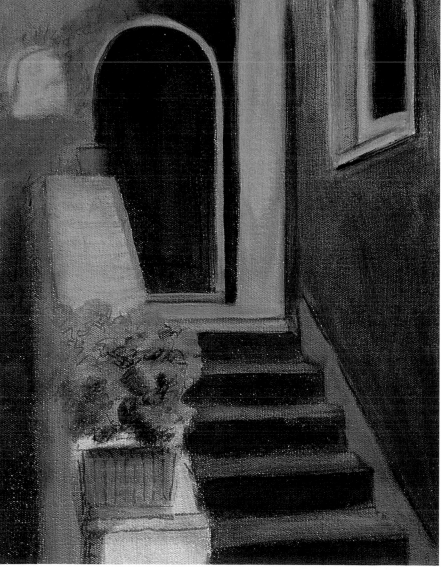

Doorway (CONTINUED)

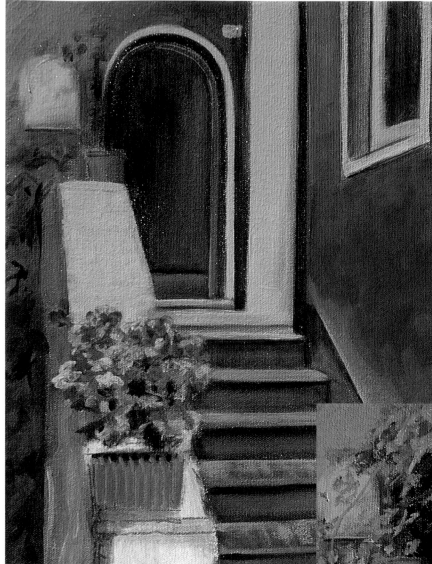

STEP FIVE To harmonize the composition, I add a thin glaze of raw sienna mixed with cadmium red light to the wall on the right. I blend the color into the underlying layer, varying the direction of the brushstrokes for interest and texture. Then I lighten the banister and base of the wall with a mixture of light blue-violet and raw sienna. I also use this mixture to drybrush the tops of the stairs and to outline accents. Next I add color to the flowers using various mixtures of phthalo green, emerald green, cadmium red light, and Naples yellow. Then I begin to define the foliage on the left with the flat side of the brush.

STEP SIX With a mix of cadmium red light and raw sienna, I glaze the top of the right wall, blending down into a darker mixture of dioxazine purple, light blue-violet, and deep magenta. Next I mix a few variations of greens and blues for the foliage along the left side and apply it in quick dabs. I create several mixes to paint the flowers, using varied proportions of cadmium red light, magenta, and Naples yellow. Then I apply a layer of highlights to the walls and banister with Naples yellow, using thicker paint and adding some areas of drybrush to create a light, impressionistic feeling.

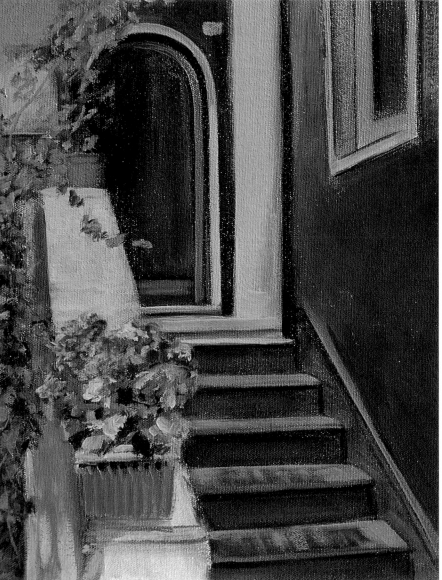

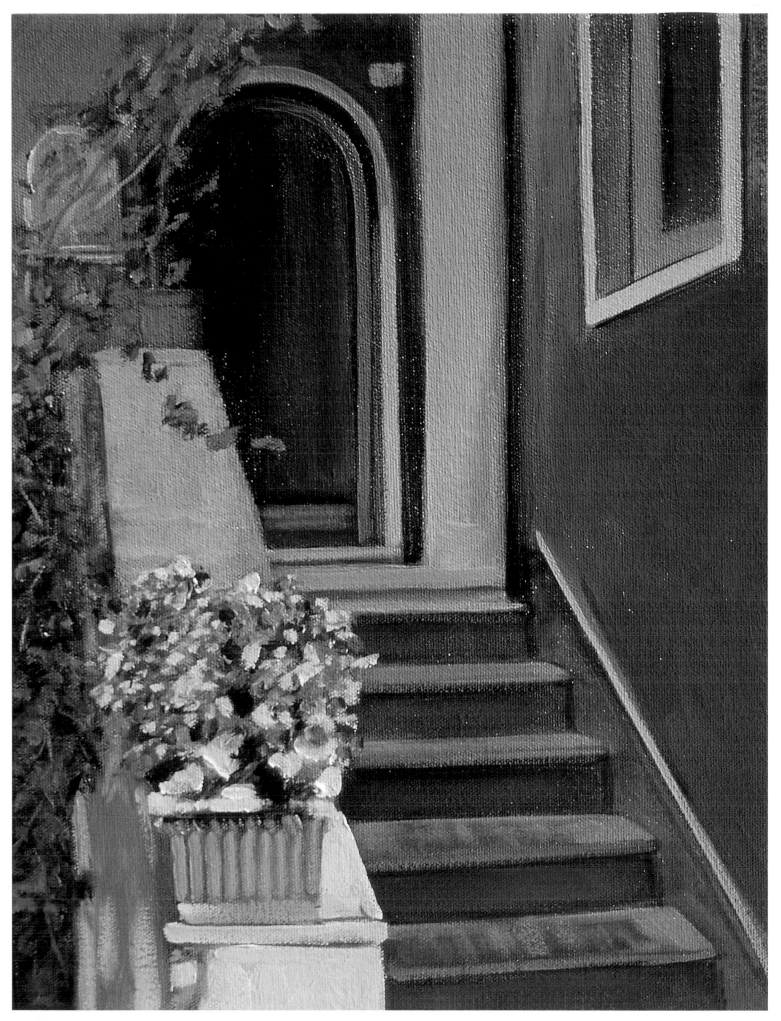

STEP SEVEN At this stage, I apply the thickest layers of paint and the final embellishments. I sharpen the details on the doorway, window, and flower pot, and I add a dioxazine purple glaze to the upper-left corner to dull the area so that it doesn't compete with the visual focus of the flowers. Then I add the brightest highlights in the flowers with a mix of white, cadmium yellow light, and Naples yellow. A few random dabs of color complete the composition.

Floral Bouquet

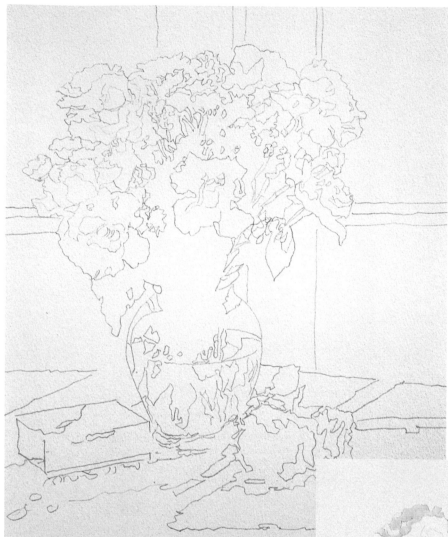

STEP ONE Because I will be painting only with thinned acrylic paints, I choose a sheet of 140-lb watercolor paper. Using a photograph for reference, I draw the scene lightly with pencil so it won't show through the final washes. I am careful to outline the most important shapes and details, such as the highlights and curves within the petals.

STEP TWO I decide to leave some high-lighted areas free of any paint so the white of the paper can serve as the highlights. I secure the paper on all sides to a drawing board with masking tape and apply liquid frisket over all future highlights. (See page 15 for more information about using liquid frisket.) Then I can paint freely, knowing the mask is "saving" the whites.

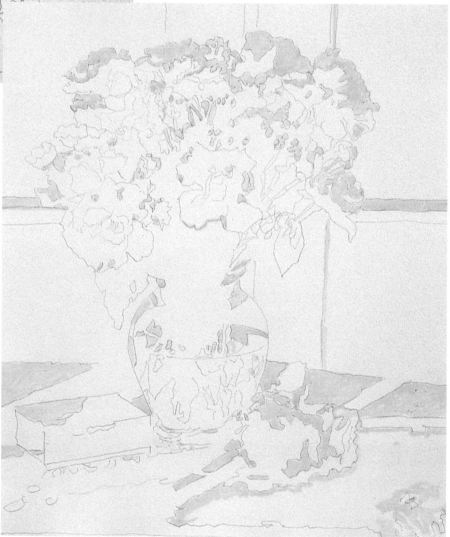

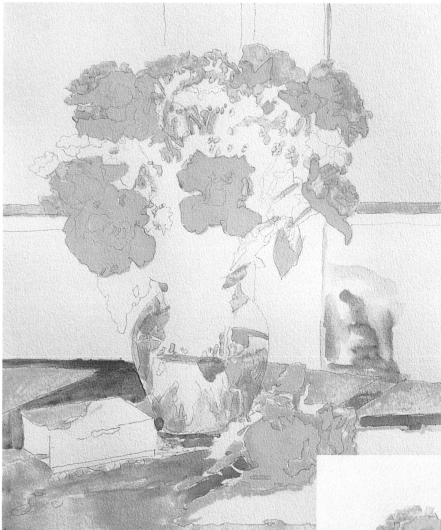

STEP THREE To maintain the look of watercolor, I use only water to make the paint flow, and I build up transparent layers from light to dark. I begin by applying a thin wash of color to the roses using a medium flat sable brush loaded with cadmium yellow light. After rinsing out the brush, I apply a wash of light blue-violet to the tablecloth, vase, and lower-right portion of the background.

STEP FOUR Next I paint the dark purple areas in the flowers and vase with dioxazine purple and light blue-violet. Using a thin wash of raw sienna and burnt sienna, I define the shapes of the window frame and music box. To add depth, I apply another layer of color in the shadow areas of the tablecloth and the roses with raw sienna thinned with water.

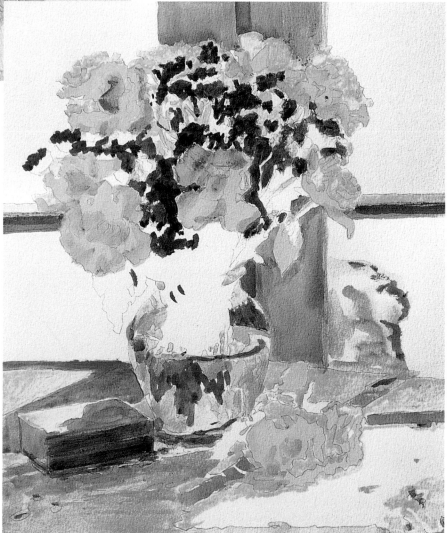

FLORAL BOUQUET (CONTINUED)

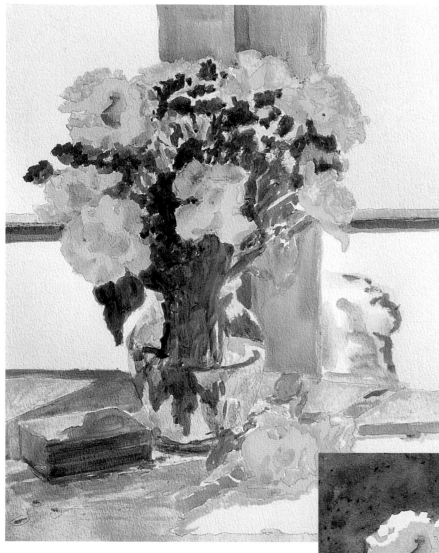

STEP FIVE Now I introduce green to the painting. I use pure phthalo green for the stems; then I mix a bit of raw sienna and cadmium yellow light with emerald green for the leaves and the highlights in the stems. At this point, each color that I add brings a greater sense of depth and dimension to the painting.

STEP SIX Since the focus of this painting is the foreground objects, I am not too concerned with detail in the background. I apply purple dioxazine to the top of the background. Then I move down into a mix of emerald green and phthalo green with a touch of dioxazine purple and white, muting the colors with a little Payne's gray. I keep the paint loose and transparent for a softer effect, and I achieve a watercolor look by pulling the colors into one another while still wet. With the largest areas of color established, I let the paint dry and then remove the frisket from the highlights with rubber cement pickup. (You can also use a kneaded eraser or your finger.)

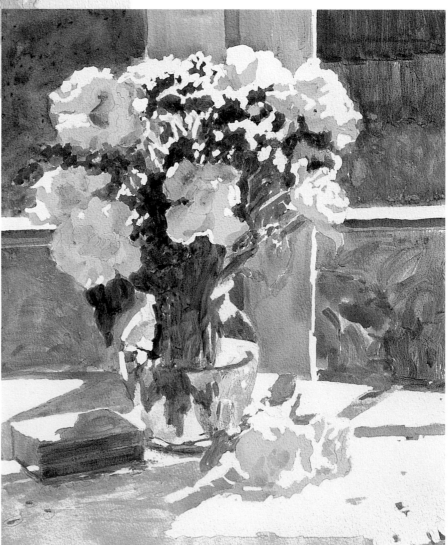

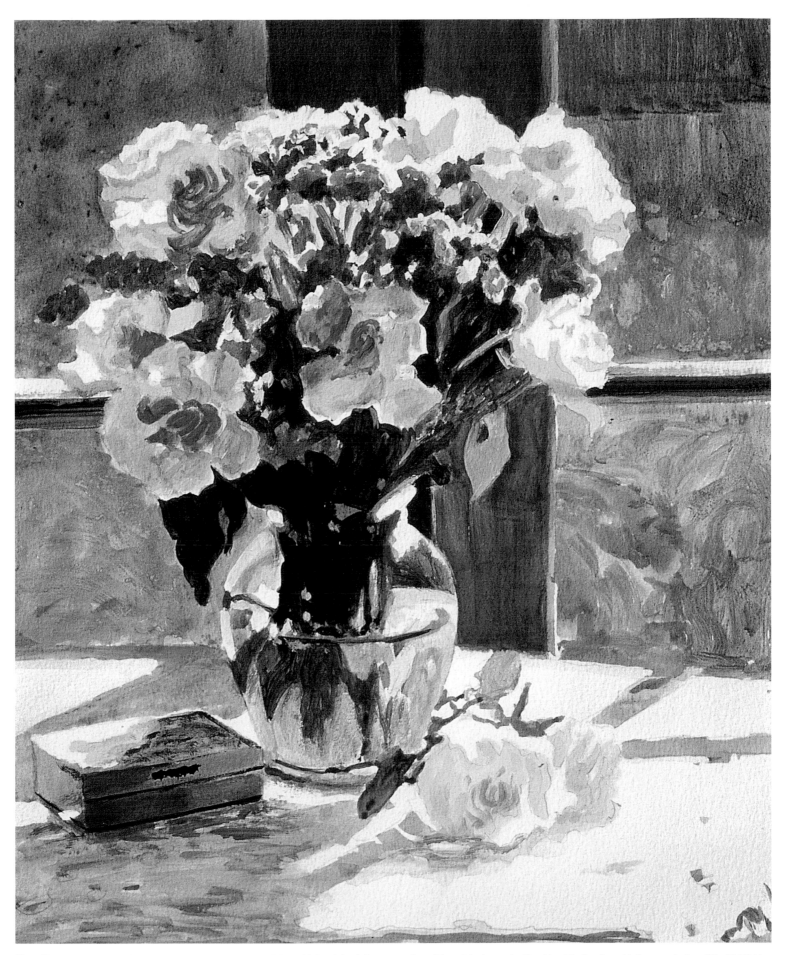

STEP SEVEN I fill in the darkest areas of the stems using a small flat sable brush loaded with a thicker mix of Payne's gray and phthalo green, drybrushing the edges of the strokes for a soft, feathery effect. Next I darken the window frame with a layer of burnt sienna, and I add contrast to the music box and rosebuds with Indian red. I continue to darken and define a few of the petal edges using the side of the brush, and I also accent a few of the highlights with a mix of cadmium yellow light and white. Then I add a few transparent layers of color to deepen the shadows, such as a wash of dioxazine purple and light blue-violet over the lower-left corner. Finally I remove the masking tape from the board and paper to view the results!

WINE AND FRUIT

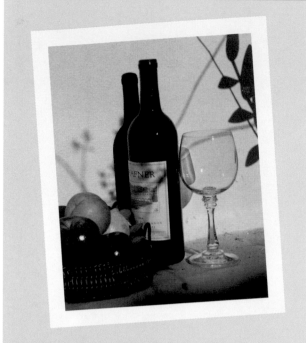

Taking Photos You don't have to paint your setups from life; in fact, taking several photos of your arrangement can help you frame your composition and choose the most effective angle.

STEP ONE First I sketch the scene on the canvas with a permanent marker, taking care to make the shapes and perspective accurate. I use a thin wash of dioxazine purple for the underpainting, since this color will complement the bright yellows I plan to add later.

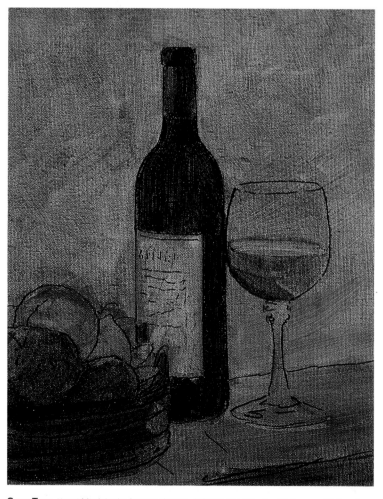

STEP TWO Now I block in the largest shapes, defining the objects with layers of thin color. First I apply raw sienna for the background and wine label. Next I cover the bottle with dioxazine purple. Then I add alizarin crimson to the bottle's neck. I also apply alizarin crimson mixed with burnt sienna to the fruit, tabletop, and wine. For the shadows, I switch to Payne's gray.

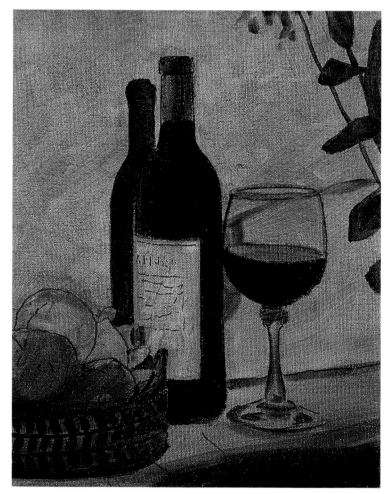

STEP THREE Now I paint the darkest colors of the wine bottle, glass, and shadows, using a mixture of Prussian blue and alizarin crimson. I avoid the left side of the bottle, saving this area for highlights. I also use this mix to define the details of the basket and the tabletop shadows. Then I use a mixture of burnt sienna and Payne's gray to sketch in a few reflections on the stem of the wine goblet.

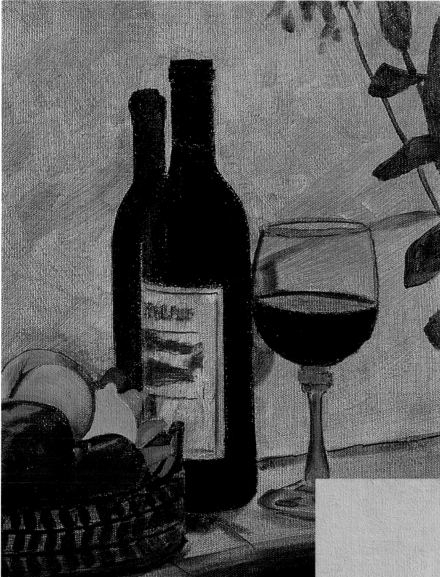

STEP FOUR At this point, I add color and dimension to the fruit. I use alizarin crimson mixed with cadmium red light to fill in the apples and outline the pear. For the highlights, I apply a mix of cadmium yellow light and raw sienna. Then I add emerald green to the mixture to paint the leaves. Next, using burnt sienna and alizarin crimson, I bring up some of the details in the neck of the wine bottle and on the label.

STEP FIVE Now it's time to "light up" the composition. Mixing Naples yellow with cadmium yellow light and white, I paint the background, allowing some of the underpainting to show through for texture. I use the same mixture to highlight the wine in the glass and to add sparkle to the stem. And I also dry-brush the color onto light areas of the wine label. Then I thin the mixture to make it more transparent and add the highlights on the left side of the bottle and on the glass.

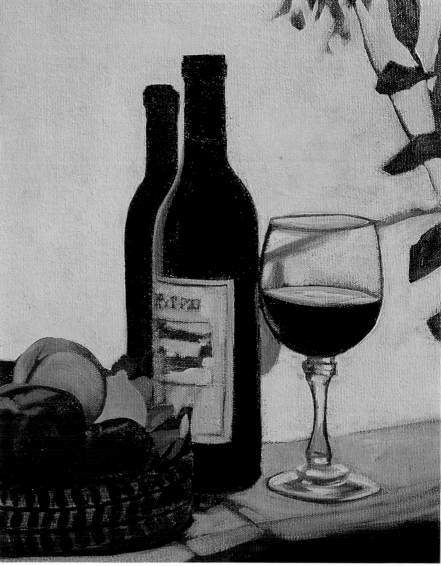

WINE AND FRUIT (CONTINUED)

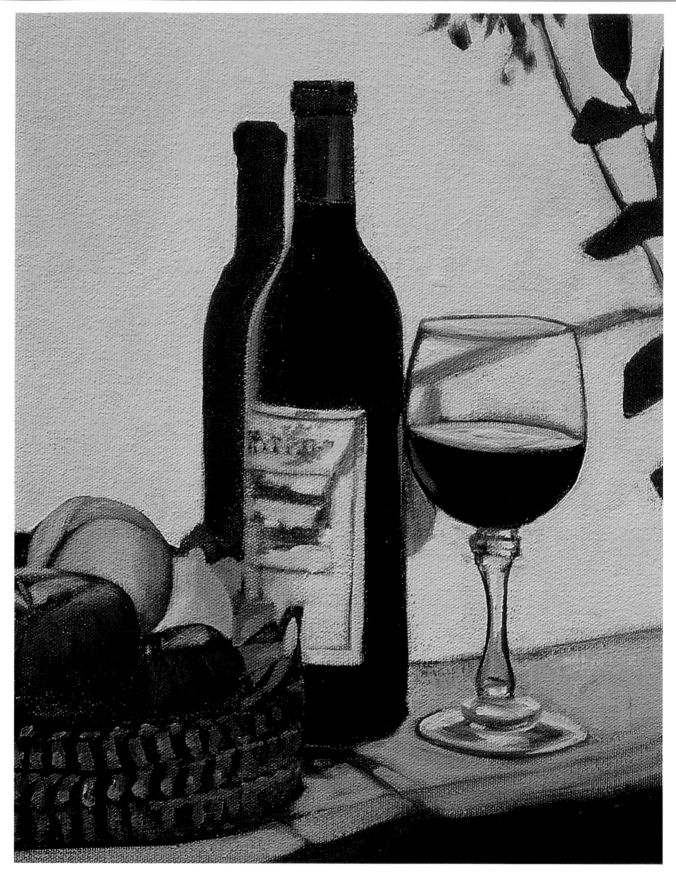

STEP SIX Using a small flat sable brush, I continue to refine smaller details on the fruit, basket, and neck of the bottle. Then I unify the colors within the painting by adding a layer of burnt sienna to the shadows on the wall.

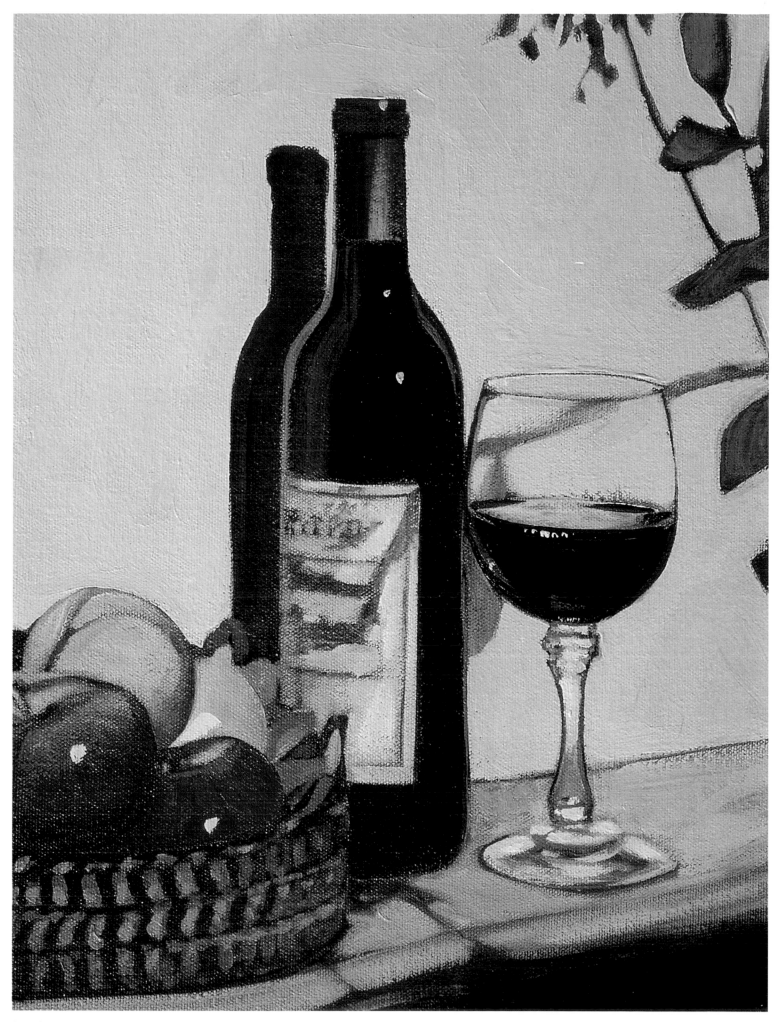

STEP SEVEN To neutralize the background wall, I apply a thick glaze of unbleached titanium mixed with flesh and a small amount of cadmium yellow light. To create interesting textural effects, I vary the direction of the brushstrokes and paint thicknesses. Then I drybrush a few highlights onto the fruit, tabletop, and wine stem. For the highlight on the left side of the bottle, I use a mixture of phthalo green and Payne's gray. Finally I apply tiny light sparkles to the bottle, apples, and wine glass with white mixed with cadmium yellow.

Garden Arch

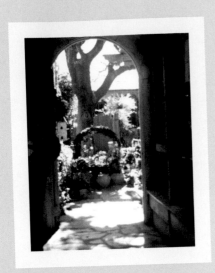

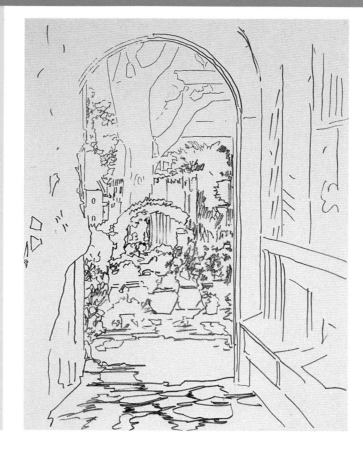

STEP ONE Keeping the photo close by for reference, I create a careful and complete sketch directly onto my canvas with a permanent marker. The only slight adjustment I make is to show a bit more of the top of the arch.

Following a Reference I know I need to follow this reference closely to make sure I re-create the perspective accurately, or my painting won't be convincing. I am happy with this photo's glowing feel and striking contrasts between the light and shadow, so I don't intend to make many changes to the color or composition.

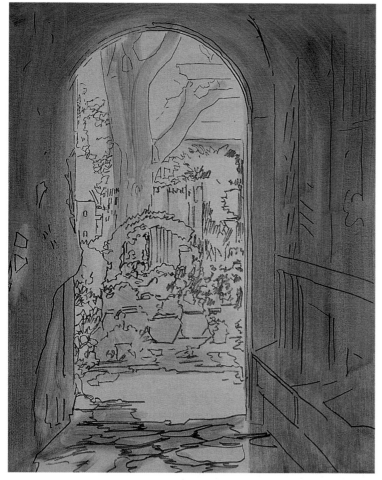

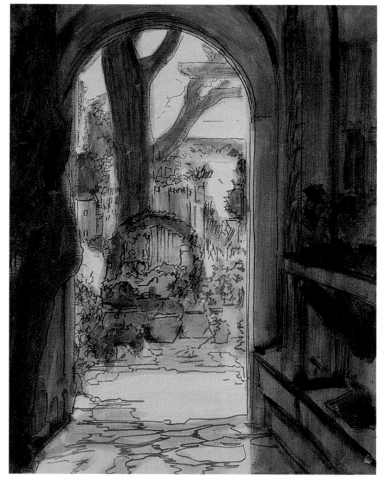

STEP TWO Now I establish a "map" of the various values in the scene. Using a large flat brush, I apply thin washes of yellow ochre and dioxazine purple to the largest areas of light and dark.

STEP THREE I fill in the arch and shadowed interior with burnt sienna and darken the tree trunk with dioxazine purple. I also apply these washes to areas of the far courtyard. Then I outline the darkest areas of the foreground with the edge of a small flat brush and a mix of acrylic glazing medium, dioxazine purple, and Payne's gray. I also add sap green to the foliage, mixing in some Payne's gray to tone down some areas and create a little variation.

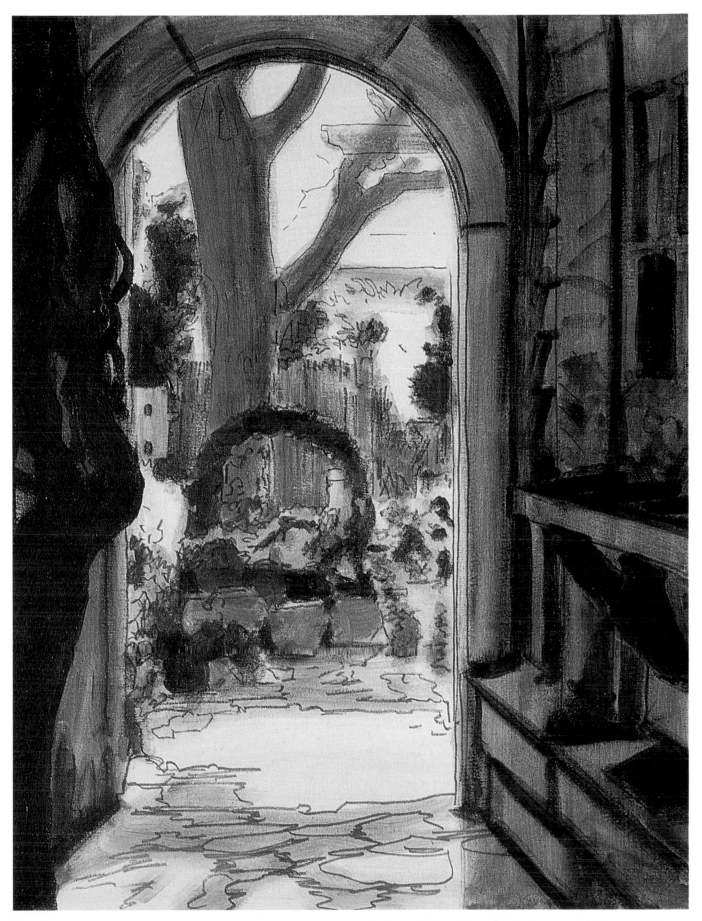

STEP FOUR Next I strengthen the darks of the underpainting to clarify some of the shapes in the foreground. I use a mixture of Payne's gray, dioxazine purple, and burnt sienna to apply thicker layers of paint, drybrushing the edges for a soft look. Then I add a glaze of burnt sienna to the tree trunk in the courtyard. At this stage, I have a clear separation between light and shadow, as well as a good sense of the detailed areas.

GARDEN ARCH (CONTINUED)

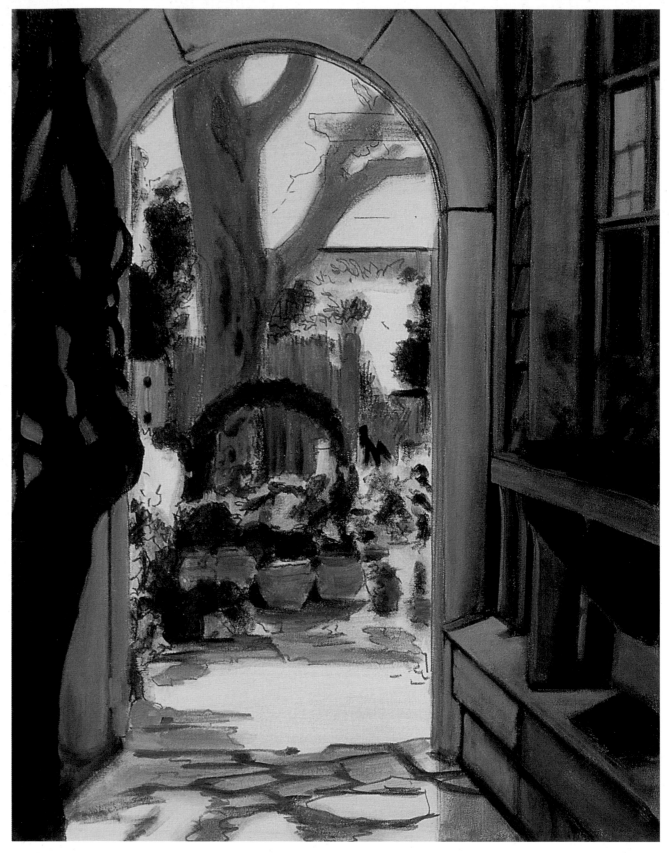

STEP FIVE Next I create mixes of light blue-violet and brilliant blue, adding burnt sienna and Payne's gray for variation. I apply these colors to the brightest areas in the archway, softening the edges with a bit of drybrushing. To unify the background and the foreground, I apply these mixes to areas of the courtyard, such as the tree trunk and flower pot shadows. Then I start to further develop the fence, flower pots, and tiles without worrying about creating photo-perfect details—although I want the scene to look convincing, the goal for this painting is to capture the atmosphere and mood of the setting as well.

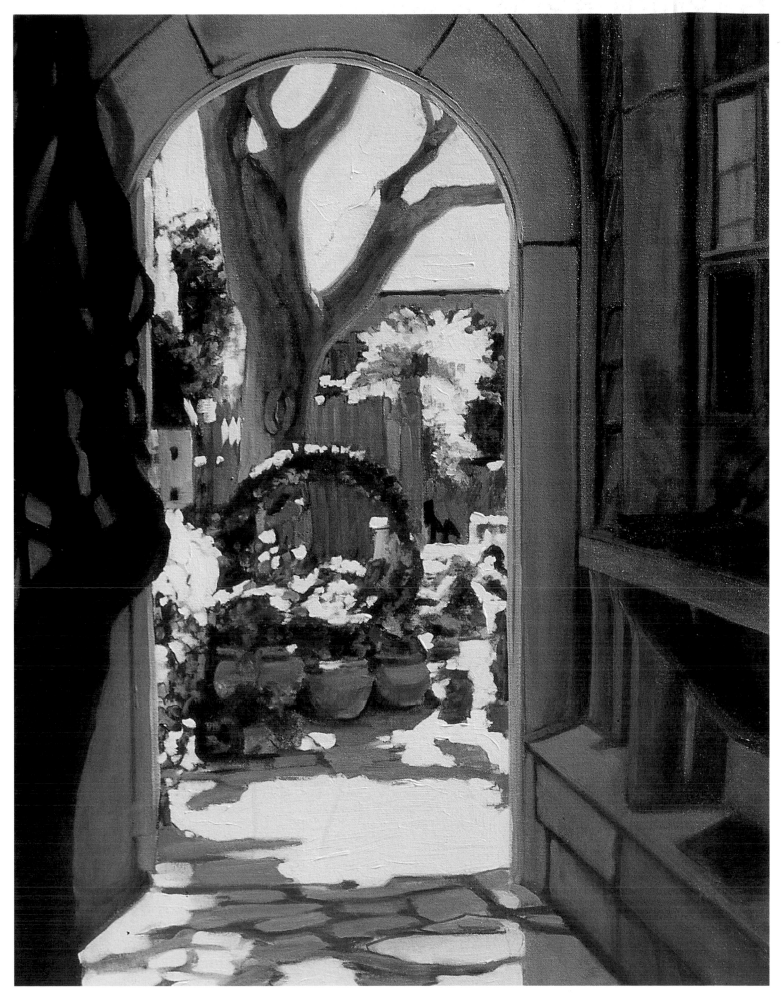

STEP SIX I decide that the architectural shape by the tree branch is confusing, so I paint over it and cover the sky with titanium white mixed with brilliant blue. Then I apply a mixture of titanium white and yellow oxide to the sunlit areas of the courtyard. I also warm up the foreground using a mix of raw sienna and acrylic glazing medium, applying a transparent layer to the arch, hallway, and floor tiles. Then I mix yellow ochre and sap green to add highlights to the foliage, also adding some cadmium red light for the flowers. Finally I outline the underside of the archway with a mixture of cadmium yellow light, bright orange, and white.

BUILDINGS BY THE SHORE

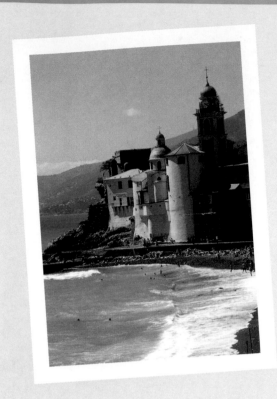

Taking an Elevated Viewpoint
I took this photo from a location higher than the ocean and beach, which elongated the foreground area to include a winding shoreline that entices the viewer into the painting.

STEP ONE Because of the architectural aspects of the subject, I first want to make sure my drawing is accurate in perspective and proportion. Then I enlarge it and project the image onto my canvas, where I trace it with a permanent marker. Of course, you don't have to use this technique to transfer the image—you may prefer to draw it freehand or use the "grid" method of transferring the image to your canvas. Whichever method you use, be sure to indicate the shapes that define the separations of light and shadow.

STEP TWO Next I break up the compo-
nents into their basic colors and values.
Using a large flat brush, I thin the paint
with water to keep it free-flowing and
transparent. For the sky, hills, and water,
I apply brilliant blue; for the shadows
and foreground, I use dioxazine purple;
and for the sunlit areas of the buildings,
I stroke on yellow oxide. I also add diox-
azine purple to the hills and water.

STEP THREE Now I apply a layer of
intense color to the scene to further
define the value differences and es-
tablish a sense of depth. I mix a bit of
acrylic glazing medium with the paint
to make it flow easily. Then, beginning
with the hills in the background, I apply
mixes of Prussian blue, Payne's gray,
brilliant blue, and phthalo green. For
the light portions of the buildings, I
apply raw sienna, using yellow ochre
for the highlights. Then I apply phthalo
green mixed with Prussian blue to the
water, using lighter shades as I move
down. For the building shadows, the
rocks, and the beach, I use a mix of
dioxazine purple and burnt sienna.

BUILDINGS BY THE SHORE (CONTINUED)

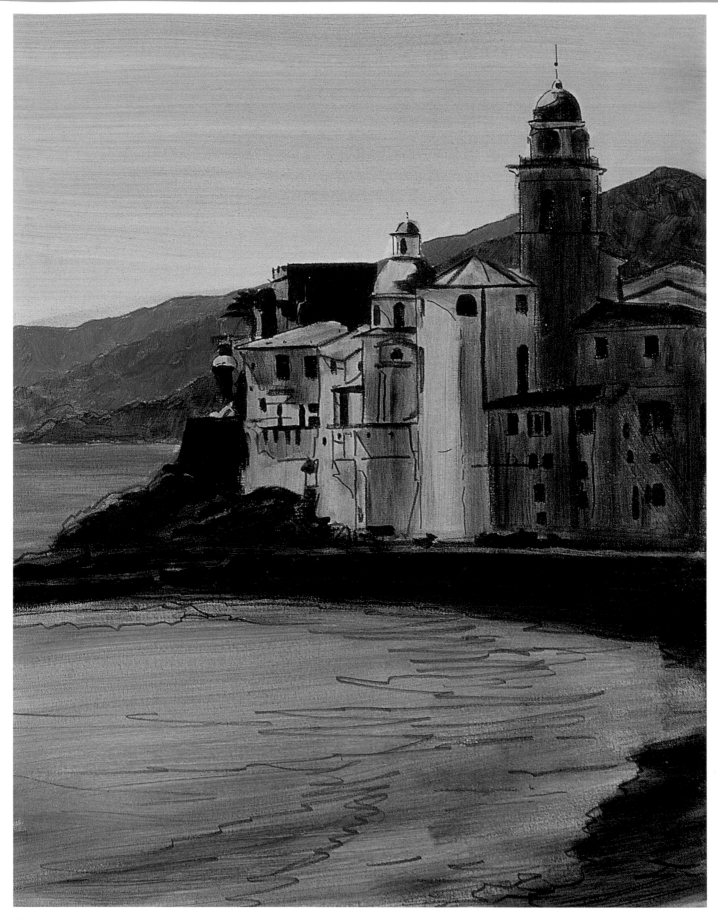

STEP FOUR At this point, I block in the darkest colors of the buildings and the waterfront with a medium flat sable brush, which allows me to "draw" the details with crisp, controlled edges. I load the brush with a thick mix of Payne's gray and dioxazine purple, filling in the shadows and architectural details, such as the windows and clock towers. Then I use the same purple-gray mix to cover the rocks and beach. When this layer dries, I glaze the shadows with burnt sienna mixed with dioxazine purple.

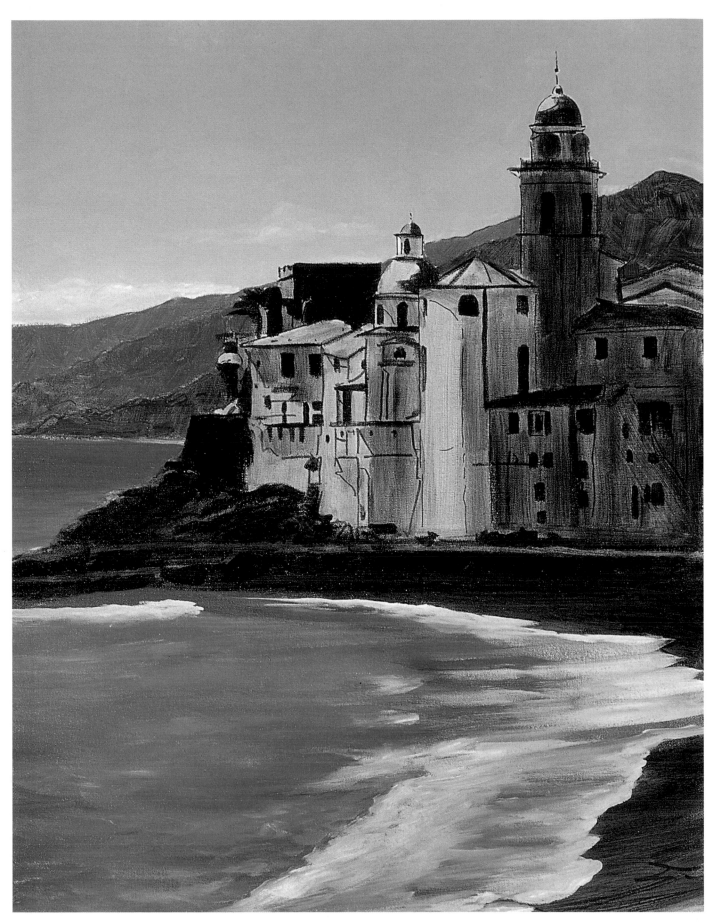

STEP FIVE Now I paint the sky all in one step, keeping the paint wet as I go so that I can blend and gradate the colors. Working from dark to light, I start at the top with a mix of titanium white, light blue-violet, and light portrait pink. As I move down, I work in more white and pink. I paint the water with a darker blue mix using varying strokes to shape the wavy surface. For the breaking surf, I load the brush with white and light portrait pink and pull the color from right to left. After the paint dries a bit, I drybrush the edges to soften them. For the buildings' reflections, I add a bit of raw sienna to the water.

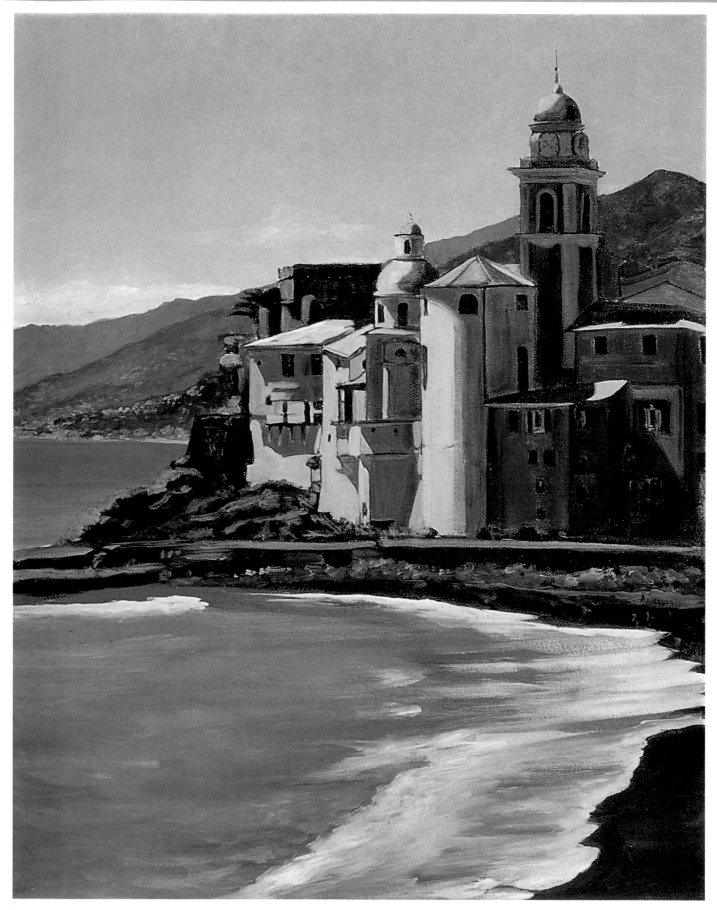

STEP SIX Next I mix sap green with brilliant blue and paint the hills with drybrush. I use the same technique with light-blue-violet, raw sienna, and a bit of white to suggest buildings in the background. Then I mix light blue-violet, cadmium red, and raw sienna for the rocks and parts of the buildings, using the edge of the brush to define them. I also use a gray mix to separate some of the details in the clock tower. With a mix of yellow oxide and white, I add a layer of color to the highlighted areas; then I further brighten the rooftops with pure white. Finally, with mixes of brilliant blue, light blue-violet, and white, I add details to the windows, clock tower, and shoreline.

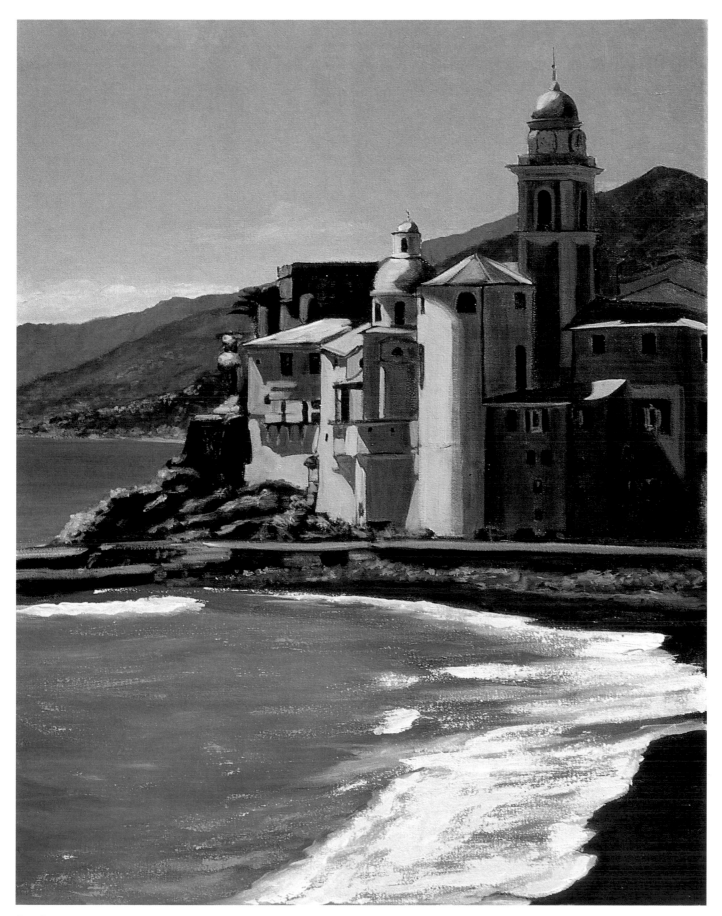

STEP SEVEN Now I mix raw sienna with acrylic glazing medium and apply a thin layer of color to the buildings' shadows and the shoreline, also adding highlights to the rocks and the walkway using raw sienna mixed with light blue. To create the final highlights in the white surf and the blue water, I load the edge of my palette knife with white and light portrait pink and pull the color across the canvas. I also add a little raw sienna to the water for the building reflections. I make sure to not get carried away with any more detail—remember that when you step back from the painting, your eyes will fill in the details for you!

MEDITERRANEAN CAFÉ

STEP ONE I use a permanent marker to make a rough sketch of my simplified café directly on the canvas. Then I cover the canvas with a thin underpainting of medium magenta, making sure that the sketch is still visible beneath.

STEP TWO Now I apply thin washes of preliminary colors to help separate and simplify the visual elements. Using a large flat brush and paint thinned with water and acrylic gel medium, I apply the paint with quick strokes. For the sky, hills, water, and shadows, I use brilliant blue, Prussian blue, and dioxazine purple. For the warm light on the buildings, umbrellas, and walkway, I apply raw sienna.

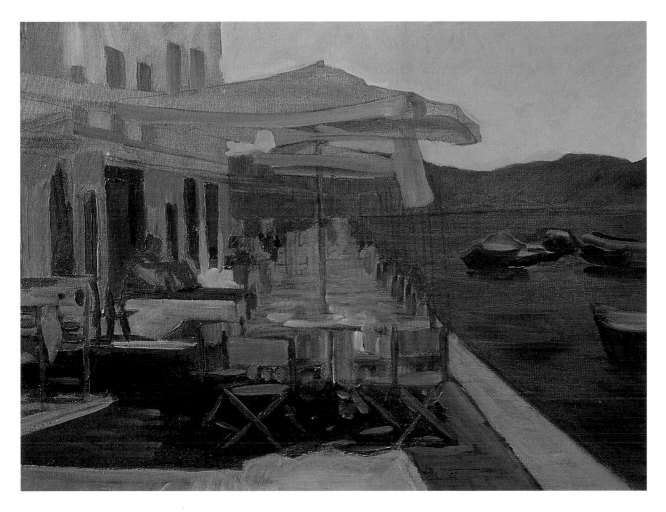

STEP THREE At this stage, I create more contrast in the values and continue breaking down the composition into basic shapes. I thicken the paint with opaque acrylic gel to intensifying the underpainting colors. I apply a deep mixture of dioxazine purple, Payne's gray, light blue-violet, and raw sienna to the shadowed areas and light blue-violet to the sky. Then I mix Prussian blue with brilliant blue and dioxazine purple, adding this mix to the sky and water. I also add a thin glaze of cadmium red light and cadmium yellow light to the buildings, tables, and sidewalk. I begin to add some rough details in the chairs, tables, and boats with strokes of Payne's gray, light blue-violet, and burnt sienna. Then I block in an underpainting for the reflected light using a mix of Payne's gray, light blue-violet, and raw sienna.

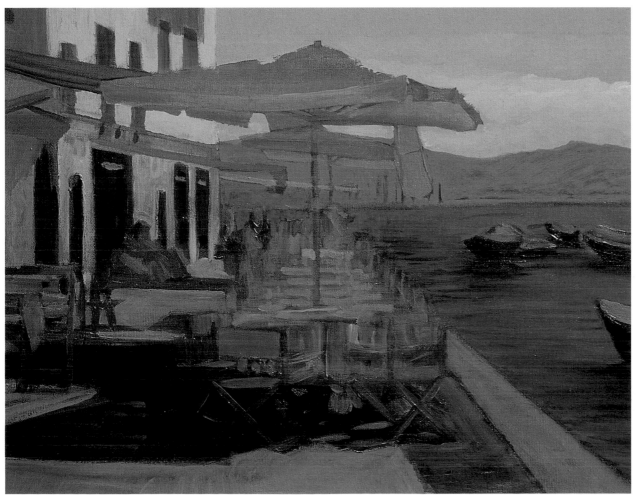

STEP FOUR Now I harmonize the colors and unify the elements by applying a thin layer of raw sienna, cadmium yellow light, and acrylic glazing medium to all the highlighted areas. Next I apply a mix of light blue-violet and Payne's gray to the sky, blending in subtle highlights of light portrait pink in the clouds. Then I add a lighter value of the previous blue mix to the hills and apply mid-range tones to the water with thin, loose strokes, pulling some paint away to allow the underpainting to show through. Finally I add definition to the buildings with cadmium red light, cadmium yellow light, and light blue-violet, and I apply a mix of Payne's gray and brilliant blue to the windows.

Mediterranean Café (continued)

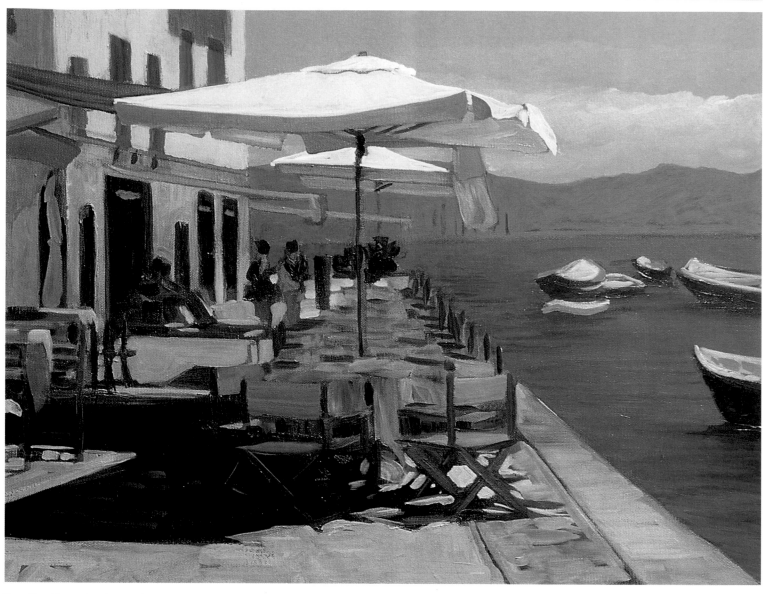

Step Five Next I mix cadmium yellow light with titanium white and apply a thick layer of this color to the umbrella tops and boat highlights, further enhancing the contrast between light and shadow. Then I add a touch of Payne's gray to the mixture to bring up the high-lights on the sidewalk. I also apply more detail to the chairs, tabletop, and umbrella shadows, working loosely and adjusting the colors along the way, always maintaining a feeling of spontaneity.

Table Detail When encountering a busy area of a painting, I keep my brushstrokes un-refined and don't worry about painstakingly rendering each item. To suggest napkins, plates, and glasses on the table, I apply various mixes of white, brilliant blue, light blue-violet, cadmium red, and cadmium yellow light with loose, impressionistic strokes and dashes.

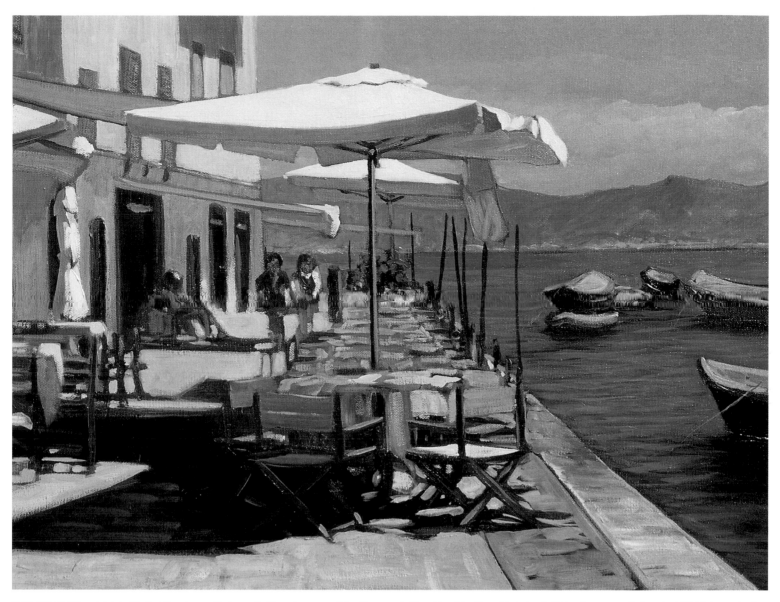

STEP SIX At this point, I decide that "less is more"—instead of focusing on small details, I keep my brushstrokes bold and confident. Using the edge of a flat brush, I add highlights to the hills and water with mixes of light blue-violet, light portrait pink, yellow ochre, and brilliant blue, blending with drybrush. Using the same technique, I add highlights to the figures, tables, and chairs. I paint the final highlights on the umbrellas with a mix of light portrait pink and white. Then I finish by applying a thin layer of yellow ochre to the sidewalk.

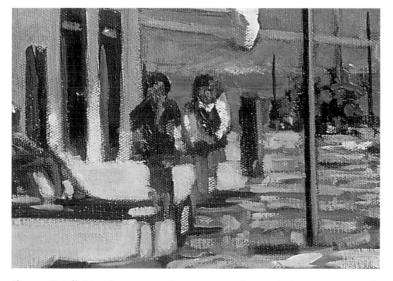

Figures Detail When figures are an element of a scene but not the focus, there's no need to render them with intricate detail. Here I've blocked in two very basic figures, employing vague shapes and only spots of color. The result is simple yet effective. The viewer has enough information to fill in the details!

Portuguese Coast

Painting Misty Weather As you can see from my reference, the misty atmosphere dulls distant elements as usual; but, to a somewhat lesser degree, it also mutes the color and softens the details of closer elements.

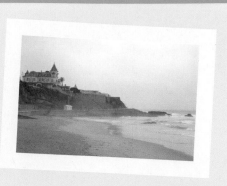

STEP ONE I begin with a simple sketch, using a fine-point black marker on a medium-textured, stretched canvas. Over the sketch, I apply a thin wash of magenta, which I use to cover the entire canvas. The magenta underpainting will add warmth to the final painting, preventing it from appearing too gloomy.

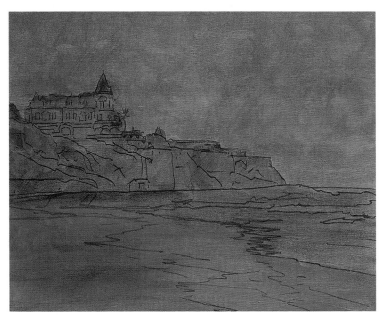

STEP TWO Using cerulean blue, sap green, red oxide, and yellow oxide, I start blocking in the color. Beginning with the sky and working down, I mix the paints with gloss medium and a little water. I dull the colors with a little Payne's gray before applying them thinly with a large, flat bristle brush.

STEP THREE Next I add dark tones to the building, cliffs, and seawall with various mixes of burnt sienna and dioxazine purple. I use a little unbleached titanium to lighten the values and gel medium to thicken the paint. A slightly smaller flat sable brush allows me to "draw" with a bit more detail.

STEP FOUR Next I develop the sky and water, using the same technique for both. For more opacity, I add gel medium to a mix of cerulean blue, light blue-violet, Payne's gray, and white, but I allow enough transparency for some of the underpainting to show through. In the water, I leave gaps where the surf will be rendered. Notice I pull some of the paint up into the rocks to establish waves, softening the edges of the water where it meets the beach with drybrush.

STEP FIVE To soften the dark tones, I add another layer of color using various mixtures of red oxide, yellow oxide, and Payne's gray. I paint the lighter colors of the building and the wall with mixtures of light blue-violet, Payne's gray, and unbleached titanium, using the edge of a small, flat brush to define the shapes. Finally I apply a lighter value of transparent yellow oxide to the beach.

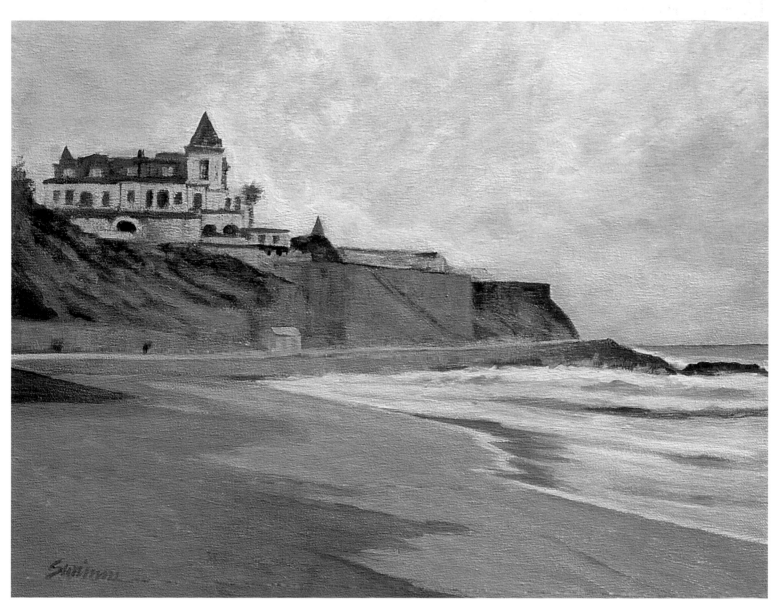

STEP EIGHT Adding a little unbleached titanium and Payne's gray to the colors already on my palette gives me the colors I need for final details and adjustments. With these mixes, I continue to refine details on the cliffs and the building. I also add another layer of color to the beach, this one more opaque. I keep the mix closest to the beach light, adding more Payne's gray, sap green, and burnt sienna for the dark areas on the left of the composition. To finish, I darken the horizon line and the details in the water and along the edge of the sand.

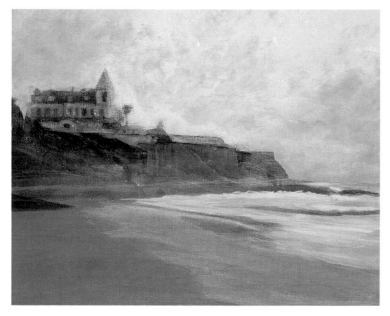

STEP SIX Now I add yet another layer of color—this time a thin glaze that covers the entire canvas. Mixing light blue-violet with light portrait pink, unbleached titanium, and a generous amount of acrylic glazing medium, I apply transparent color using large brushstrokes. I apply a thicker glaze over the sky and water to create a sense of clouds and surf, working the paint into the surface. (You can pull off the glaze with a dry brush if it gets too thick.)

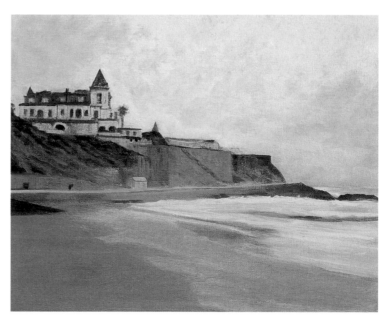

STEP SEVEN Starting with a muted, bluish-gray mixture of dioxazine purple, Payne's gray, and titanium white, I add building details with the edge of a medium flat sable brush. For variation, I also use light blue-violet mixed with Payne's gray and sap green mixed with light blue-violet and Payne's gray. For the windows, rooftops, cliffs, and seawall, I apply brownish mixes of unbleached titanium with Payne's gray and either alizarin crimson or burnt sienna.

Candy Cart

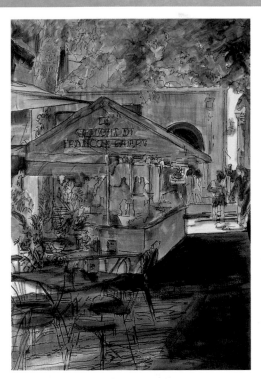

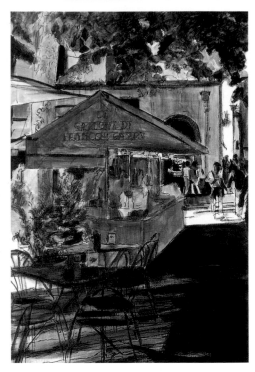

STEP ONE After sketching, I use a large flat sable brush to wash over the buildings with a mix of raw sienna, sap green, and gloss medium, adding burnt sienna for the dark areas. For foliage, I use phthalo green mixed with Payne's gray.

STEP TWO I block in the cart and tables with burnt sienna, mixing dioxazine purple, Payne's gray, and cerulean blue for the shadows. For the distant shadows, wall, and figures, I mix dioxazine purple, phthalo blue, and light blue-violet.

STEP THREE Now I lay in dark colors that will serve as an underpainting for the highlights. I apply darks to the foliage, along with background and foreground shadows. And I also glaze over the cart and tables.

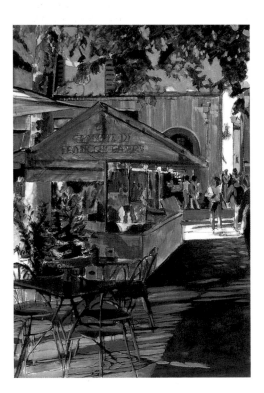

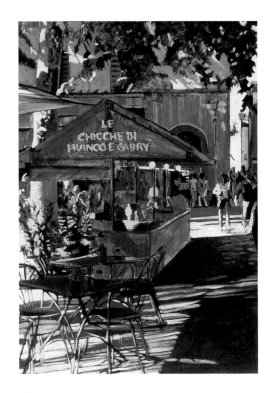

STEP FOUR Next I mix a few purples. I apply these more opaque colors to the foreground shadows with a medium flat sable brush. For harmony, I also work these colors into shadows throughout the scene. Next I apply color to the tree trunk using variations of burnt sienna mixed with magenta, raw sienna, dioxazine purple, and light blue-violet. Then I add light blue-violet, white, and bronze yellow to the purple mixes for the area where the building peeks through the foliage. On the building, I drybrush a mix of magenta, raw sienna, and light blue-violet, using dioxazine purple mixed with cerulean blue in the arch.

STEP FIVE It's now time for the first layer of highlights. I begin by mixing light portrait pink with yellow oxide for the lettering on the canopy, which I quickly and loosely apply with the edge of the medium flat brush. For the more opaque highlights in the trees and building, I add unbleached titanium to the lettering mix. Then, with light portrait pink mixed with yellow oxide and a little blue-violet, I use drybrush to add highlights to the street and foreground.

Creating Dimension To make the foliage appear to come forward in the scene, rather than lying flat against the façade, I employ light and shadow. By applying light values to highlight the foliage itself, the leaves appear to come forward in the painting, especially in contrast to the shadowed building.

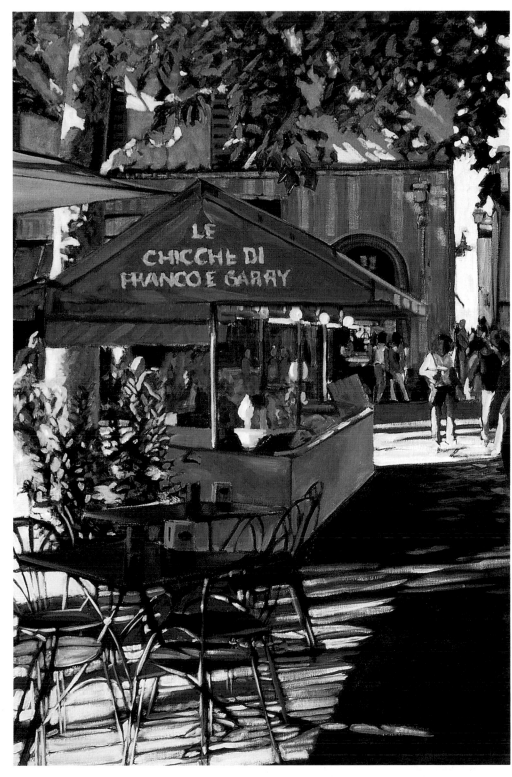

"Drawing" Highlights To give dimension to the thin chairs and table, I use my brush as a drawing tool. I separate light and shadow areas by applying highlights with a more opaque layer of paint, using the edge of a flat sable brush. Although using the brush's edge gives me more control, I don't worry too much about precision—shadows and highlights are naturally asymmetrical, so perfectly straight lines would appear out of place.

**Cool Foreground
Shadow Variations**

*Dioxazine purple + Payne's
gray + titanium white*

*Dioxazine purple +
more Payne's gray + more
titanium white*

STEP SIX A few final light color applications will finish the painting. I add color to the foliage with mixtures of sap green, raw oxide, bronze yellow, and red-orange, applying the color randomly and varying the brushstrokes. For contrast, I make sure to retain some of the shadow areas. I also add a more opaque layer of color to the canopy, this time using a brighter mixture of burnt sienna and red-orange; for additional highlights, I add spots of cadmium orange mixed with cadmium yellow light.

*More dioxazine purple +
Payne's gray + more
titanium white*

Foliage Darks
*Phthalo green + dioxazine
purple + Payne's gray*

Cart and Tabletop Glaze
*Burnt sienna + red-orange +
glazing medium*

Foreground Shadows
*Phthalo blue + light blue-
violet + Payne's gray*

Background Shadows
*Burnt sienna +
dioxazine purple*

ITALIAN ROOFTOPS

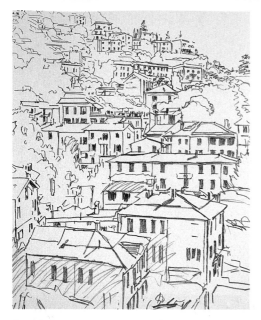

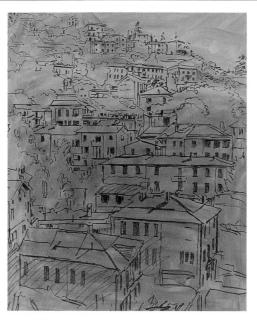

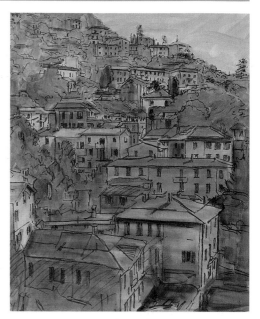

STEP ONE Rather than faithfully following my photo reference, I've decided to crop out the foreground of the piece for a stronger, more proportionate composition. I loosely sketch the changed scene on a 30" x 24" stretched canvas, paying careful attention to the perspective but only loosely rendering the details.

STEP TWO I start with only two colors—cerulean blue and burnt sienna. I thin the paint with gloss medium and a little water, and then I use a very large flat sable brush to cover the canvas with large, sweeping strokes. I blend the colors slightly where they meet to create a visual guideline for where the value transitions will occur.

STEP THREE Next I begin applying my darks, starting with a mixture of sap green, Payne's gray, and dioxazine purple to the foliage. Then I layer burnt sienna on the foreground buildings. I distinguish the shadows with dioxazine purple, which I also apply to the background buildings and rooftops in the distance.

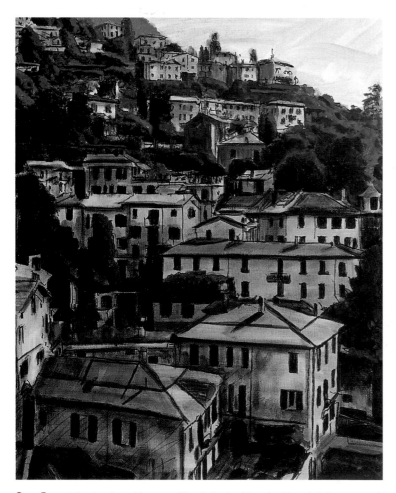

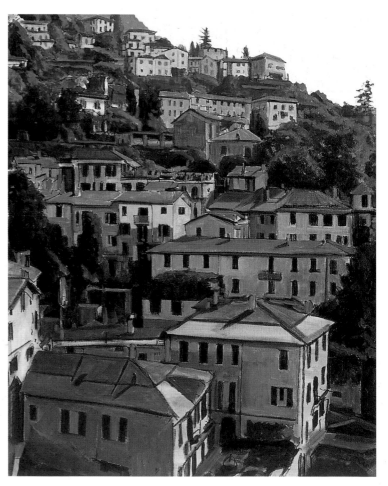

STEP FOUR I develop the architecture with a dark mix of Prussian blue, phthalo green, and alizarin crimson, adding water for lighter values. I shape the foliage with variations of emerald and permanent green mixed with a little dioxazine purple and Payne's gray. For distant foliage, I add purple and blue.

STEP FIVE I add mixes of burnt sienna, yellow oxide, magenta, dioxazine purple, and gloss medium to the buildings. I mix light portrait pink and unbleached titanium for the sky. Then, with light blue-violet, light portrait pink, and yellow oxide, I paint around the windows, adding touches of light blue-violet mixed with dioxazine purple.

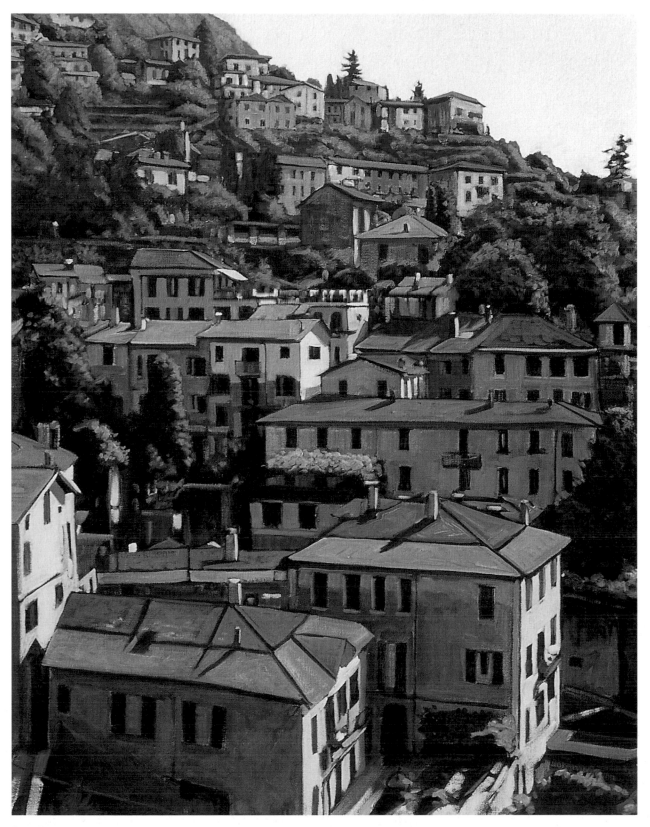

*Dioxazine purple +
light blue-violet*

*Cerulean blue +
Payne's gray*

*Light blue-violet +
Payne's gray*

*Dioxazine purple +
unbleached titanium*

*Payne's gray +
bronze yellow*

*Red oxide +
unbleached titanium*

STEP SIX To brighten foliage highlights, I mix a few variations of sap green, chromium oxide green, and bronze yellow. I apply the paint more thickly, using drybrush to create a sense of the transition from light to dark. Next I add color to the foliage shadows using sap green mixed with dioxazine purple. I also add a mix of light blue-violet, white, and gloss medium to the sky. For highlights in the buildings, I apply light portrait pink mixed with bronze yellow. I add details and highlights to the rooftops by mixing variations of red oxide, light portrait pink, bronze yellow, and chrome orange.

RIVER SPREE

Water Reflections

*Light portrait pink +
magenta*

*Light portrait pink +
magenta + light blue-violet*

*Light portrait pink +
magenta + light blue-violet
+ ultramarine blue*

*Sap green +
dioxazine purple*

STEP ONE First I select a 14" x 18" canvas for my painting, and then I make a very loose sketch with a fine-line black marker before covering the entire canvas with a thin under-painting of cerulean blue.

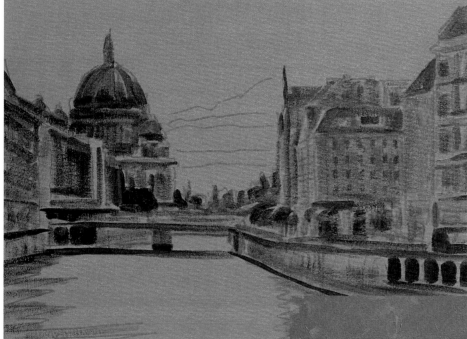

STEP TWO Because I want to capture an outdoor feeling in this work, I mix a gel extender medium with the paint to create a thicker, impasto-type consistency. When I need to vary the thickness of my paints, I just thin them with a little water. To begin, I set up my palette with burnt sienna, raw sienna, ultramarine blue, and Payne's gray. With a large flat brush, I apply basic blocks of color to the canvas, using the edge of the brush to define the shapes.

STEP THREE For the sky and water, I use Payne's gray mixed with ultramarine blue and light blue-violet, again thickening the paint with gel medium. I keep this underpainting for the sky color, and then I paint the clouds. To darken the reflections along the waterline, I add more Payne's gray to the mix, and I also add dioxazine purple before painting some of the architectural details, such as the outline of the dome.

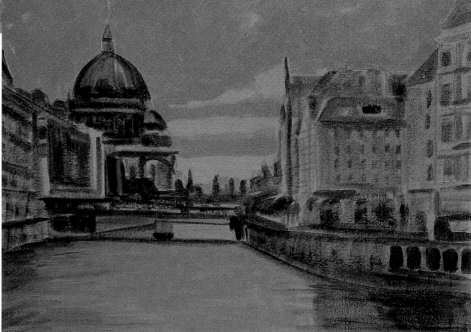

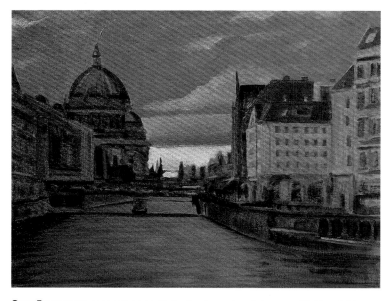

STEP FOUR Now I add warm mixes of alizarin crimson, burnt sienna, and lt. blue-violet; raw sienna, lt. blue-violet, and Payne's gray; burnt sienna and lt. blue-violet; and dioxazine purple, lt. blue-violet, and Payne's gray. I also apply reflections (see colors on page 132) using lighter mixes for sky highlights and adding ultramarine blue in the shadows. For the water, I stroke horizontally, and I adjust the edge with a mix of dioxazine purple and sap green.

EXPLORING THE SUN'S EFFECT

The strength and position of the sun have a strong influence on outdoor scenes, producing highlights and shadows that differ according to time of day. For example, subtly changing the color and shadows of a scene can convey a cool morning, a blazing noon, or a warm late afternoon.

Comparing Times of Day The same scene produces two very different impressions in the morning (left) and at mid-day (right). The sun's position affects the colors of the scene and alters the shadows on the tree, roof, and street.

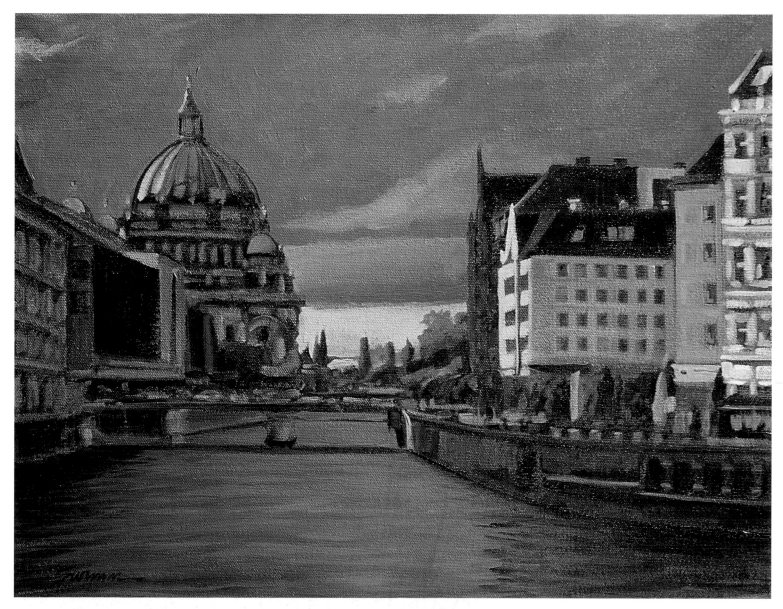

STEP FIVE For the dome, I use variations of phthalo green mixed with light blue-violet and gel medium. Then, for the distant foliage, I mix sap green, Payne's gray, and burnt sienna, and I apply the color with single brushstrokes. Next I build up the values of the buildings, applying raw sienna mixed with unbleached titanium and light blue-violet, then switching to alizarin crimson mixed with light blue-violet for the roofs. I also apply a few dabs of color to the dome and the façade on the left. Then I work with the water reflections on the right, applying loose, horizontal strokes of alizarin crimson mixed with raw sienna. For highlights on the dome and buildings, I mix titanium white and cadmium yellow light, switching to cadmium red light for roof highlights. I work these colors over the entire canvas, using drybrush in places to suggest detail. Then, to finish, I glaze over the clouds with light blue-violet.

ATHENS NIGHT SCENE

Creating Intimacy Night scenes have an intimacy to them unmatched by most daytime subjects. To enhance that sense of closeness, I chose to focus on the figures and activity in the scene, rather than on the buildings.

STEP ONE I select a relatively small 18" x 24" stretched canvas to enhance the intimate, romantic nature of the scene. Then I make a loose sketch with a fine-line black marker. I keep my drawing very simple, and I don't focus too much on precision, concentrating instead on capturing the basic shapes of the composition.

STEP TWO To begin, I establish the separation of the light and dark areas with transparent washes of two colors: dioxazine purple and raw sienna. First I mix the paints with gloss medium to make them more fluid. Then I apply the colors with a very large flat brush, using quick, sweeping motions and blending the paint in areas of transition.

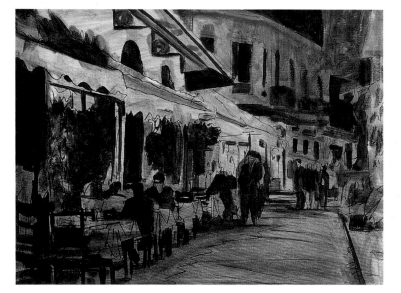

STEP THREE When the underpainting is dry, I establish the darkest values of the scene, using my sketch as a guide for their placement. I fill in all the darkest shadow areas using a large flat brush loaded with a mixture of Payne's gray, sap green, and gel medium. Using the edge of the brush makes it easy to draw and define the details, especially on the figures.

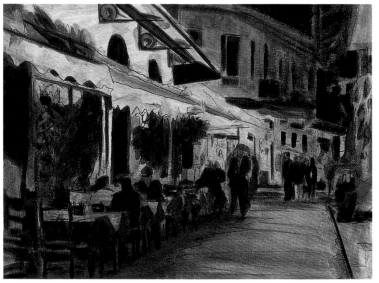

STEP FOUR Now I apply mixes of yellow oxide, raw sienna, and burnt sienna to the street and buildings. For harmony, I thin yellow oxide with glazing medium to glaze over the entire scene, working the paint into the canvas with a large brush to soften edges. For contrast, I reestablish the darkest values. Then I apply alizarin crimson to the tablecloths and figures.

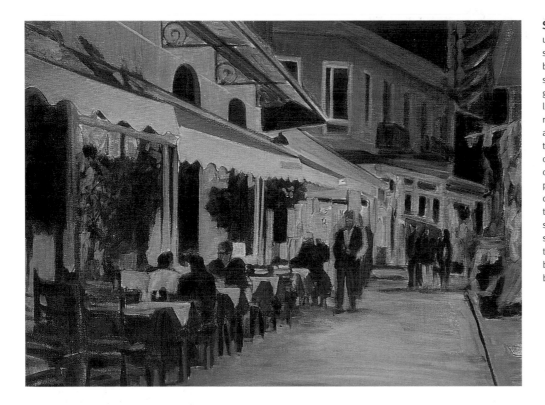

STEP FIVE Next I bring up the mid-range values, starting with the distant buildings and a mix of raw sienna, Payne's gray, and gel medium. I gradually lighten the color in the remaining buildings by adding yellow oxide to the mix. Next I apply a mix of light blue-violet, yellow oxide, and light portrait pink to the awnings, table-cloths, and figures. I add the same colors to the street and a few abstract shapes on the right, some-times lightening the colors by incorporating some un-bleached titanium.

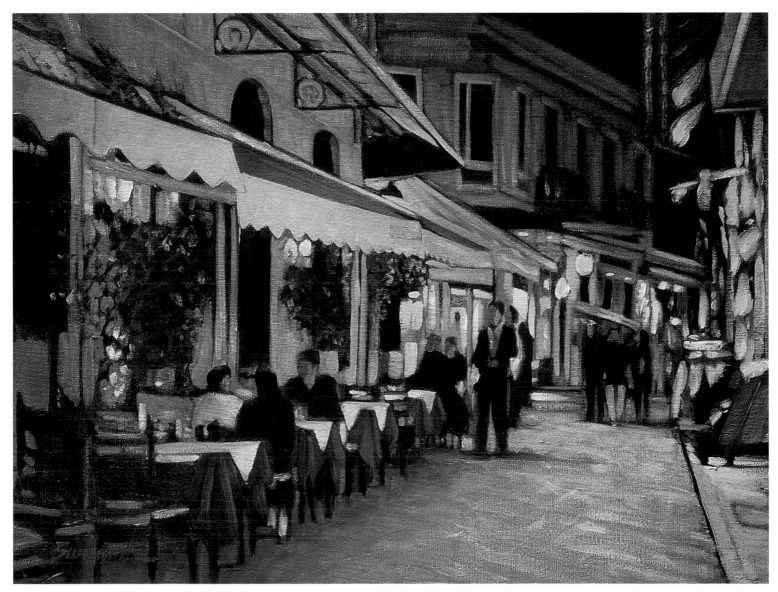

STEP SIX With a thicker, more opaque mixture of paint, I further define and embellish the shapes and details. Using a large flat brush, I add accents to the buildings, awnings, and windows. When the paint dries, I develop the details with drybrush, scumbling medium-free paint onto the surface to create texture. This works especially well in the walls of the build-ings and the street. Next I add the lightest highlights, applying light blues, pinks, yellows, and oranges with both thick spot applications and drybrush strokes. Then I build up another layer of color in the street, mixing gel medium with the paint for spots of solid color. I also add final touches to the figures, the foliage, and the buildings.

135

PORTUGAL STREET SCENE

STEP ONE I start depicting this street scene with a rough sketch on my canvas. After drawing the major visual elements with a fine-line marker, I cover the entire canvas with a thin wash of medium magenta. This underpainting will add warmth and harmony to the finished painting.

STEP TWO When my underpainting is dry, I block in the largest areas of color using a large flat bristle brush. At this stage, I keep the paint transparent so that the drawing is still visible. I also mix the colors—dioxazine purple, Payne's gray, sap green, burnt sienna, raw sienna, and light blue—with gloss medium before applying them to the canvas.

STEP THREE Now I focus on defining the darkest areas of the scene. Using the edge of my brush, I add shape and architectural details to the buildings. Then, with a mix of sap green and Payne's gray, I apply shadows to the foliage. I also mix dioxazine purple with burnt sienna for shadows in the street. Although the painting is still at a beginning stage, the contrasts between light and dark are already beginning to reveal themselves.

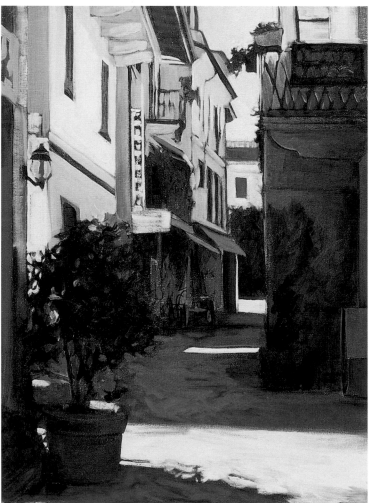

STEP FOUR Next I fill in large areas of highlights with various mixes of red oxide, yellow oxide, light portrait pink, unbleached titanium, and light blue-violet, mixing in gel medium for opacity. I start with the buildings on the left and then continue with the remaining buildings, the sky, and the street. Next I use sap green mixed with light blue-violet to define the leaves of the foreground plants, switching to burnt sienna mixed with Payne's gray for the planters. I also touch up street and building shadows using various mixes of light blue, dioxazine purple, burnt sienna, unbleached titanium, red oxide, sap green, and Payne's gray. (See color samples on page 137.)

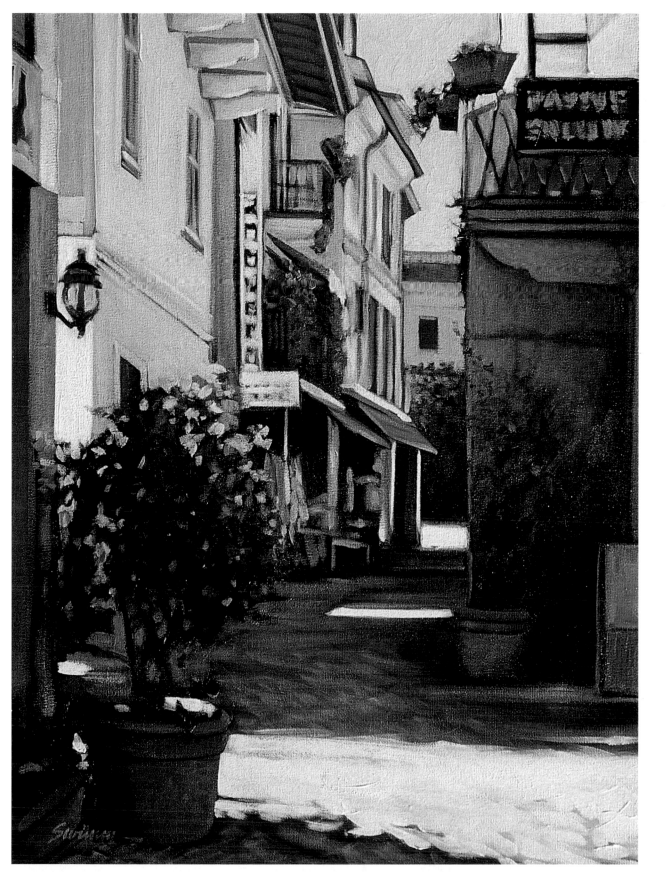

Dioxazine purple + Payne's gray

Dioxazine purple + light blue

Dioxazine purple + burnt sienna

Sap green + Payne's gray

Unbleached titanium + red oxide

STEP FIVE Again concentrating on the light values, I add another layer of highlights. First I create a transparent mix of light portrait pink and light blue for the sky, also using this color for foreground street highlights and spots of light on the foliage and planter. Next I mix some lighter color variations for the buildings on the left, using mixes of cadmium yellow light, unbleached titanium, light portrait pink, and chrome orange. I use the edge of my brush to sharpen the details in the windows and doorways. I apply final highlights to the foliage using sap green mixed with yellow oxide and light blue. Then I bring out the reflections in the shadow areas of the street by drybrushing on random strokes of raw sienna mixed with a little Payne's gray and light blue-violet mixed with a little Payne's gray. I also use drybrush to soften edges, including the horizontal edge of the foreground shadow. To finish, I add one more layer of highlights to the planters, this time using red oxide mixed with Payne's gray.

Italian Hillside

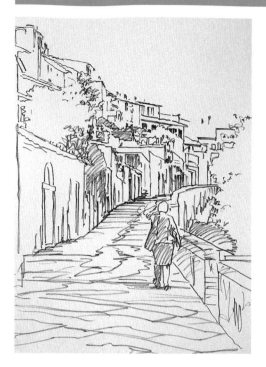

Step One I deliberately chose a vertical composition for this piece to showcase the steep hill and the compact, overlapping buildings. After choosing the format, I make a rough sketch of the scene on a 36" x 24" canvas with a fine-line marker, mapping out the basic shapes and shading.

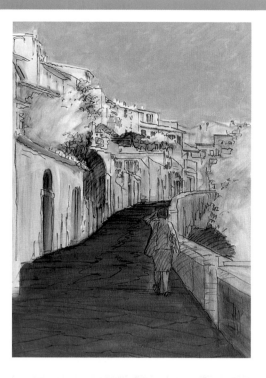

Step Two I mix gloss into my paints and apply burnt sienna to the buildings; Prussian blue to the street; light blue-violet to the sky; Prussian blue mixed with phthalo green to the foliage; and dioxazine purple to the figure, wall, and shadows.

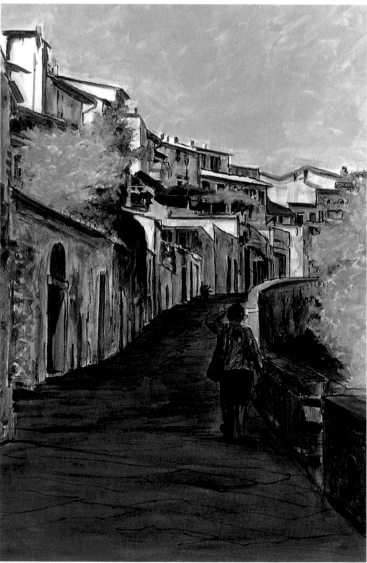

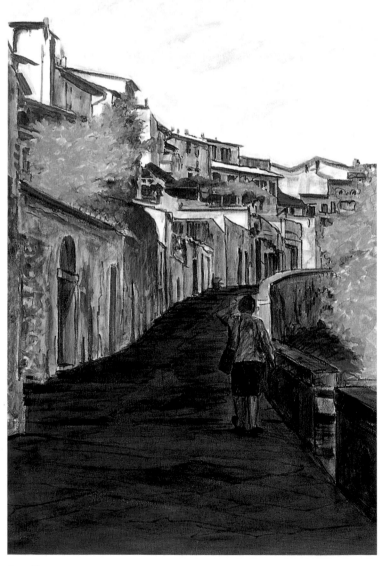

Step Three I apply a mix of Prussian blue, Payne's gray, and burnt sienna to the figure, wall, and roofs; and sap green mixed with Payne's gray to the foliage. I glaze the street with a purple and blue mix, using burnt sienna for the buildings.

Step Four Now I apply raw sienna to the foliage. I glaze magenta over the building shadows and a mix of Payne's gray and phthalo green over the street, adding burnt sienna highlights. Over the sky, I glaze unbleached titanium mixed with gloss.

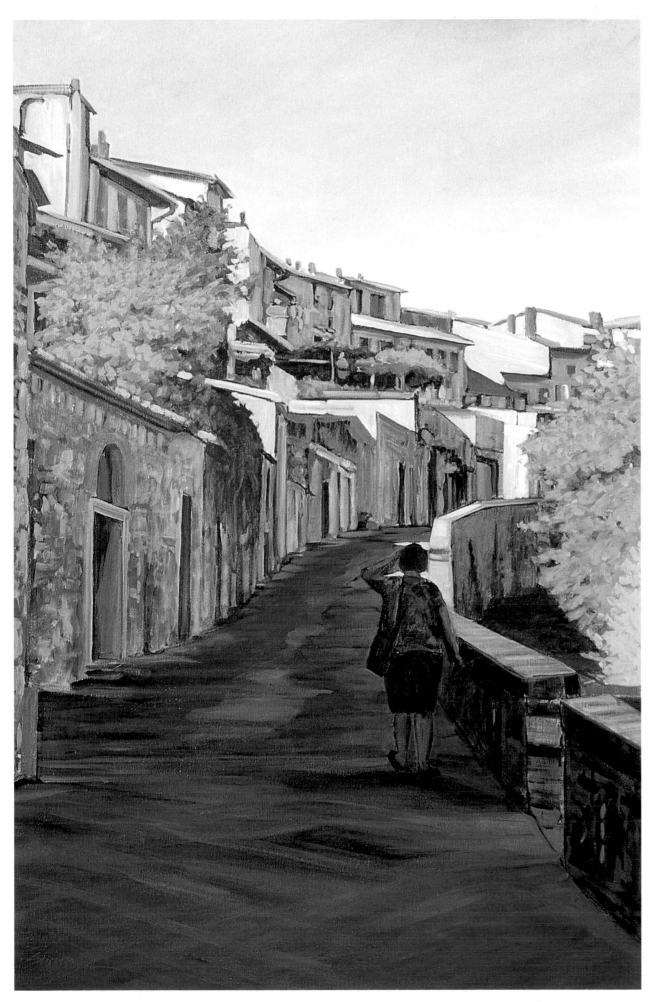

*Payne's gray +
light blue-violet*

*Payne's gray +
light blue-violet +
Prussian blue*

*Red oxide +
Payne's gray*

STEP FIVE For the street's finishing touches, I mix three colors (see color samples, above right), thin the paint with gloss, apply it with crisscross strokes, and blend while it's still wet. Next I dab light blue-violet mixed with burnt sienna and raw sienna onto the buildings for texture. Then I apply burnt sienna mixed with dioxazine purple and light blue-violet to the figure. To brighten the sky, I apply a mix of light portrait pink and light blue-violet, blending as I work from top to bottom. I highlight the trees with a mix of raw sienna, yellow oxide, and sap green. Then I highlight the buildings with thick mixes of red oxide, white, and cadmium yellow medium.

SANTORINI VIEW

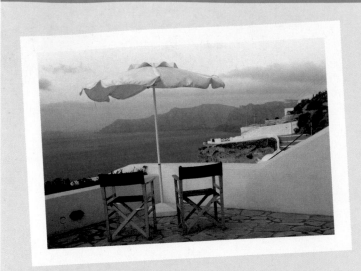

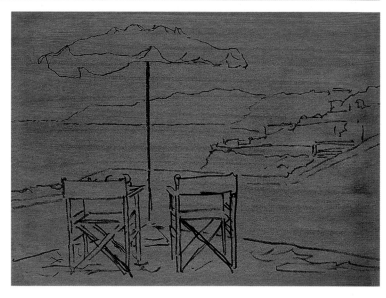

Exaggerating Reflected Color In this photo, you can see a few nuanced colors reflected in the white umbrella and the off-white wall. But to emphasize the reflected color and add drama to the scene, I'm going to change the time of day, pulling in sunset colors and reflections.

STEP ONE Using a small 12" x 16" canvas, I make a rough sketch that defines only the most important shapes and areas of color separation. Then I wash over the sketch with a thin, transparent wash of magenta, which will enhance the warmer tones of the painting as well as help to unify and harmonize later applications of color.

Opaque Colors

Prussian blue + dioxazine purple	*Sap green + cerulean blue*	*Dioxazine purple + burnt sienna + unbleached titanium*	*Light blue-violet + dioxazine purple*	*Magenta + burnt sienna*	*Dioxazine purple + burnt sienna + Payne's gray*

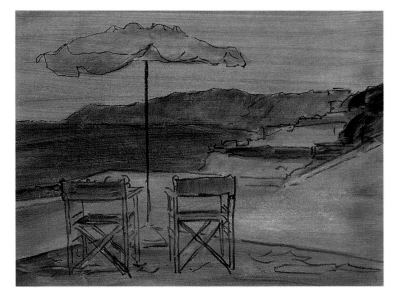

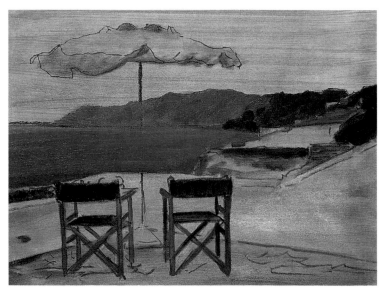

STEP TWO I mix dioxazine purple with burnt sienna, adding gloss medium to improve the flow of the paints; then I rough in the hills and water with this mixture and a medium flat sable brush. Next I switch to raw sienna for the umbrella and the walls—again adding gloss medium to the paints—and I mix in sap green, Payne's gray, and dioxazine purple for the darkest areas of the foliage and chairs.

STEP THREE Next I apply more opaque color (see color samples above), adding a light-blue mix to the background hills and moving forward with a purple mix. I also apply a thin layer of Prussian blue to the water, blending in cerulean blue and light blue-violet while it's wet. I use a darker blue mix for the deck chairs and shadows, switching to sap green mixed with cerulean blue for foliage. I add details to the chair legs with a mix of magenta and burnt sienna.

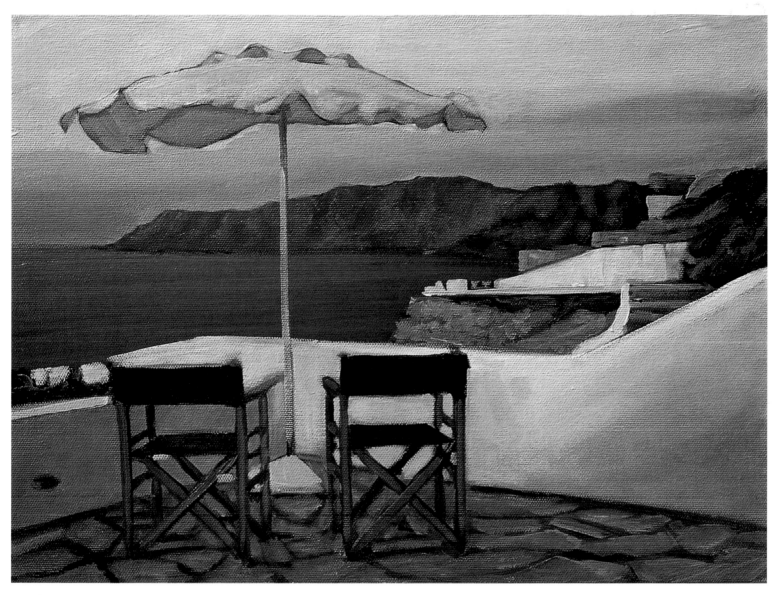

STEP SIX To complete the painting, I make a few final value adjustments. First I build up the highlight colors of the wall by applying reflected colors from the sky—yellow oxide, light portrait pink, and magenta. Then I add details to the chair arms and legs with burnt sienna. Using leftover mixes from the palette, I adjust a few colors in the shadows. Then I add one more layer of color to the patio, filling in the areas between the outlines and highlighting the pole using unbleached titanium, which I mix with a little touch of dioxazine purple in the shadow. Note that it's not just the white umbrella that reflects the colors of the setting sun and surrounding ocean—even the stucco walls, patio tiles, and chair frames do.

STEP FOUR Now I work into the sky with light portrait pink, yellow oxide, and magenta—thinned with gloss medium—blending the colors from top to bottom. I add a little light blue-violet as I get closer to the horizon. Using the same mix, I add reflected color to the walls. Then I darken the shadows in the foreground with dioxazine purple, magenta, Prussian blue, and raw sienna, suggesting the tiles. Then I add light blue-violet to the wall.

STEP FIVE With a mix of burnt sienna, light blue-violet, magenta, and bronze yellow, I add color to the hills. I add another layer to the water, blending as I move from top to bottom. I use Prussian blue to darken the chair fabric and patio tile outlines. And I add another layer of sky color, lightening with unbleached titanium. I apply this color to the umbrella, using a raw sienna and Payne's gray mix for shadows. For wall highlights, I mix Naples yellow with white.

INDEX